CRUISE O MATIC

This edition published in 2000 by Chronicle Books.

English translation copyright © 1988 by Chronicle Books.

Copyright © 1987 by Graphic-sha Co., Ltd., Tokyo. All rights reserved. No part of this book may
be reproduced in any form without written permission from the publisher.

Printed in Hong Kong

ISBN 0-8118-2777-1

Library of Congress Cataloging-in-Publication data available.

Cover design: **Jeremy Stout**

Distributed in Canada by
Raincoast Books
8680 Cambie Street
Vancouver, B.C. V6P 6M9

10 9 8 7 6 5 4 3 2 1

Chronicle Books
85 Second Street
San Francisco, California 94105

www.chroniclebooks.com

CRUISE O MATIC

Automobile Advertising of the 1950s

YASUTOSHI IKUTA

CHRONICLE BOOKS

SAN FRANCISCO

"TEST DRIVE" A '50 FORD!

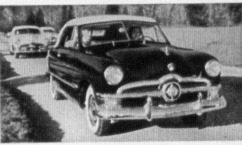

*"IT SHINES ON DRESS PARADE...
IT PROVES ITS METTLE IN ACTION!"*

SEE, HEAR AND FEEL
THE DIFFERENCE

*"IT'S GOT 'LET'S GO' STARTS
AND CAT'S PAW STOPS!"*

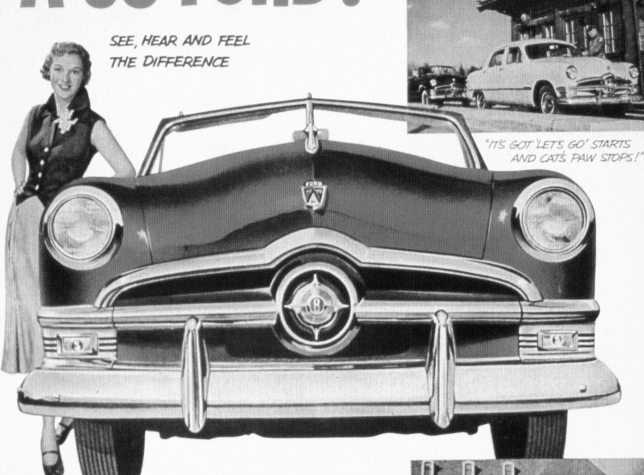

Before you buy any car, your Ford Dealer invites you to "Test Drive" the '50 Ford! "Test Drive" it for power... for comfort... for ease of handling. As for economy—the rapidly growing family of '50 Ford owners has found that this car is designed for top value in original purchase price, and top economy of operation and maintenance. And for looks—well Ford has won the Fashion Academy's Gold Medal again for 1950! See it—"Test Drive" it at your Ford Dealer's today!

THERE'S A IN YOUR FUTURE WITH A FUTURE BUILT IN!

*"IT TAKES THE MEDAL FOR BEAUTY
AND IT'S BUILT TO LIVE OUTDOORS!"*

Beauty—here are today's lowest-built, most thoroughly streamlined cars—featuring advanced Skyliner Styling you can buy now with assurance that it sets the pace for a long time to come!

Luxury—beyond anything ever offered! Most room in any car—nylon or exclusive worsted upholsteries in combination with leather-grain trim, glare resistant instrument panels—color-harmonized custom luxury and convenience all around!

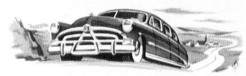

Performance—four rugged Hudson series—each with smooth, high-compression power—blazing getaway, masterful going for the open road. All Hudsons handle with marvelous ease—give you the world's best ride!

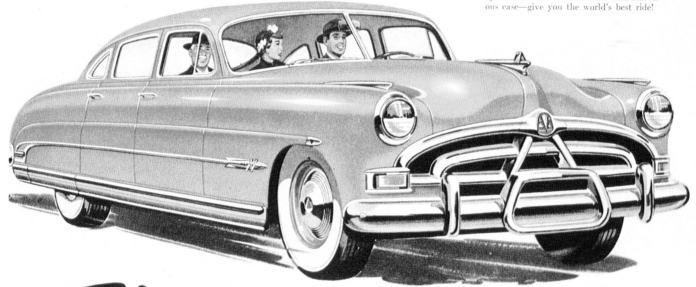

Fabulous motoring
HUDSON FOR '51
starring the HUDSON HORNET
and its sensational H-145 engine

Miracle H-power for the spectacular Hudson Hornet!

This new H-145 high-compression engine gives the fabulous Hudson Hornet—the star in Hudson's line-up for '51—*performance unlimited*—and on regular gas! It's a sensational engine—marvelously smooth—superbly simple in design for lowest upkeep costs. And, like all Hudson engines, it is built to outlast any other engine on the market.

Hydra-Matic Drive optional at extra cost on Hudson Hornet, Commodore and Super-Six models.

Durability—designed and built to last longer! Rugged, steel girder Monobilt body-and-frame*. Chrome-alloy engine blocks—toughest in the industry. Engines balanced as a complete unit for extra thousands of smooth miles—in fact, quality and strength in every inch of every Hudson!

**Trade-mark and patents pending*

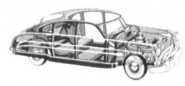

Famous "step-down" design—Hudson's exclusive recessed floor for America's lowest center of gravity! Fabulous motoring with the most room—best ride—greatest safety you can buy in any car!

Rugged Custom Series—PACEMAKER • SUPER-SIX • COMMODORE • HUDSON HORNET

'51 Hudson Hornet

The New

DeSoto
Fire Dome 8

With its mighty 160 h.p. V-Eight

Engine...Power Steering...Power

Braking...and No-Shift Driving...it

is the most revolutionary new car

of 1952. See and *drive* it!

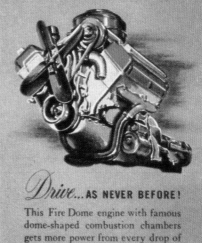

Drive...AS NEVER BEFORE!

This Fire Dome engine with famous dome-shaped combustion chambers gets more power from every drop of fuel. Terrific acceleration and cruising performance *on regular gas.*★★★★ Smart, practical Air-Vent Hood directs stream of cool air to carburetor for maximum engine power.

Steer...WITHOUT EFFORT!

Power Steering is easy as dialing a telephone...you can turn wheel with one finger. Hydraulic power does the work. Parking is *easy!*

DE SOTO DIVISION, CHRYSLER CORPORATION

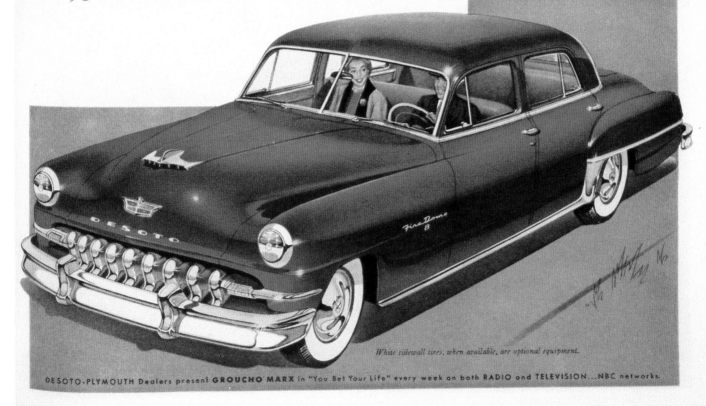

White sidewall tires, when available, are optional equipment.

DESOTO-PLYMOUTH Dealers present **GROUCHO MARX** in "You Bet Your Life" every week on both **RADIO** and **TELEVISION**...NBC networks.

'52 De Soto Fire Dome 8

Longest "Holiday" of the Year!

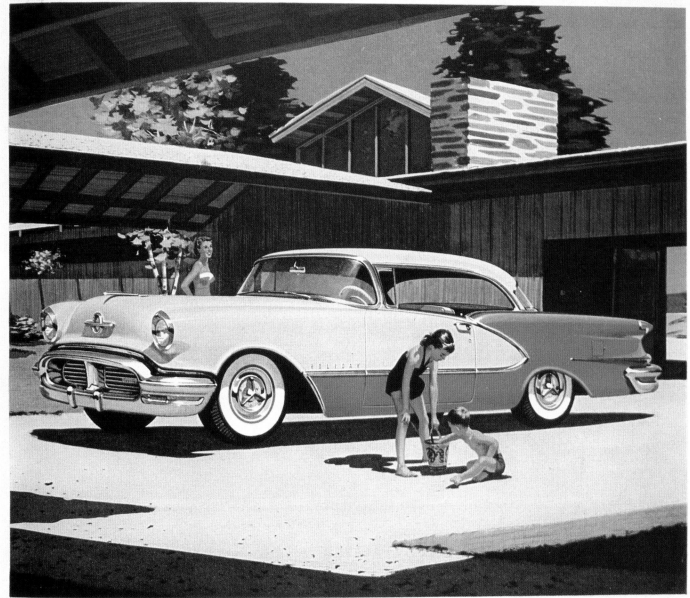

NINETY-EIGHT DELUXE HOLIDAY COUPÉ

▶ Right now . . . and through every month to follow . . . this Oldsmobile Ninety-Eight De Luxe *Holiday* Coupé lives up to its name. For indeed, it is powered high, styled low and long, to add a vacation-like zest to driving. Its Rocket T-350 Engine is always ready with a safety reserve of power to make short, easy work of any trip. The relaxing smoothness of Jetaway Hydra-Matic Drive is yours, too . . . and the effort-saving precision control of Safety Power Steering. This car cuts a proud figure . . . at ease in your driveway or in action on the road. Your Oldsmobile dealer suggests that you inspect it carefully, drive it critically. And this is an experience to be enjoyed *right now!*

NINETY-EIGHT
BY
Oldsmobile

A QUALITY PRODUCT BROUGHT TO YOU BY AN OLDSMOBILE QUALITY DEALER

'56 Oldsmobile 98 Holiday Coupe

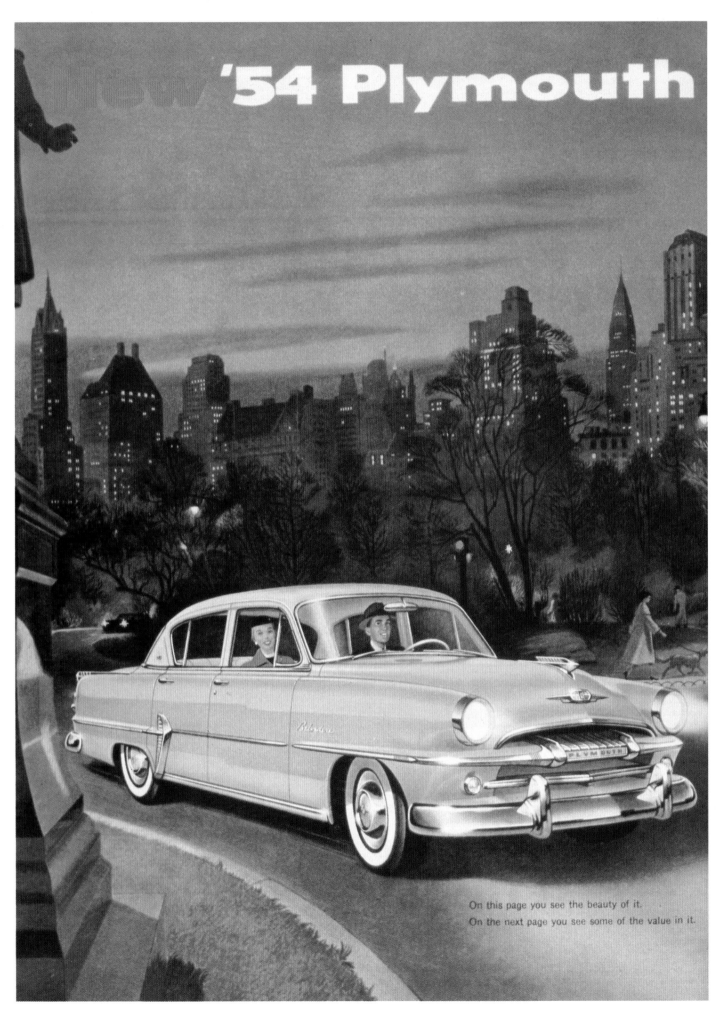

new '54 Plymouth

On this page you see the beauty of it.
On the next page you see some of the value in it.

'54 Plymouth

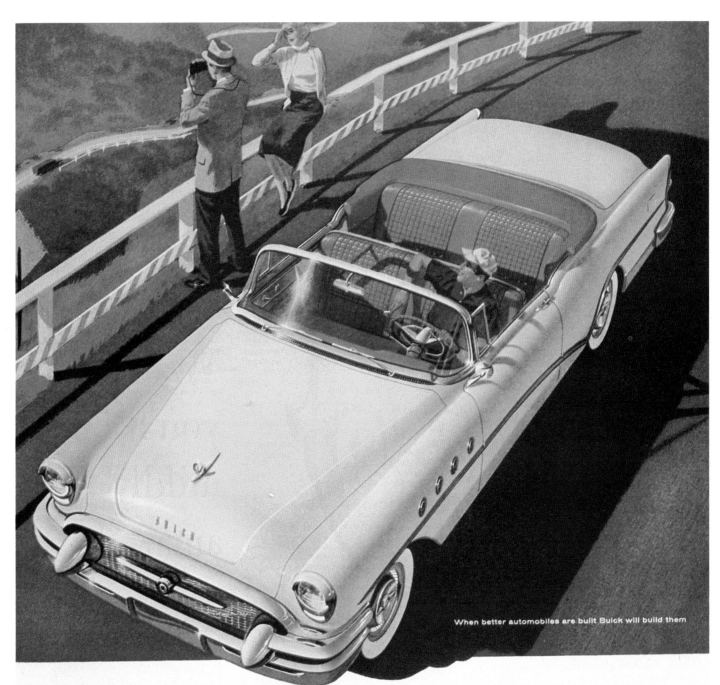

When better automobiles are built Buick will build them

Why not make a smart move – just for the fun of it?

IT makes good sense, if you like the finer things in life, to go looking where the cream lies thickest.

In motoring, that means a meeting with ROADMASTER – and for a very sound reason.

This top-of-the-line Buick is the very cream of the most successful line of Buicks in all history—with sales now soaring to an all-time best-seller high.

That brings to the buyer of a ROADMASTER many things not to be had in other fine cars of similar stature.

For the advantages that are bringing such soaring success to *all* Buicks are merely the beginnings for ROADMASTER.

Here, the great Buick ride of all-coil springing is made measurably better by larger tires, by bigger

brakes, by special cushioning in the car's interior.

Here, exclusive fabrics and finish are fully in keeping with the custom production status of this luxurious automobile.

And here, as you would expect, is a long list of items provided as standard equipment at no extra cost—including Buick's much-wanted Safety Power Steering.

But this year, the move to ROADMASTER is a smarter move than ever in the fine-car field – because here you get the most modern automatic transmission yet developed.

It is the new Variable Pitch Dynaflow—smooth to the absolute—improved in gasoline mileage—thrilling beyond all previous experience when you call for action. And it is given life by the highest horsepower ever placed in a Buick.

So may we suggest that you look into ROADMASTER – just for the fun and satisfaction it can bring you? Your Buick dealer will gladly arrange matters—and show you the sensible price that Buick's volume production permits for this custom-built automobile.

BUICK *Division of* GENERAL MOTORS

ROADMASTER
Custom Built by Buick

'55 Buick Roadmaster

9

The *New* PACKARD

WITH TORSION-LEVEL RIDE

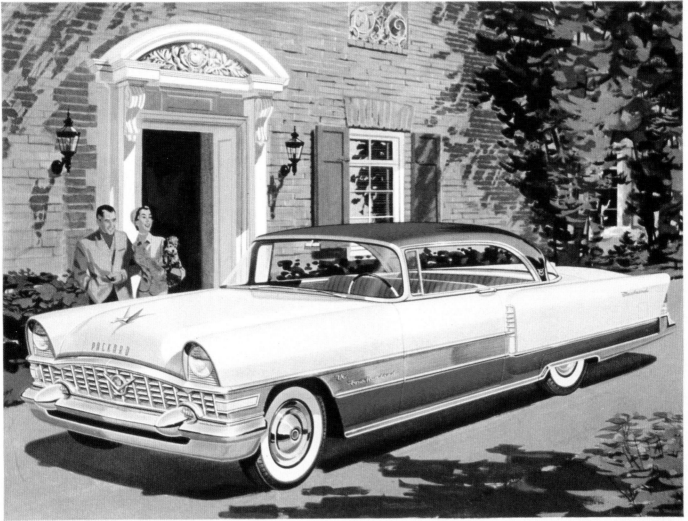

THE NEW PACKARD 'FOUR HUNDRED'—"ASK THE MAN WHO OWNS ONE"

Greatest Ride Development in Automotive History

PRIDE OF POSSESSION—a gleam in the owner's eye . . . ardent admiration—a gleam in *other* eyes . . . this is the impression the *new* Packard is making on owner and onlooker, alike!

Packard engineers, in common with Packard designers, had exclusiveness as their objective. For *only* Packard has Torsion-Level Ride which eliminates coil and leaf springs . . . smooths the road . . . levels the load—*automatically!* In other cars the twisting forces of wheel shock are sent to the frame, creating pitch and bounce

and wracking of the frame and body. In Packard, these same forces are transmitted along the new suspension system and absorbed *before* they reach frame or passengers. And an ingenious power-controlled levelizer keeps the *new* Packard always at "flight-level" regardless of load.

Packard owners can be proud of more than the ride. A new "free-breathing" V-8 engine, 275 horsepower in the Caribbean, 260 in all other models, delivers more driving force to the rear wheels, at all road speeds, than any other

American passenger car engine. And new Packard Twin Ultramatic is the smoothest, most alert of all automatic transmissions.

Gracefully contoured and luxuriously appointed, here is the *one* new car in the fine car field. Your Packard dealer will be happy to place the keys to a *new* Packard at your disposal . . . drive it and *let the ride decide!*

Take the Key and See

PACKARD DIVISION • STUDEBAKER-PACKARD CORP.

This is the Eldorado—a new adventure in automotive design and engineering—with brilliant and dramatic styling . . . hand-crafted, imported leather interiors . . . "disappearing" top . . . and a sensational 270-h.p. engine. In all that it is, and does, and represents . . . it is the finest fruit of Cadillac's never-ending crusade to build greater quality into the American motor car.

Now in limited production • Price on request

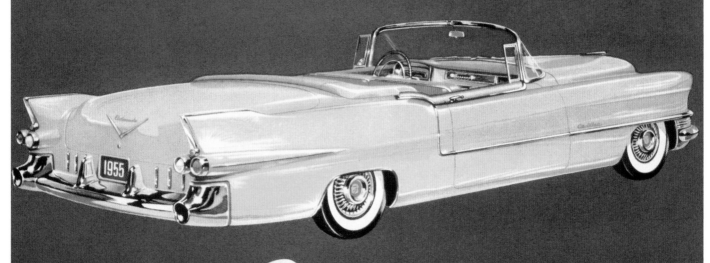

Eldorado
BY CADILLAC

CADILLAC MOTOR CAR DIVISION • GENERAL MOTORS CORPORATION

'55 Cadillac Eldorado

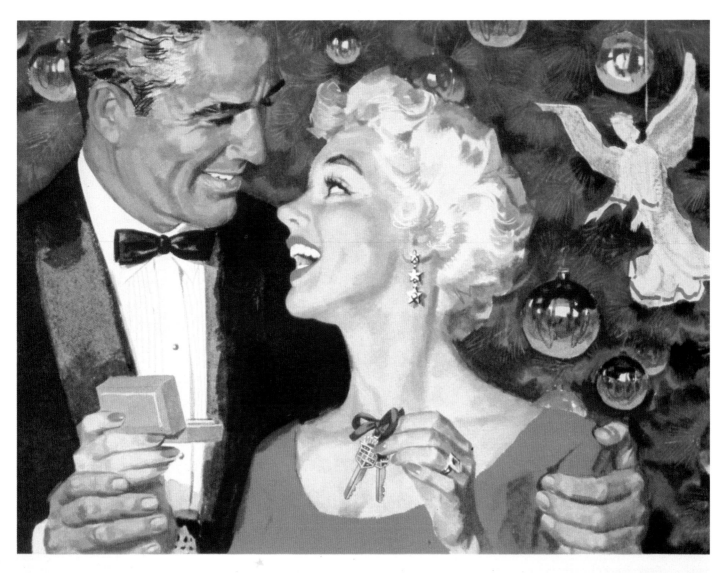

The Christmas They'll Never Forget!

Cadillac

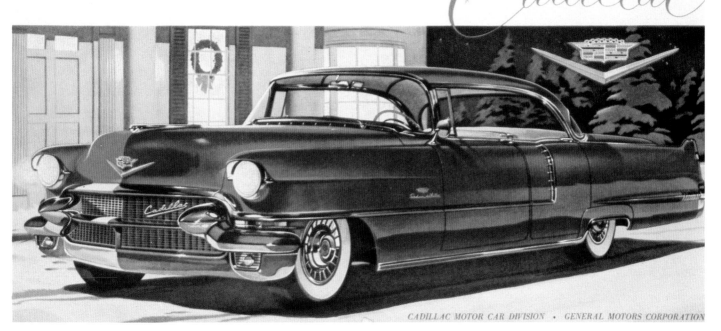

CADILLAC MOTOR CAR DIVISION · GENERAL MOTORS CORPORATION

'56 Cadillac Fleetwood

12

— The seats of the Caribbean series cars are reversible and they strikingly new note to the beauty of the car's interior. Here, plump, leather fits perfectly into the outdoor sports picture.

— On more formal occasions, the beautiful brocade fabric is espe appropriate. Notice the ingenious and practical separation between comfort-contoured seat cushions and back rests.

For 1956 Packard Presents
America's easiest-handling,
safest-riding car...

And certainly the Smartest!

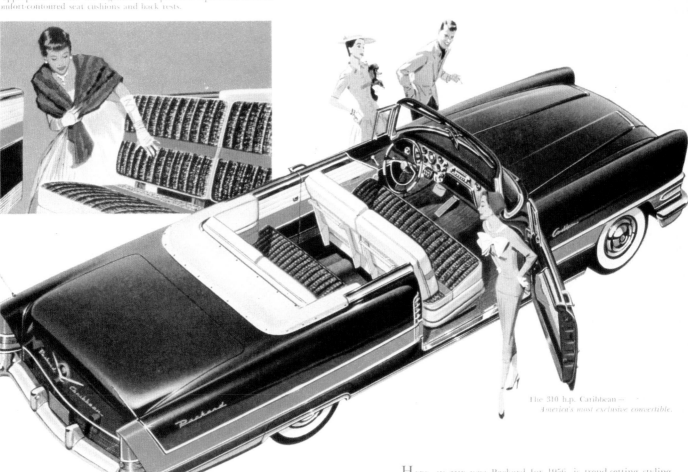

The 310 h.p. Caribbean —
America's most exclusive convertible.

— Packard's Electronic Push-Button Control is the ultimate in matic motoring. You select gears by simply pressing a button and the nse is electronically swift, smooth and sure.

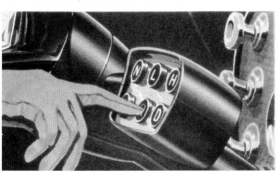

HERE, IN THE *new* Packard for 1956, is trend-setting styling that you, yourself, might have dictated.

Typical of this brilliant Packard touch are the Caribbean seats, the first reversible seats in any automobile. They are as new and original and finely fashioned as a decorator's smartest creation . . . and they permit you to change your car's decor from sleek leather to glowing fabric at the flip of a cushion.

Naturally, Packard's performance is on a par with its style. Packard's advanced Torsion-Level Ride offers comfort, handling ease and safety that no car relying on coil and leaf springs can even approach. America's most powerful V-8 engine puts 310 horsepower at the tip of your toe. Packard's Ultramatic, smoothest and swiftest of all automatic transmissions, now enables you to select gears by simply pushing a button on its Electronic Push Button Control panel.

Your dealer invites you to drive the limited edition Caribbean, the regal Patrician, the care-free Four Hundred. When you do, we believe you'll agree that this is *the greatest Packard of them all* . . . America's easiest-handling, safest-riding car, and certainly the smartest!

PACKARD DIVISION • Studebaker-Corporation
Where Pride of Workmanship Still Comes First.

'56 Packard Caribbean

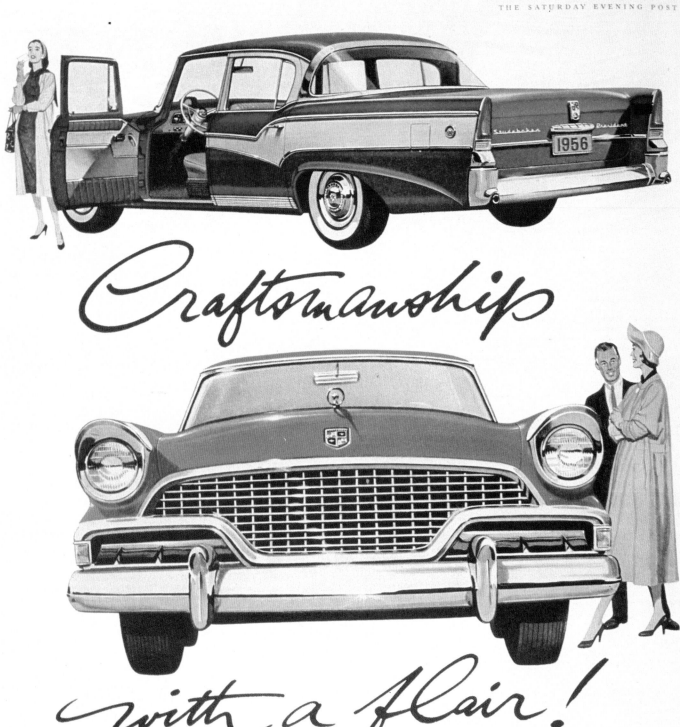

Craftsmanship

with a flair!

Here's the look of luxury—and it's in the *low price field!* It's the big new Studebaker—and never before has there been such a difference in low price cars. Here's why:

You get the longest wheelbase—120½ inches—and the biggest power—210 hp.—in its class. You get a fabulous floating ride, along with silky bursts of speed that only the costliest cars can rival.

And from its massive new grille to its high-falutin' dual exhausts, you get beauty. Inside, surrounded by lovely color-keyed interiors, soothed by a sound-conditioned ceiling, you get luxury beyond compare.

Yes, only Studebaker brings you new style, new power, new beauty—*Craftsmanship with a Flair* in the low price field! There are 16 new and different models for you to choose from: beautiful passenger cars, *big* station wagons, exciting family sports cars. See them at your Studebaker Dealer's soon!

Studebaker THE BIG NEW CHOICE IN THE LOW PRICE FIELD

STUDEBAKER DIVISION, STUDEBAKER-PACKARD CORPORATION—WHERE PRIDE OF WORKMANSHIP STILL COMES FIRST!
Tune in TV Reader's Digest every week.

'56 Studebaker

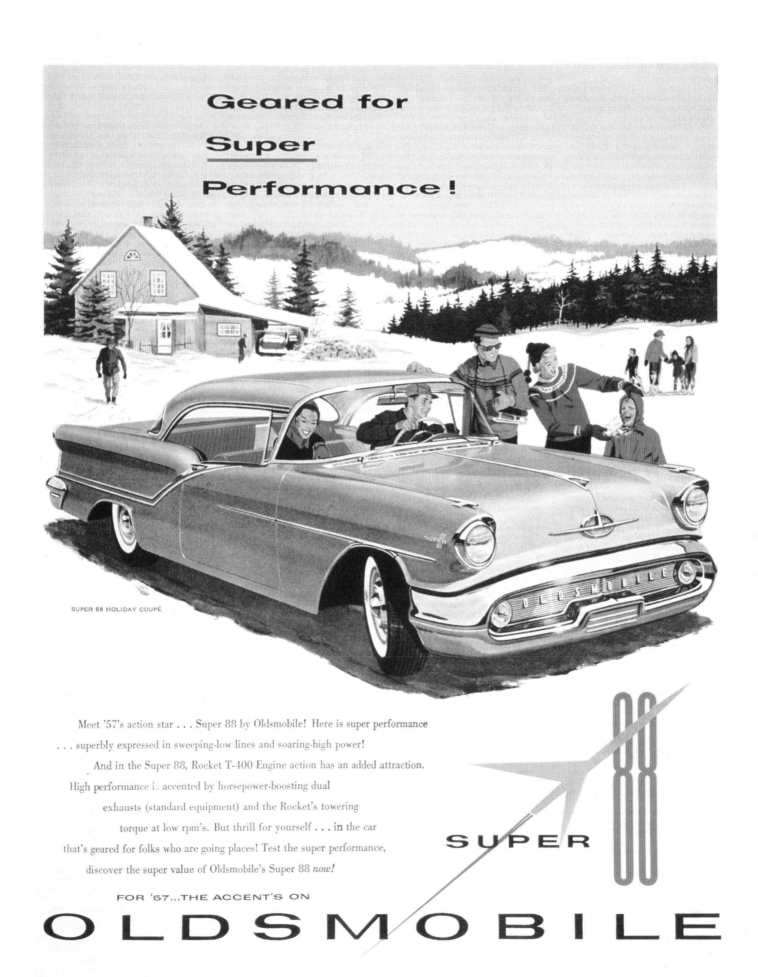

Geared for Super Performance!

SUPER 88 HOLIDAY COUPÉ

Meet '57's action star . . . Super 88 by Oldsmobile! Here is super performance . . . superbly expressed in sweeping-low lines and soaring-high power!

And in the Super 88, Rocket T-400 Engine action has an added attraction. High performance is accented by horsepower-boosting dual exhausts (standard equipment) and the Rocket's towering torque at low rpm's. But thrill for yourself . . . in the car that's geared for folks who are going places! Test the super performance, discover the super value of Oldsmobile's Super 88 *now!*

FOR '57...THE ACCENT'S ON

SUPER 88

OLDSMOBILE

'57 Oldsmobile Super 88

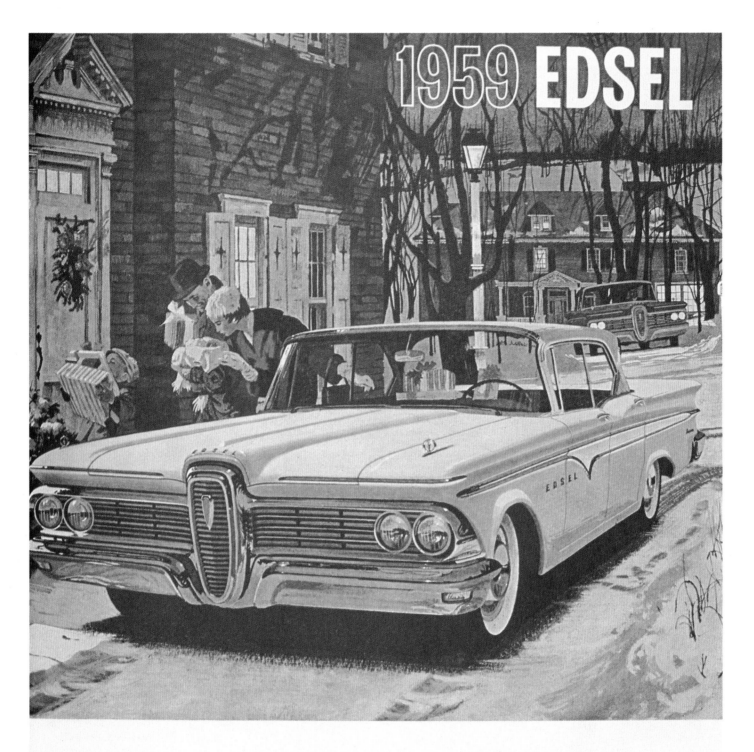

1959 EDSEL

Half its beauty is its new, low price!

Makes history by making sense

Exciting new kind of car! Plenty of room for six. Plenty of power without hogging gas. Soundly engineered. Solidly built. And priced with the most popular three!

This is the car built with a shrewd buyer in mind—a car that really makes sense! Crisp, clean lines give you the kind of distinction that's always in style. Sound engineering provides generous six-passenger room without useless length, and gives you four new mileage-minded engines—including a thrifty six and a spirited new V-8 that uses *regular* gas! Price? A new Edsel Ranger is priced almost exactly the same as many models of Plymouth, Chevrolet and Ford! This comparison is based on actual factory suggested retail prices. See for yourself. At your Edsel Dealer now.

EDSEL DIVISION · FORD MOTOR COMPANY

'59 Edsel

16

For America the decade of the 1950s, or more simply just the fifties, was a wonderful time.

Not only was America taking a leading role in world politics; it was glorifying in unparalleled economic prosperity. The income of Americans was climbing year by year and the standard of living rose steadily. Technological innovations were resulting in the marketing of more appealing products, and to disseminate these goods advertising poured forth from the pages of magazines and newspapers.

Advertising took the middle class in its everyday, American way of life, and illustrated a happy slice of it. Two cars and a carpeted home in the suburbs was the ideal of the average American of the times, but this ideal was nowhere more clearly evident than in magazine advertising. The powerful influence of advertising on the American society of the fifties rivaled even that of education and religion.

This book is a visual retrospective of magazine advertising through the decade of the fifties. The five representative text and picture weeklies of the day — *Life, The Saturday Evening Post, Collier's, Look,* and *Holiday* — provided most of the advertising illustrations appearing in this edition. Only illustrations that are thought to have best exemplified the atmosphere of the times were selected and, fading and discoloration not withstanding, reproduced as far as possible in their original form and color.

Thus, more than a collection of advertising "masterpieces" or a "best works" edition, this retrospective attempts to bring forth the glory of the fifties through a presentation of the best automobile advertising of the period.

The decade of the 1950s was the golden age of the American automobile industry. America enjoyed a monopolistic prosperity, while scorning the European automobile-manufacturing countries, which had been left exhausted by World War II. The full-sized car made in Detroit, with its powerful V-8 engine in a big, five-meter-long body, symbolized the wealth and clout of the American superpower.

The Rolling Jukebox

The most identifiable feature of American cars of the 1950s was the soaring tail fin, which made its first appearance on the 1948 Cadillac. At the outset, within General Motors itself, those who opposed this innovation outnumbered whose who thought it would sell. The consumers, however, loved it. The style perfectly matched not only the upsurge of nationalism in the United States, which, after weathering both World War II and the Korean War had risen to become the number-one superpower in the world, but also the boldness that Americans exhibited in general.

Thus, with each year's new model the tail fin became larger and more exaggerated. Its most extreme manifestation graced the 1959 Cadillac. Moreover, from about 1955 on, cars made by GM's competitors began to resemble Cadillacs, for the majority of cars produced after the mid-fifties bore the fashionable tail fin.

Another unmistakable characteristic of American cars of the fifties was their shiny chromium plating. In addition, striking primary colors like red, yellow, and blue became popular for car body coloration. American cars had tended to be excessively decorated ever since the twenties, and the material prosperity America enjoyed during the fifties caused the tendency to spread rapidly.

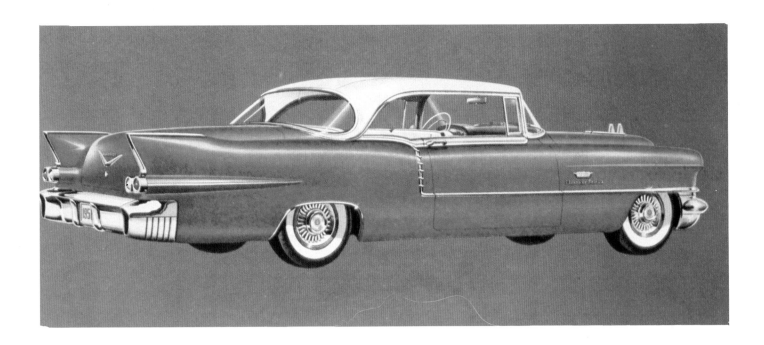

The V-8 Engine's Height of Popularity

The 1950s saw the proliferation of the large V-8 engine. In 1950, only a little over 40 percent of American cars had V-8 engines. At that time, it was commonly held that V-8 engines were for high-class cars and V-6 engines were for middle-class cars and cars for the general public. Like the tail fin, however, the engine rapidly got larger. In 1953 50 percent of all cars had V-8 engines; by 1957 that number had grown to 80 percent.

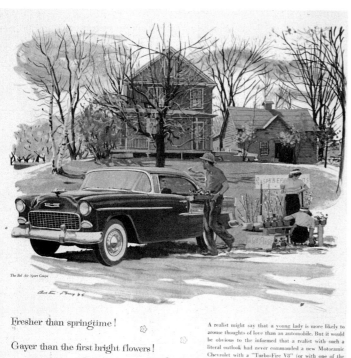

The Bel Air Sport Coupe

Fresher than springtime!

Gayer than the first bright flowers!

With a new V8 and two new 6's to choose from!

What could turn a young man's fancy to thoughts of love quicker than the new Chevrolet!

A realist might say that a young lady is more likely to arouse thoughts of love than an automobile. But it would be obvious to the informed that a realist with such a literal outlook had never commanded a new Motoramic Chevrolet with a "Turbo-Fire V8" (or with one of the new 6's) under its bonnet!

For here is an experience in plus-power that will delight the senses as fully as the long, low lines of the new Chevrolet will delight the eye. . . . There are many new features about the new Chevrolet that the cold-minded will embrace with all the logic and reason at their command . . . just as Chevrolet's fresh styling and gay colors and great power will send the fanciful soaring! Won't *you* take the time to see and drive the new Chevrolet? . . . Chevrolet Division of General Motors, Detroit 2, Michigan.

Motoramic **CHEVROLET** *Stealing the thunder from the high-priced cars!*

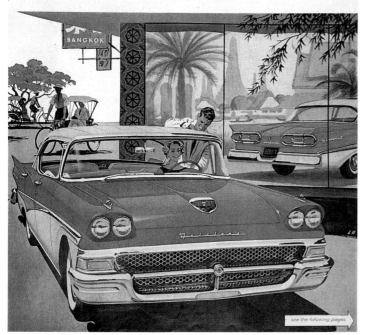

Announcing the great new 58 FORD
PROVED AND APPROVED AROUND THE WORLD

A new car rolled out of Detroit one day last July, bound for the greatest adventure in motor car history. The car: the 58 Ford. The assignment: to test the performance and dependability of this new car around the world . . . if possible.

The route was the most rugged that could be laid out. After London and Paris came the Alps; after Rome came Yugoslavia's rockbound seacoast; after Istanbul came the camel-tracks of Iran and Afghanistan; then the Khyber Pass

through the Himalayas, the bullock-trails of India, the jungle roads east to Vietnam. Weather: worse than you'll ever encounter—122° heat, sandstorms, and 24-hour-a-day rains.

The 58 Ford rolled beautifully, easily through the severest road test ever given a car *before* its American announcement. The Ford *endured*—and came through still glittering and fresh.

Acclaimed from Buckingham Palace to the Taj Mahal, it showed camels how to cross deserts

and elephants how to move through jungles. It was *proved* and *approved* by everyone from natives who had never seen an American car before to famous stylists and nabobs who have seen every car built.

Never before has such a trip been made. This round-the-world performance test became a victory parade, from London to Saigon and back to Detroit. Again, in the Ford tradition, the 58 Ford has broken a trail far out beyond competition.

see the following pages

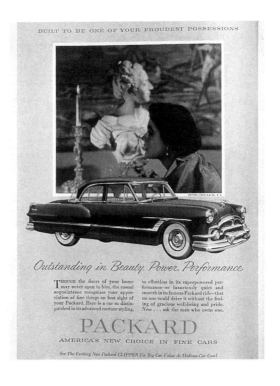

BUILT TO BE ONE OF YOUR PROUDEST POSSESSIONS

Outstanding in Beauty, Power, Performance

Though the doors of your home may never open to him, the casual acquaintance recognizes your appreciation of fine things on first sight of your Packard. Here is a car so distinguished in its advanced contour styling, so effortless in its superpowered performance—so luxuriously quiet and smooth in its famous Packard ride—that no one could drive it without the feeling of gracious well-being and pride. Now . . . ask the man who owns one.

PACKARD
AMERICA'S NEW CHOICE IN FINE CARS

See The Exciting New Packard CLIPPER For Big-Car Value At Medium-Car Cost!

19

Cars as Status Symbols

In the America of the 1950s, a car was not only a means of transportation, but a symbol of its driver's status and personality as well. Each make of car had a specific image that led drivers to buy it.

For example, Cadillacs and Imperials were cars for managers; Buicks and Packards were for intellectuals like doctors, lawyers, and college professors; Pontiacs were for school teachers; and Nashes were for housewives. People started to upgrade their cars as their social status rose.

A friend of mine who studied in the United States was once told by an American professor, "In this country, there is only one way to judge people: see what kind of car he drives. Now that doesn't mean that those who drive high-class cars are always high-class people, but those who drive low-class cars are without doubt low-class people. Watch out for them!"

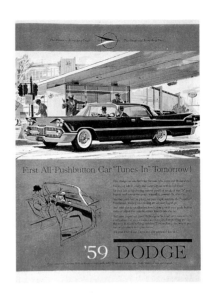

First All-Pushbutton Car "Tunes In" Tomorrow!

'59 DODGE

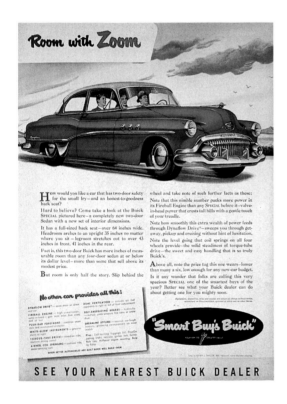

Room with Zoom

No other car provides all this:

"Smart Buy's Buick"

SEE YOUR NEAREST BUICK DEALER

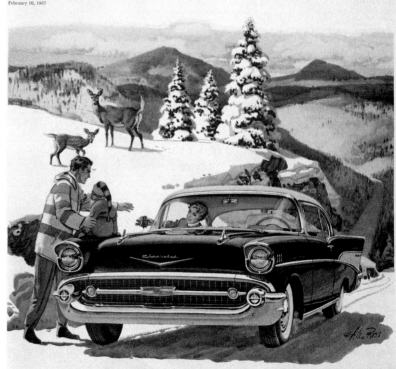

February 16, 1957

SWEET, SMOOTH AND SASSY—the beautiful Bel Air Sport Coupe. You can see and feel the solid quality of its Body by Fisher.

filled with grace and great new things

CHEVROLET

1 USA
BY CHEVROLET

It looks agile, graceful and easy to handle — and it more than lives up to its looks! Chevy offers fuel injection and America's first and only triple-turbine transmission.

You expect something pretty special in the way of driving pleasure the very first time you take charge of a new Chevrolet. Those clean, graceful contours hold a promise of quicksilver responsiveness. And there's something about the low, action-poised profile that tells you Chevy's a honey to handle.

It doesn't take long to find out that this car lives up to all its "advance notice"—and

then some! Horsepower ranging up to 245* translates your toe-touch into cream-smooth motion. You find that turning a corner is almost as easy as making a wish. And you see how Chevrolet's solid sureness of control makes for safer, happier driving on city streets, superhighways and everything in between.

If you drive a new Chevrolet with Turbo-glide (an extra-cost option), you'll discover triple-turbine takeoff and a new flowing kind of going.

Stop by your Chevrolet dealer's and sample all these great new things! . . . Chevrolet Division of General Motors, Detroit 2, Mich.

Famous Cars That Disappeared from the Scene

The American automobile industry reached its apex during the 1950s. Production records in Detroit constantly achieved new heights, and by 1955 the number of U.S. domestic new car registrations had reached 7,170,000.

Even with such strong overall growth, the monopoly of the big three manufacturers — GM, Ford, and Chrysler — steadily progressed. Although independent automakers such as Hudson, Kaiser-Frazer, Nash, Packard, Studebaker, and Willys challenged the giant manufacturers in a last-ditch struggle to survive, their market shares continued to slide. In 1955 Kaiser and Willys disappeared; in 1957, Hudson and Nash; and in 1958, Packard.

The big three automakers also had to fight hard for their shares of the market. In 1957 the Edsel, introduced to the market by Ford with a huge promotional campaign, sold poorly. (The number of registrations of the new car was 26,000 in the first year, 38,000 in 1958, and 40,000 in 1959.) Production stopped after only three years. The annual sales of Chrysler's De Soto dropped sharply around 1958, and its production was halted in 1960.

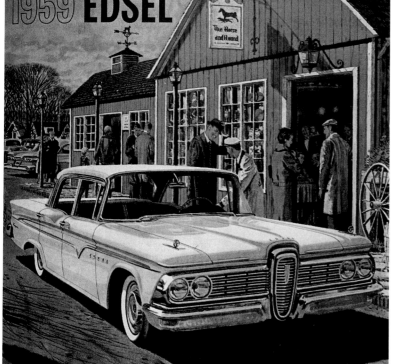

FOR YOUR FALL CHANGE
... see my dad!

TEXACO DEALERS
in all 48 states

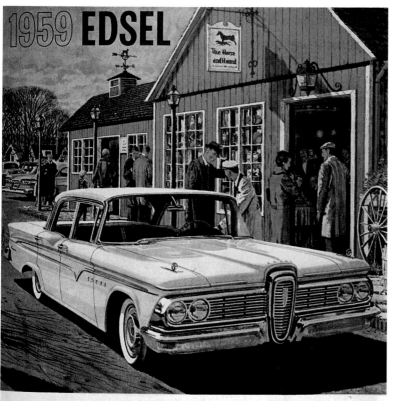

1959 EDSEL

The Horse and Hound

Looks right! Built right! Priced right!

Makes history by making sense

Exciting new kind of car! A full-size, six-passenger beauty. Roomy without useless length. Built to last. Powered to save. And priced with the most popular three!

Here's the kind of car you hoped would happen. All the spacious luxury you could ask for—yet much easier to park and drive. Because Edsel's new styling sensibly called for *less length* this year! And

Edsel engineering sensibly planned for all the power you can use—but with *real gas savings* every mile! Edsel's four new engines include an efficient, thrifty six and a new, economy V-8 that does you proud

on *regular fuel!* It all makes sense—and so does the new, low price. *For the 1959 Edsel is actually priced with the most popular three—Ford, Plymouth and Chevrolet!*

EDSEL DIVISION · FORD MOTOR COMPANY

The Signs of the End of the American Age

Beginning in about 1957, signs of a serious change of affairs began to appear in the prosperous United States. That year the Russians launched the space satellite *Sputnik;* in 1958 there was an economic recession, deficits appeared in the international balance of trade, and Europe regained lost power. Incidents like these cropped up to suggest that the end of Pax Americana was at hand.

At the same time a distinct change appeared in the automotive industry as well. The gaudy, overdesigned cars with their poor gas mileage began to lose popularity. Americans started showing an interest in the economical European small cars that boasted good gas mileage. The small imports, which were not included in the 1955 statistics, appeared in 1957 with a sales figure of 210,000, in 1958 with 380,000, and in 1959 with 610,000. By the end of the 1950s, small cars represented 10 percent of all U.S. new car registrations.

Naturally, somewhere among that 10 percent could be found the small cars from Japan — Toyota and Nissan — although the actual number sold was still negligible. But throughout the 1960s and 1970s, Japanese cars gradually increased their market share, finally almost monopolizing the American imported car market, and contributing to today's U.S.-Japan trade war. This trend toward increased sales of the small imported car that started late in the 1950s portended the end of the age of the full-sized car from Detroit.

Today, we rarely see these colorful, chrome-bedecked cars outside of advertisements like those shown in this book. The car that so well symbolized the American glory of the 1950s has disappeared into the pages of history.

1955 U.S. New Car Sales
Quantity & Rank of Various Makes

Make	Rank	Quantity	Share
CHEVROLET	1	1,640,681	22.9%
FORD	2	1,573,276	21.9%
BUICK	3	737,879	10.3%
PLYMOUTH	4	647,352	9.0%
OLDSMOBILE	5	589,515	8.2%
PONTIAC	6	530,007	7.3%
MERCURY	7	371,837	5.1%
DODGE	8	284,323	3.9%
CHRYSLER	9	144,618	2.0%
CADILLAC	10	141,038	1.9%
DE SOTO	11	118,062	1.6%
STUDEBAKER	12	95,761	1.3%
NASH	13	93,541	1.3%
PACKARD	14	52,103	0.7%
HUDSON	15	43,212	0.6%
LINCOLN	16	35,017	0.5%
IMPERIAL	17	11,840	0.2%
WILLYS	18	6,267	negligible
KAISER	19	959	negligible
CONTINENTAL	20	606	negligible

Total Sales $7,169,908

(Source: Automotive News Almanac)

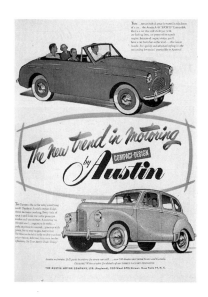

1950

◄Chevrolet, Chrysler, Dodge, and De Soto all begin to sell hardtops.
◄The 3 millionth Oldsmobile comes off the assembly line. Oldsmobile completely stops manufacturing a 6-cylinder car and installs 8-cylinder engines in all models.
◄The Chrysler Company celebrates its twenty-fifth anniversary.
◄The Korean War prompts U.S. military authorities to grant large contracts to all automotive manufacturers for the production of military vehicles.
◄The 1951 models are introduced. Many have V-8 engines, automatic transmissions, and curved windshields.

1951

◄Chrysler and Buick introduce cars with power steering.
◄The Willys-Overland Company introduces the Aero-Willys as its postwar model.
◄The Kaiser-Frazer Company announces the cessation of production of the Frazer car.
◄ In December, the 100 millionth American automobile comes off the assembly line.

1952

◄The Studebaker Company celebrates its 100th anniversary.
◄The GM Cadillac division celebrates its fiftieth anniversary.
◄The Chrysler Crown Imperial is given a 12-volt battery with AC dynamo.
◄The Hudson Jet debuts.
◄The Willys-Overland Company introduces two new models: the Arrow Ace and the Arrow Lark.

1953

◄Both the GM Buick division and the Ford Company celebrate their fiftieth anniversaries.
◄Kaiser-Frazer changes its company name to Kaiser Motors. In addition, the company buys out Willys-Overland.
◄Automatic transmission becomes an option in almost all models; moreover, it becomes a standard installation for high-priced models. The 12-volt battery becomes the mainstream power supply.

1954

◄The Nash-Kelvinator Company and Hudson Motors unite to form the American Motors Corporation (AMC).
◄The Studebaker Company and Packard Motors unite to form the Studebaker-Packard Corporation.

1955

◄The American automotive industry enjoys the best business in its history, with production volume exceeding 9,200,000 vehicles (7,950,000 private passenger vehicles).
◄Kaiser retreats from the passenger vehicle market and goes strictly into four-wheel drive Jeep production.
◄American Motors installs 8-cylinder engines into its Ambassador series.

1956

◀The Ford Company goes public and begins to sell its stock. About a million shares owned by the Ford Foundation are released to the market at a price of $64.50 per share.
◀A new freeway law is promulgated, and the 41,000-mile interstate system is begun.
◀The Studebaker-Packard Company decides to close its Packard plant, moving production of the Packard to the Studebaker factory.
◀The forty-second national automobile show is held at the newly constructed New York Coliseum. For the first time in its history, the show is broadcast throughout the country on television, and about 21.6 million Americans tune in.

1957

◀Oldsmobile celebrates its sixtieth anniversary.
◀The 10 millionth Plymouth comes off the line.
◀American Motors ceases production of the Nash and Hudson cars with their 1957 models.
◀Ford introduces the Edsel.

1958

◀Ford reaches the 50-million-vehicle milestone.
◀Chrysler reaches the 25-million-vehicle milestone.
◀GM celebrates its fiftieth anniversary.
◀Studebaker-Packard ceases production of Packard cars altogether.
◀Chrysler acquires 25 percent of the French corporation Simca.

1959

◀Ford ceases production of the Edsel a mere three years after its debut in 1957. During this period, the number of registered owners in the U.S. domestic market totals only 106,000.

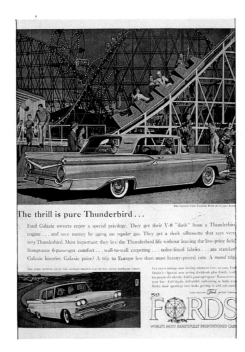

The thrill is pure Thunderbird...

Here's an economy car with a difference you'll like: room! Thirty miles per gallon. A sensible price. And inexpensive upkeep. These economy features make the Peugeot '403' an <u>easy</u> car to own. Just as important, it is a <u>comfortable</u> car to ride in. A family of 5 or 6 can travel for hours on its foam rubber-padded leatherette seats—and arrive refreshed! The Peugeot is highly maneuverable. Easy to park. And the price of $2175 (P.O.E., N.Y.) includes all this: sliding sunroof, whitewall or Michelin "X" tires, 4-speed synchromesh transmission, heater-defroster, padded dashboard, electric clock and reclining seats.

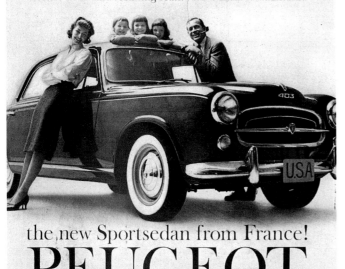

the new Sportsedan from France!

PEUGEOT

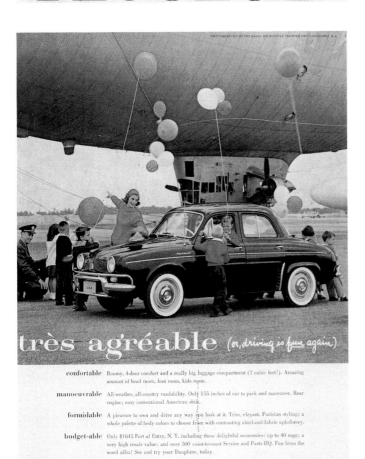

très agréable (or, driving is fun again)

confortable Roomy, 4-door comfort and a really big luggage compartment (7 cubic feet!). Amazing amount of head room, foot room, kids room.

manœuvrable All-weather, all-country roadability. Only 155 inches of car to park and maneuver. Rear engine; easy conventional American shift.

formidable A pleasure to own and drive any way you look at it. Trim, elegant, Parisian styling; a whole palette of body colors to choose from with contrasting vinyl-and-fabric upholstery.

budget-able Only $1645 Port of Entry, N. Y. including these delightful economies: up to 40 mpg; a very high resale value; and over 500 coast-to-coast Service and Parts HQ. Fun from the word *allez!* See and try your Dauphine, today.

RENAULT *Dauphine*

Small Is Beautiful

"Better than they like eating, Americans like to get into a full-sized V-8 car, its air-conditioner turned up, and cruise along the highway at top speed with the car radio blasting away. Small, foreign cars that look like movable toilets won't be acceptable to the American consumer." So believed the managers of U.S. automotive manufacturers like GM and Ford in the 1950s.

This, however, was merely the arrogance of Detroit.

As the American lifestyle changed, so did the public's taste in cars. In particular, middle-class, urban consumers readily switched to small, economical European cars. A rapid increase was also noted in the number of people who chose small European cars over American cars for their supplementary vehicle.

Year after year, the European cars steadily expanded their market share. In 1957 the number-one imported car was the Volkswagen, fondly called the Beetle. The second-ranking import was Renault, followed by British Ford, MG, Hillman, and Volvo.

Japanese cars like Toyota and Datsun appeared in the rankings only in the 1960s, especially in the latter half, some ten years after the above rankings.

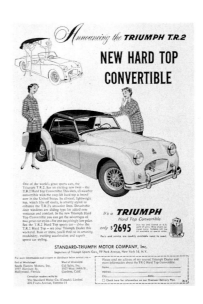

Announcing the TRIUMPH T.R.2

NEW HARD TOP CONVERTIBLE

It's a *TRIUMPH*
Hard Top Convertible
only $2695

STANDARD-TRIUMPH MOTOR COMPANY, Inc.

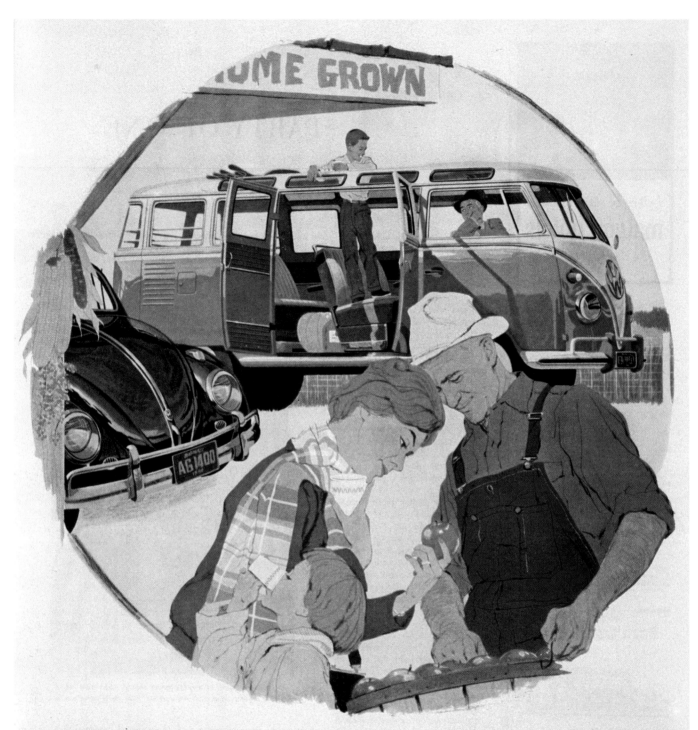

The full of sun, full of fun Station Wagon

A Volkswagen DeLuxe Station Wagon, to be sure! It's the growing American family's
pride and joy — roomy as can be — and carefree as the whole outdoors with sliding sun-roof, skylights and
big picture windows. And with all this fun . . . Volkswagen quality,
Volkswagen dependability, Volkswagen economy.

Famous VW Service and Genuine VW Spare Parts available in all 49 states

For free full-color
illustrated brochure, write
P. O. Box 2502, New York 17, N. Y.

VOLKSWAGEN

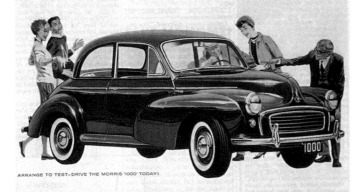
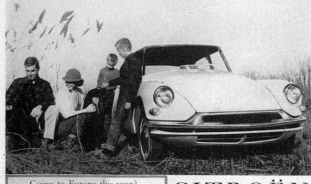
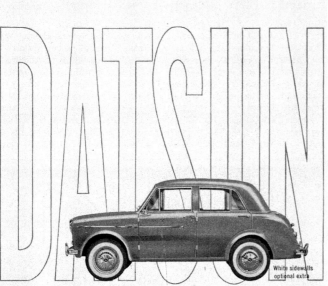
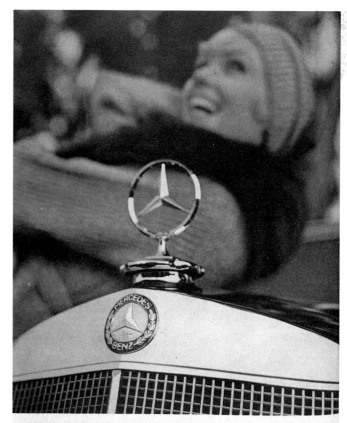

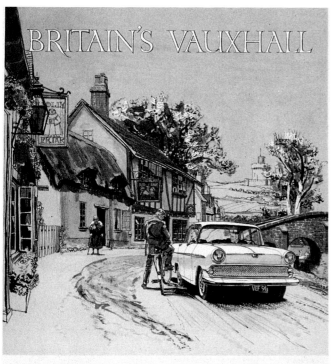

BRITAIN'S VAUXHALL

This is the fine small car from England
sold and serviced by Pontiac dealers throughout America

You'll like the Vauxhall for the same reasons the British do. It's compact, trim, taut and more often than not goes thirty-five miles on each gallon of gasoline. Yet nothing has been overlooked to give it the convenience Americans demand.

It seats five passengers comfortably. There are four good-size, easy-to-enter doors. The windshield is the wrap-around type, as is the rear window. There's ample trunk space. The gearshift is American style. And, most significantly,

your Vauxhall can be readily serviced by authorized Pontiac dealers located in practically every village and hamlet throughout the States.

Built by General Motors in England, the Vauxhall is becoming an extremely popular import among Americans who want something distinctive in a small car.

See or call the Pontiac dealer nearest you and tell him you'd like to try out a Vauxhall for a day or so. It's quite an automobile.

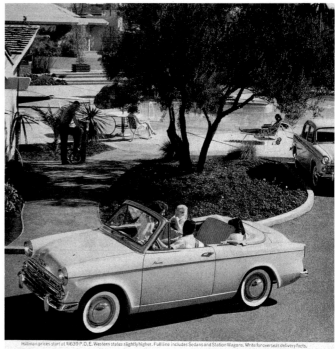

Hillman prices start at $1639 P.O.E. Western states slightly higher. Full line includes Sedans and Station Wagons. Write for overseas delivery facts.

Hillmanship proves that the best things in life can cost $2099

Open up and let the sun shine in. Top adjusts to 3 positions. Precision engine gives up to 35 mpg. Room for 5. Full-size trunk for luggage. Test-drive it at your Hillman dealer's now.

ROOTES PRODUCTS: SUNBEAM · SINGER · HUMBER **HILLMAN**
Rootes Motors, Inc., 505 Park Ave., N.Y., N.Y. · 9830 W. Pico Blvd., L.A., Calif. · Rootes Motors (Canada) Ltd., Toronto, Montreal, Vancouver

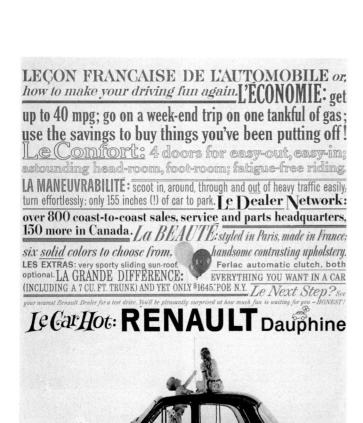

LEÇON FRANCAISE DE L'AUTOMOBILE *or, how to make your driving fun again.* L'ÉCONOMIE: get up to 40 mpg; go on a week-end trip on one tankful of gas; use the savings to buy things you've been putting off! Le Confort: 4 doors for easy-out, easy-in; astounding head-room, foot-room; fatigue-free riding. LA MANEUVRABILITE: scoot in, around, through and *out* of heavy traffic easily; turn effortlessly; only 155 inches (!) of car to park. Le Dealer Network: over 800 coast-to-coast sales, service and parts headquarters, 150 more in Canada. *La BEAUTÉ:* styled in Paris, made in France; *six solid colors to choose from,* handsome contrasting upholstery. LES EXTRAS: very sporty sliding sun-roof, Ferlac automatic clutch, both optional. LA GRANDE DIFFERENCE: EVERYTHING YOU WANT IN A CAR (INCLUDING A 7 CU. FT. TRUNK) AND YET ONLY $1645. POE N.Y. *Le Next Step?* See your nearest Renault Dealer for a test drive. You'll be pleasantly surprised at how much fun is waiting for you—HONEST!

Le Car Hot: **RENAULT** Dauphine

HOLIDAY/JUNE

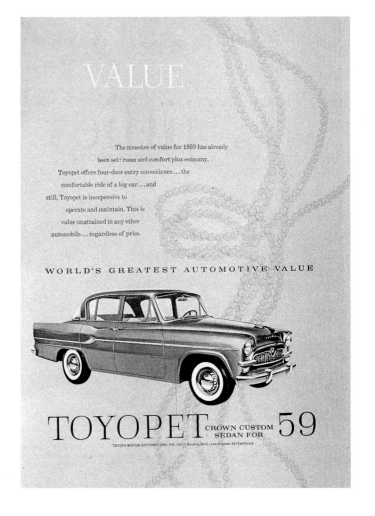

VALUE

The measure of value for 1959 has already been set: room and comfort plus economy. Toyopet offers four-door entry convenience...the comfortable ride of a big car...and still, Toyopet is inexpensive to operate and maintain. This is value unattained in any other automobile...regardless of price.

WORLD'S GREATEST AUTOMOTIVE VALUE

TOYOPET CROWN CUSTOM SEDAN FOR **59**
TOYOTA MOTOR DISTRIBUTORS, INC. /8711 Beverly Blvd. / Los Angeles 48 / California

first

in Valve-in-Head performance with economy

Step out in a Chevrolet and enjoy *higher thrills* with *lower costs* every minute, month and mile you drive! You'll find owners are right when they say Chevrolet brings you the finest combination of thrills and thrift available today. For it's the only low-priced car powered by a *Valve-in-Head* Engine . . . trend-setter for the industry. And remember—Chevrolet offers a choice of *two* great Valve-in-Head engines at lowest cost!

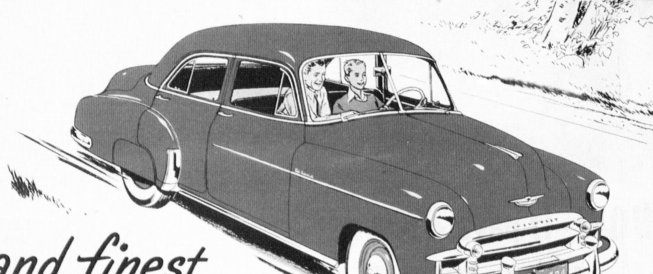

The Styleline De Luxe 4-Door Sedan

and finest

for thrifty No-Shift Driving or Standard Driving

CHEVROLET Chevrolet gives you the *finest* kind of *no-shift driving* at lowest cost, with the phenomenal Powerglide Automatic Transmission, teamed with a 105-h.p. Valve-in-Head Engine.* You get the finest kind of *standard driving* at lowest cost in a Chevrolet with the highly improved standard Valve-in-Head Engine and Silent Synchro-Mesh Transmission.

Combination of Powerglide Automatic Transmission and 105-h.p. Engine optional on De Luxe models at extra cost.

at lowest cost

with fine-car feature after fine-car feature at lowest prices

CHEVROLET Moreover, Chevrolet brings you many other exclusive fine-car features, including Body by Fisher for topmost beauty, comfort and safety; Center-Point Steering and the Unitized Knee-Action Ride for maximum steering-ease and riding-ease; and Curved Windshield with Panoramic Visibility and Proved Certi-Safe Hydraulic Brakes for greatest safety protection. See and drive Chevrolet, and you'll agree, it's *first and finest at lowest cost!*

AMERICA'S BEST SELLER . . . AMERICA'S BEST BUY

CHEVROLET MOTOR DIVISION, *General Motors Corporation*, DETROIT 2, MICHIGAN

'50 Chevrolet

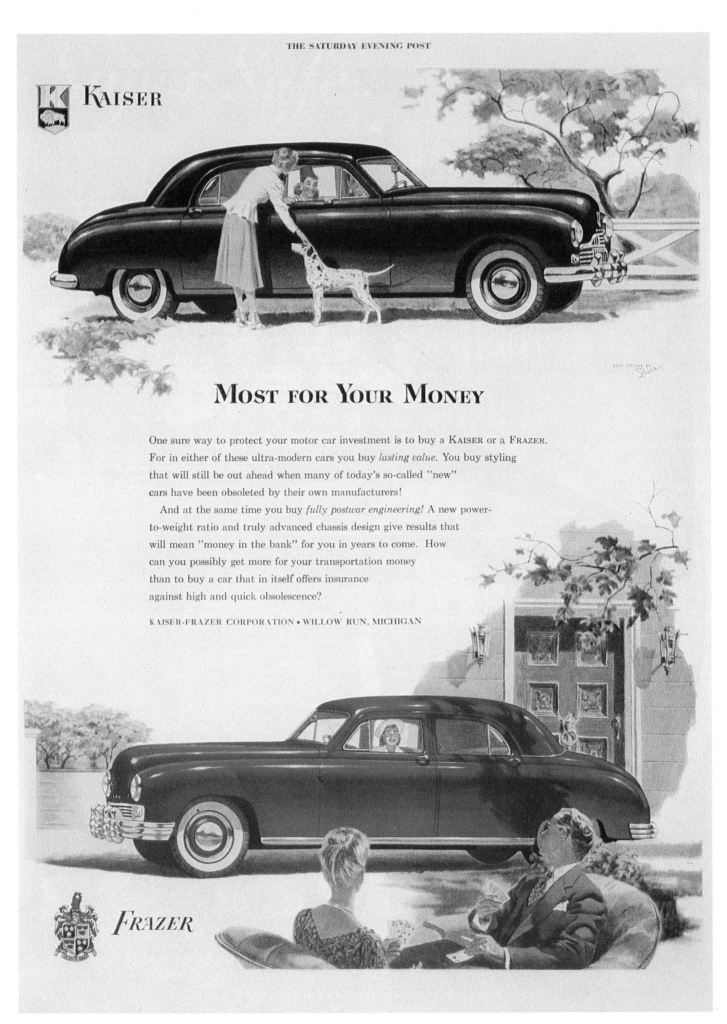

KAISER

MOST FOR YOUR MONEY

One sure way to protect your motor car investment is to buy a KAISER or a FRAZER.
For in either of these ultra-modern cars you buy *lasting value.* You buy styling
that will still be out ahead when many of today's so-called "new"
cars have been obsoleted by their own manufacturers!

And at the same time you buy *fully postwar engineering!* A new power-
to-weight ratio and truly advanced chassis design give results that
will mean "money in the bank" for you in years to come. How
can you possibly get more for your transportation money
than to buy a car that in itself offers insurance
against high and quick obsolescence?

KAISER-FRAZER CORPORATION • WILLOW RUN, MICHIGAN

FRAZER

'48 Kaiser—Frazer

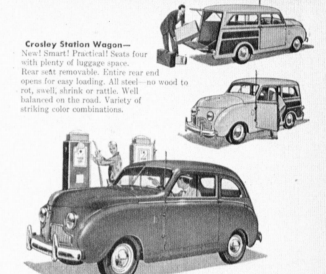
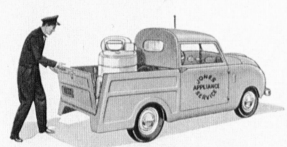
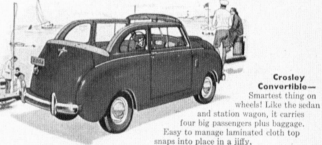
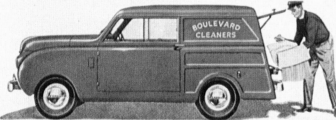

"It didn't *seem* like 400 miles"

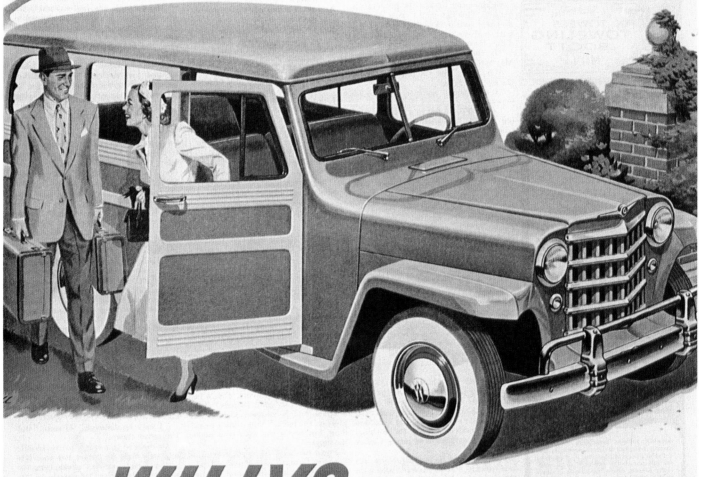

WILLYS *makes sense*

–IN DESIGN –IN ECONOMY –IN USEFULNESS

'49 Willys Station Wagon

now comes a dream of a car ... a daring, fun-loving dream,

realized in steel and chrome ... ready to thrill those "special" kinds of

people of every age who tire of the ordinary and always seek the uncommon:

meet the Jeepster

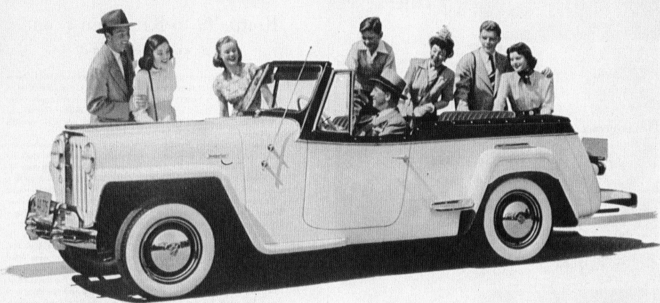

The fleet, low-slung lines of the Jeepster tell you in
advance: "Here is a companion for carefree moments".
Come, sit under the wheel, and deny if you can
the desire to roam new roads with the Jeepster.
Take off from the crowded highway, the mob is
not for you. Seek the unspoiled spots and strange scenes.
Go with the wind, commanding the power of
the mighty 'Jeep' engine. And soon, you'll settle
back in the seat with a smile ... For this is *fun*.

If you're headed for the shore, the mountains,
or a brisk turn on the boulevard,
your spirits will run high with the Jeepster.
Vacation journey or workaday errand alike are
less tiring, because there's a lift to your spirits.
Leave the more formal cars to more formal people.
You'll drive the Jeepster for the sheer joy of
driving, of going somewhere, with laughter
in your heart and a song on your lips.

Meet the Jeepster now, at Willys-Overland dealers.

WILLYS-OVERLAND MOTORS, TOLEDO, OHIO, U.S.A. · MAKERS OF AMERICA'S MOST USEFUL VEHICLES

'49 Willys Jeepster

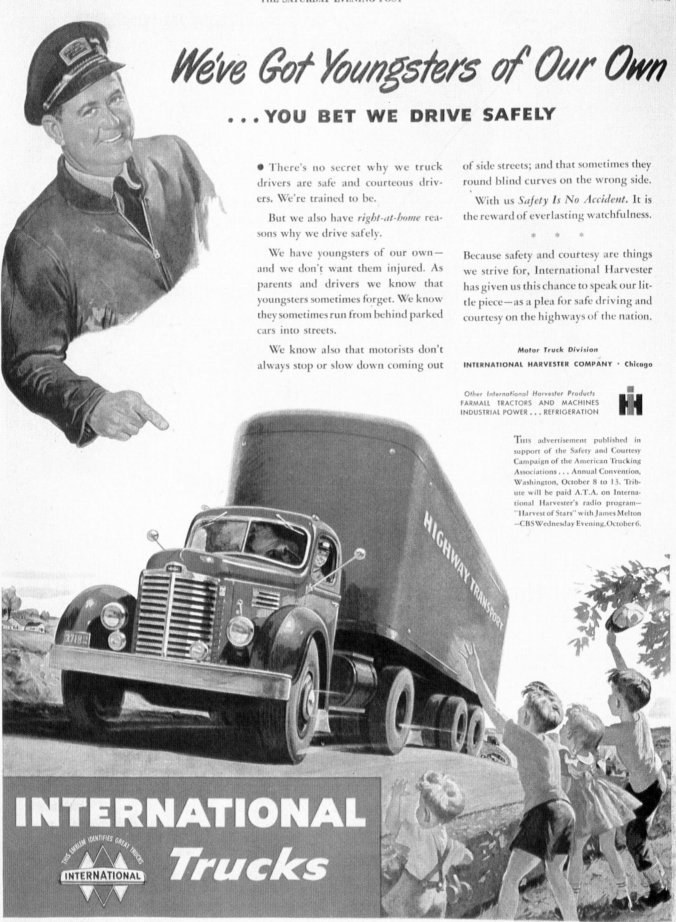

We've Got Youngsters of Our Own

...YOU BET WE DRIVE SAFELY

● There's no secret why we truck drivers are safe and courteous drivers. We're trained to be.

But we also have *right-at-home* reasons why we drive safely.

We have youngsters of our own—and we don't want them injured. As parents and drivers we know that youngsters sometimes forget. We know they sometimes run from behind parked cars into streets.

We know also that motorists don't always stop or slow down coming out of side streets; and that sometimes they round blind curves on the wrong side.

With us *Safety Is No Accident*. It is the reward of everlasting watchfulness.

* * *

Because safety and courtesy are things we strive for, International Harvester has given us this chance to speak our little piece—as a plea for safe driving and courtesy on the highways of the nation.

Motor Truck Division
INTERNATIONAL HARVESTER COMPANY · Chicago

Other International Harvester Products
FARMALL TRACTORS AND MACHINES
INDUSTRIAL POWER ... REFRIGERATION

THIS advertisement published in support of the Safety and Courtesy Campaign of the American Trucking Associations ... Annual Convention, Washington, October 8 to 13. Tribute will be paid A.T.A. on International Harvester's radio program—"Harvest of Stars" with James Melton—CBS Wednesday Evening, October 6.

HIGHWAY TRANSPORT

INTERNATIONAL Trucks

THIS EMBLEM IDENTIFIES GREAT TRUCKS
INTERNATIONAL

International Truck

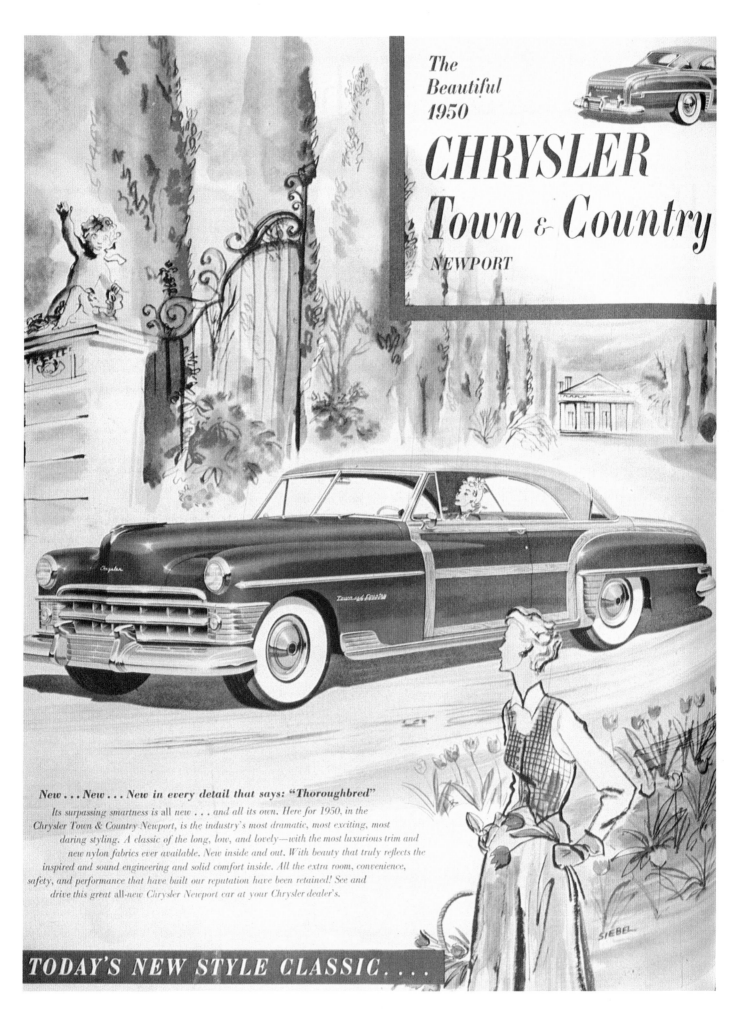

The Beautiful 1950

CHRYSLER

Town & Country

NEWPORT

New . . . New . . . New in every detail that says: "Thoroughbred"

Its surpassing smartness is all new . . . and all its own. Here for 1950, in the Chrysler Town & Country Newport, is the industry's most dramatic, most exciting, most daring styling. A classic of the long, low, and lovely—with the most luxurious trim and new nylon fabrics ever available. New inside and out. With beauty that truly reflects the inspired and sound engineering and solid comfort inside. All the extra room, convenience, safety, and performance that have built our reputation have been retained! See and drive this great all-new Chrysler Newport car at your Chrysler dealer's.

SIEBEL

TODAY'S NEW STYLE CLASSIC. . . .

'50 Chrysler Town & Country

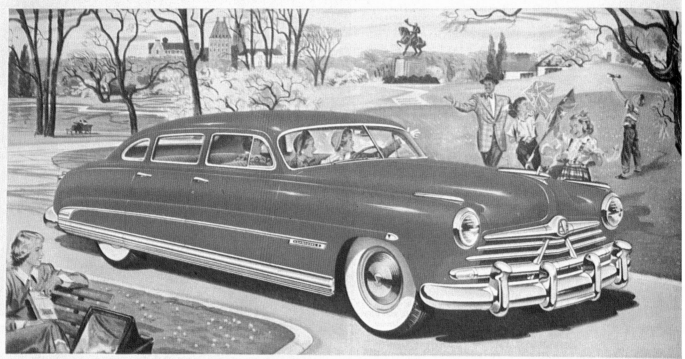

Available with New Super-matic Drive† — Only Cars with "Step-Down" Design

Most Room! Best Ride! Safest!
"The New Step-Down Ride"

Available only in Hudson because Hudson is built differently

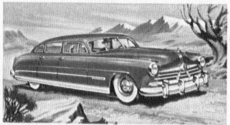

Best ride? Yes! Free-flowing, low-built design quickly tells you that the New Hudson has the lowest center of gravity in any American automobile—and this right along with full road clearance! As a result, you know instinctively that this thrilling motor car hugs the road more tenaciously than any other automobile, and is therefore America's best-riding and safest car! Hudson dealers everywhere invite you to try "The New Step-Down Ride" and experience these wonders firsthand!

Safest? Absolutely! Hudson's low center of gravity makes it a steady, sure-handling car. And for even greater safety, Hudson's Monobilt body-and-frame*, an all-welded, all-steel single unit of construction, rides you down within a base frame (shown in red above) with box-section steel girders completely encircling and protecting the passenger compartment—even outside the rear wheels!
*Trade-mark and patents pending.

MOST room in any car at any price, and with all this you get, in Hudson, America's best-riding, safest car!

Your very first glance inside the New Hudson shows you that the seats are positioned not only ahead of the rear axle, but entirely ahead of the rear wheels.

This permits full use of body width, and as a result, the sensational New Hudson of normal exterior width brings you seat cushions that are *up to 12 inches wider* than those in cars of greater outside dimensions! Even the door controls and arm rests in Hudson are set in recessed door panels so that they do not interfere with passenger room.

You'll see, too, that Hudson's exclusive "step-down" design, with its recessed floor, brings vital space into the passenger compartment, instead of wasting it under the floor and between frame members as is the case in all other cars!

This provides, in Hudson, more head room than in any mass-produced car built today.

But Hudson's fabulous room is only part of the story. We invite you to read, to the left, why "The New Step-Down Ride" is America's best and safest ride—then see your Hudson dealer—soon! Hudson Motor Car Company, Detroit 14.

HUDSON

NOW ... 3 GREAT SERIES

Lower-Priced Pacemaker

Famous Super

Custom Commodore

MOST ROOM! ... BEST RIDE! ... SAFEST!

ONLY HUDSON, THE CAR WITH "THE NEW STEP-DOWN RIDE", BRINGS YOU THESE ADDITIONAL FEATURES ... Chrome-alloy motor blocks which minimize wear and reduce upkeep costs • *Triple-Safe Brakes*—finest hydraulic system with reserve mechanical system on same pedal, plus finger-tip-release parking brake • *Fluid-Cushioned Clutch* • *Wide-arc vision* with Curved Full-View windshield and rear window • *Weather-Control*†—Hudson's heater-conditioned-air system • *Super-Cushion tires* • *Safety-Type wide rims* • *Center-Point Steering* and more than 20 other high-performance, long-life features that help make "step-down" designed Hudsons leaders in resale value, coast to coast, as is shown by Official Used Car Guide Books! †Optional at extra cost.

'50 Hudson

Shiftless....*and very proud of it !*

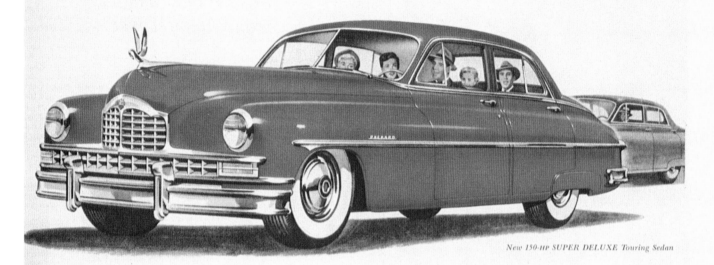

New 150-HP SUPER DELUXE Touring Sedan

There's never been anything like

Packard Ultramatic Drive

You'll have no clutch pedal to push . . . no gears to shift. And those are just the *first* two points to remember about Packard Ultramatic Drive!

You'll never be annoyed by jerking or clunking, or "racing engine sensation". . . never bothered by gas-wasting slippage at cruising speeds . . . never "out-smarted" by complicated automatic controls.

In *every* phase of motoring. Packard Ultramatic Drive brings you wonderful new driving ease . . . be-cause it begins with new basic *principles*.

Born of a 16-year Packard development program—backed by $7,000,000 in new manufacturing facilities—Packard Ultramatic Drive is now available, at extra cost, on an increasing number of models.

Don't miss a demonstration of this amazing new drive! Once you've heard the whole exciting story, you'll know why impartial technical observers call it "the *last word* in automatic, no-shift control!"

ASK THE MAN WHO OWNS ONE

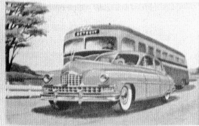

More responsive: No slippage at cruising speeds. No lag, waiting for gears to shift. For in-stant bursts of acceleration—just *"tramp down!"*

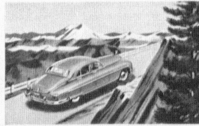

More positive: No over-heating of the drive mechanism during long climbs. Smooth, grad-ual engine braking on down-grades.

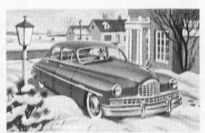

More flexible: Choice of *acceleration* or *cruis-ing*, in both low and high range: Easy change from Forward to Reverse without clashing.

'50 Packard

FOR 1950—IT'S THE NASH AIRFLYTE!

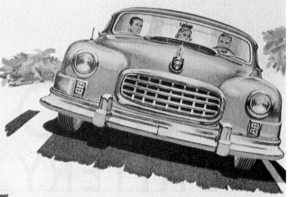

Now—Hydra-Matic Drive! Yes, in the Nash Ambassador Airflyte you can have the best of all automatic transmissions—Hydra-Matic Drive. And with exclusive Nash Selecto-Lift Starting you just lift a lever—and *go.* The clutch is gone. Your hands do nothing but steer. Your left foot does nothing at all!

20% Less Wind-Drag! Like invisible wings, the air-splitting Airflyte design speeds you along with 20% less wind-drag than the average car of current design—proved by scientific wind-tunnel test. That means less fuel cost... less wind noise... less fatigue... greater stability.

Slip into the seat of a 1950 Nash, and watch two words—*Airflyte Construction*—loom big in your life.

Different? You sit inside a twist-proof, rattle-proof, all-welded fuselage that's *twice* as rigid—and so spacious the seats can become Twin Beds.

It slips through the air with 20% less wind-drag—and with new Super-Compression power, *you've got performance!*

Rough road? Feel those super-soft coil springs soak up shock like a sponge soaks water. Airflyte Construction makes this a rock-solid road-hugger. Raw weather? Just set that Nash "Weather Eye."

Gas gauge stuck at "full"? Man, you're new around here! A Nash Statesman gets more than 25 miles to a gallon at average highway speed. See two great 1950 Airflyte series at your Nash dealer's now—drive the new Ambassador with Hydra-Matic!

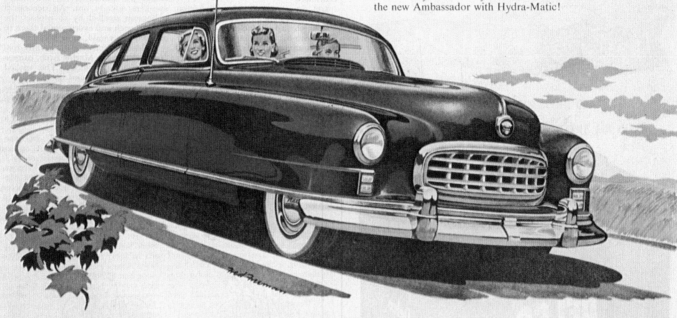

ONE SINGLE WELDED UNIT STRONGER —WEIGHS LESS

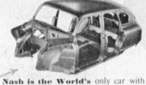

Nash is the World's only car with Airflyte Construction. The entire frame and body, floor, roof and rear fenders are built as a single welded unit... twice as rigid as ordinary construction... squeak-free, rattle-proof. Makes possible new safety, economy and riding comfort.

Nash AIRFLYTE
The Statesman · The Ambassador
GREAT CARS SINCE 1902

Nash Motors, Division Nash-Kelvinator Corporation, Detroit, Mich.

'50 Nash

You've got to _drive_ it to believe it!

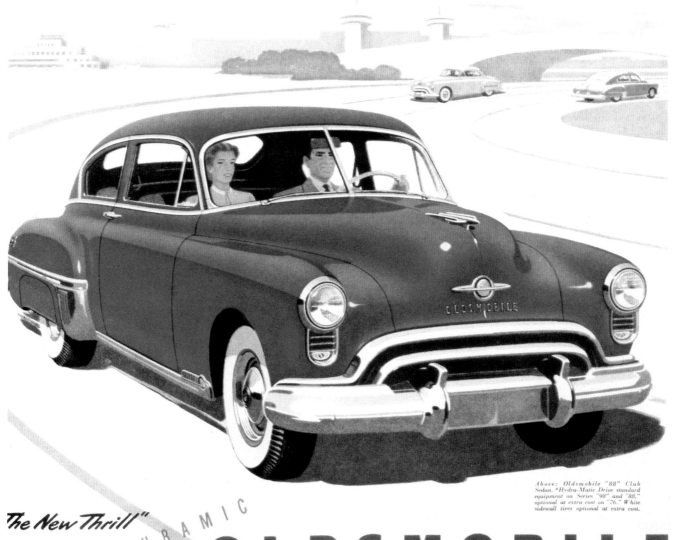

You can always tell an Oldsmobile "88"—not just by the numerals on the rear fender—but also by the way it *goes!* The first time you see that sleek Futuramic hood sweep ahead of the field, you get a hint of that "Rocket" Engine power. But to appreciate an "88," you've got to *try* it! Then—and only then—can you feel for yourself that swift-surging "Rocket" response . . . so smoothly delivered by Hydra-Matic Drive*. Only then will you experience the maneuverability that goes with the "88's" compact Body by Fisher. And only then will you know the unique "88" sensation—that soaring, air-borne ease of travel! You've got to *drive* it to *believe* it—and your Oldsmobile dealer invites you to do so soon! Phone him—make a date with the "88"—discover the most thrilling "New Thrill" of all!

"88"

LOWEST-PRICED CAR WITH "ROCKET" ENGINE

*Above: Oldsmobile "88" Club Sedan. *Hydra-Matic Drive standard equipment on Series "98" and "88," optional at extra cost on "76." White sidewall tires optional at extra cost.*

The New Thrill"

FUTURAMIC

OLDSMOBILE
DIVISION OF GENERAL MOTORS

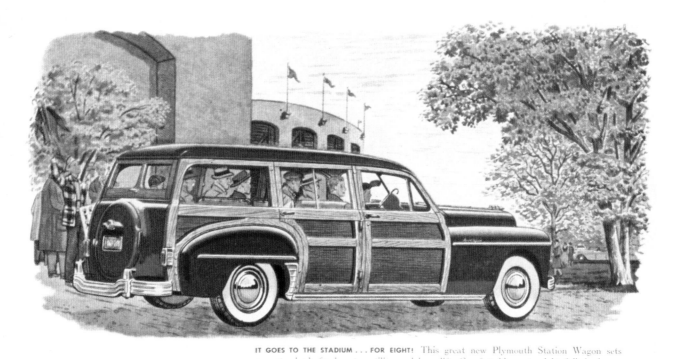

IT GOES TO THE STADIUM . . . FOR EIGHT! This great new Plymouth Station Wagon sets new standards for beauty, utility and long life. Comfortably seats eight full-sized passengers. Both rear seats quickly and easily removed for maximum loading space. Handsome, easy-to-clean vinyl plastic seats and seat backs. Natural-finish bonded plywood body panels with long-life finish on all-wood surfaces. New body construction—new steel floor and top—make this the safest, most rugged Plymouth Station Wagon ever built—with Plymouth engineering advantages throughout. Before you buy—compare!

PLYMOUTH

PLYMOUTH
BUILDS GREAT CARS

THE CAR THAT LIKES TO BE COMPARED

WHAT SPORT . . . TO DRIVE IT! This beautiful new Plymouth Convertible Club Coupe features distinguished styling and all-weather comfort. Electric-hydraulic mechanism silently raises or lowers new, smartly styled top in about fifteen seconds. Roomy rear seat with plenty of leg room. More powerful 97-horsepower engine with seven-to-one compression ratio. Ignition-Key Starting with electric automatic choke. The famous Plymouth Air Pillow Ride is now smoother than ever before! See your nearby Plymouth dealer now.

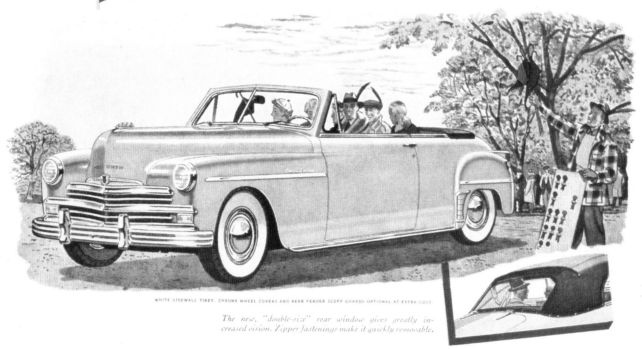

WHITE SIDEWALL TIRES, CHROME WHEEL COVERS AND REAR FENDER SCUFF GUARDS OPTIONAL AT EXTRA COST.

The new, "double-size" rear window gives greatly increased vision. Zipper fastenings make it quickly removable.

'49 Plymouth

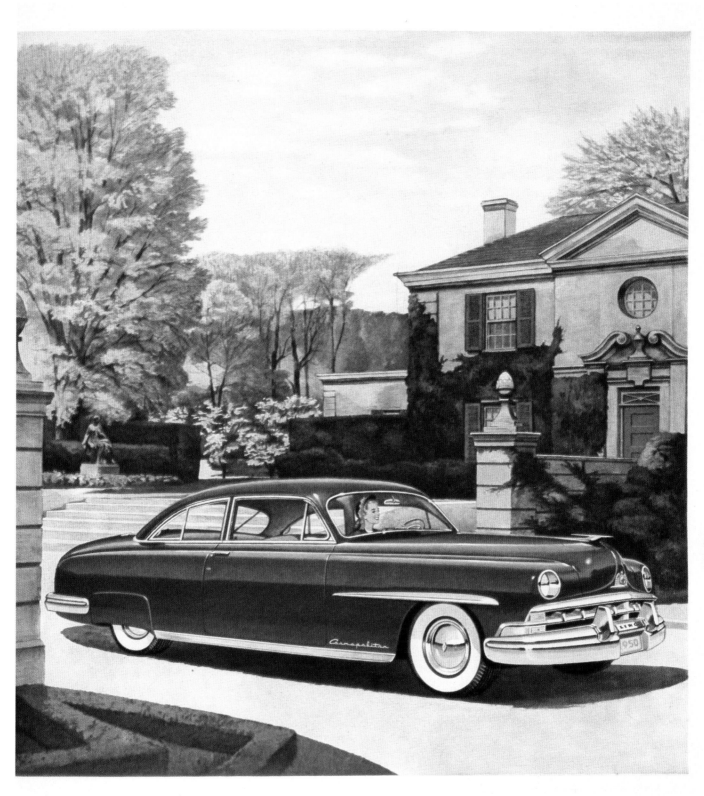

As outstanding as it is in all other respects...in luxury...in comfort...in performance...in safety...

and in prestige...<u>distinction</u> is the chief distinction of the 1950 Lincoln Cosmopolitan...

and you may drive it everywhere with pride in that assurance. Lincoln Division of Ford Motor Company.

Improved HYDRA-MATIC transmission optional at extra cost

Lincoln...Nothing could be finer

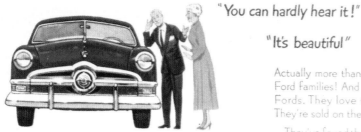

"You can hardly hear it!"

"It's beautiful"

Actually more than a quarter-million families are *two*-Ford families! And many of them have two big *1950* Fords. They love the extra handiness of two cars! They're sold on the extra economy of Ford ownership.

They've found that "Power Dome" combustion chambers in both the 100 h.p. V-8 and the 95 h.p. Six give high compression performance on regular gas—a saving that amounts to real money! And they've found that Fords are low in first cost and high in resale value!

Now Thousands own <u>two</u> fine cars...

"Plenty of room for every thing"

"Drives like a dream"

"Wide, easy opening rear deck"

and they're both '50 FORDS

Two smart travelling companions are the Ford Tudor Sedan and Ford Station Wagon! Both have styling that merited the Fashion Academy's Gold Medal Award.

The 35% easier-acting "King-Size" Brakes, the famous Ford "Lifeguard" Body—both cars have these Ford quality features and many more! "Test Drive" a Ford at your Dealer's today—the car you now own may well provide a down payment on *two* '50 Fords!

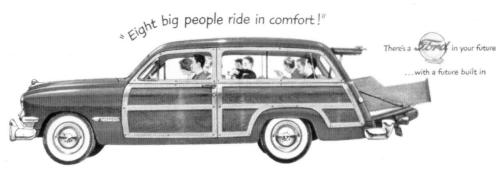

"Eight big people ride in comfort!"

There's a *Ford* in your future

...with a future built in

'50 Ford

There's Magic under the Hood
OF WILLYS' SMART NEW JEEPSTER

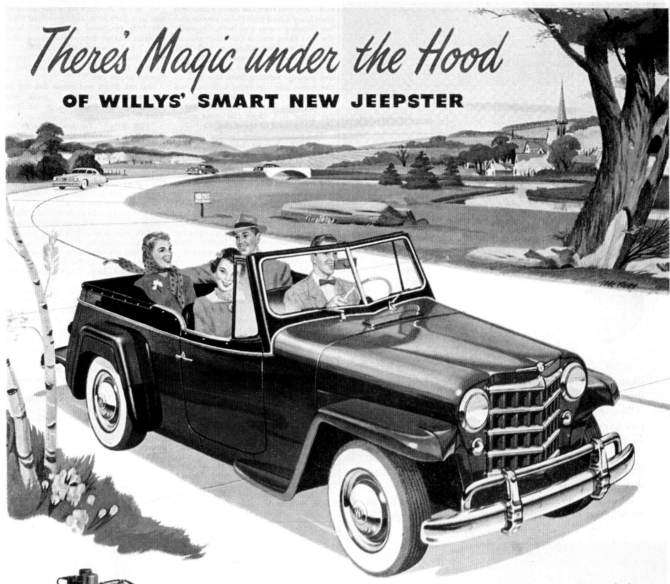

HURRICANE POWER!

The most advanced engine in the low-price field—F-head design, with valve-in-head intake, valve-in-block exhaust. Compression 7.4 to 1, but does not require premium fuel. This amazing new engine gives the Jeepster increased power plus record long mileage.

A surge of eager power at your command . . . a fuel thriftiness almost miserly—that's the magic combination you get in the new Jeepster with the *HURRICANE* Engine. Visit a Willys dealer and drive this low-slung, bold-prowed beauty . . . feel its quick, light steering response, its road-hugging stability on curves. Then get the *great news*—the Jeepster's new low price . . . hundreds under the average open sports car!

See These Jeepster Features...

Snug-fitting top with full-view rear window. Exclusive Planadyne front suspension. Easy-posture seats with washable upholstery, room for five.

White sidewall tires, overdrive and grille guard optional at extra cost.

The New Jeepster

WILLYS-OVERLAND MOTORS, TOLEDO · MAKERS OF AMERICA'S MOST USEFUL VEHICLES

'50 Willys Jeepster

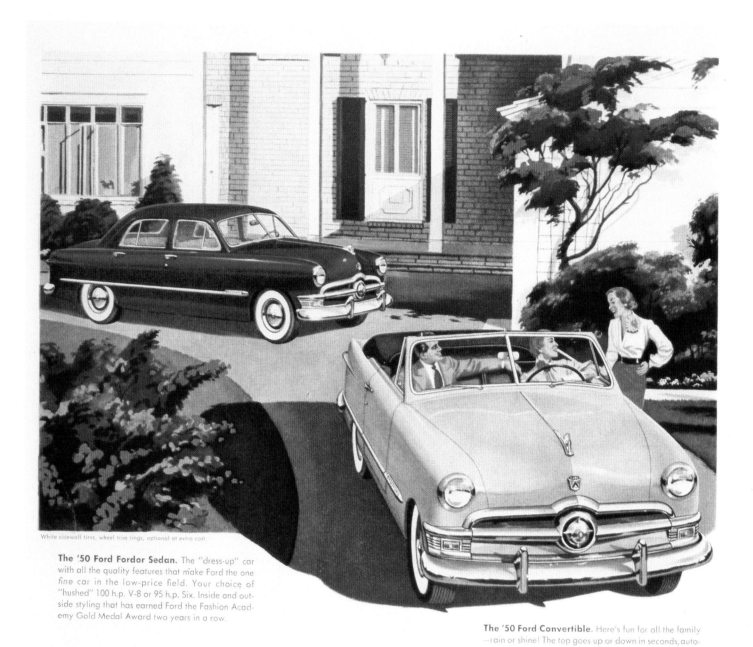

White sidewall tires, wheel trim rings, optional at extra cost.

The '50 Ford Fordor Sedan. The "dress-up" car with all the quality features that make Ford the one fine car in the low-price field. Your choice of "hushed" 100 h.p. V-8 or 95 h.p. Six. Inside and outside styling that has earned Ford the Fashion Academy Gold Medal Award two years in a row.

The '50 Ford Convertible. Here's fun for all the family —rain or shine! The top goes up or down in seconds, automatically. Your choice of all-leather or fabric-and-leather upholstery. New non-sag front seat with foam-rubber cushioning. King-Size Brakes work 35% easier!

250,000 families are two-Ford families

"I'll pick up the children, Sis, as soon as school is over."

"Bob and I can go straight to the Smiths. We'll meet you there."

"Nobody has to wait with two big Fords in the family."

Think of it! There's not one Ford but *two* in the garages of over 250,000 American families! Why? Because they have found that *nothing else* matches *two-car* convenience! What's more, they've found that owning two Fords costs little more than one high-priced car! Fords are economical to buy, economical to run and there's less dollar depreciation at "trade-in" time!

Why not see your Ford Dealer today and "Test Drive" these two Ford running mates? You'll SEE, HEAR and FEEL the difference. And the car you now own may well provide the down payment on two new '50 Fords!

There's a *Ford* in your future
...with a future built in!

'50 Ford

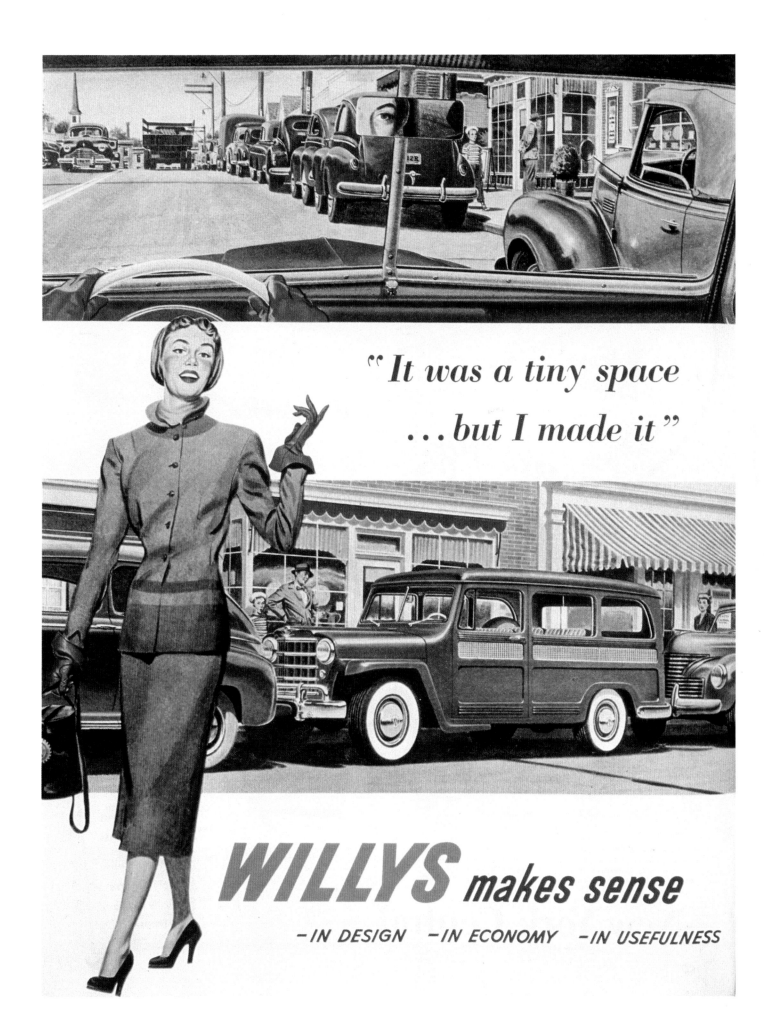

"It was a tiny space ...but I made it"

WILLYS makes sense

−IN DESIGN −IN ECONOMY −IN USEFULNESS

'52 Willys Station Wagon

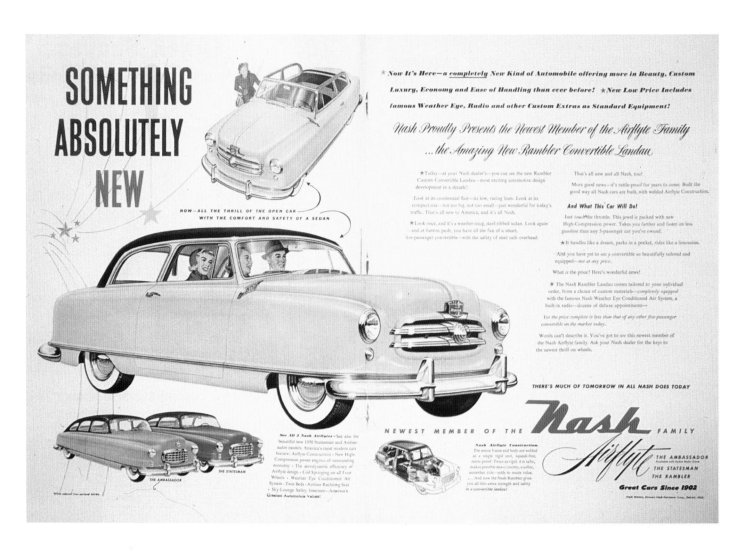

THIS CAR IS BUILT TO STAY NEW

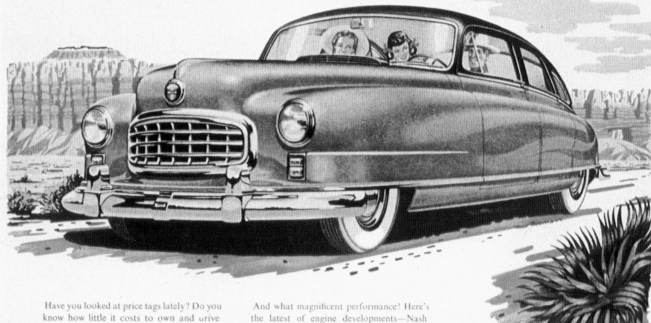

Have you looked at price tags lately? Do you know how little it costs to own and drive the most modern of America's fine cars?

Here are safety—comfort—economy and *long life* you will find *only* in Nash, the car of Airflyte Construction.

In beauty alone it is so efficient that you speed along with 20.7% less air drag than the average of all other cars tested. Drive it. Hear and feel the difference.

More Miles per Gallon

Then compare economy. These are *big* cars, with utmost room—but Airflyte Construction means better than 25 miles to the gallon at average highway speed in the Nash Statesman.

And what magnificent performance! Here's the latest of engine developments—Nash high-compression power on *regular* gasoline!

Check further. You'll find no other car offers a Weather Eye Conditioned Air System . . . or Twin Beds . . . or the Airliner Reclining Seat . . . or the riding smoothness of Nash.

And Hydra-Matic Drive!

In the 1950 Nash Ambassador you may have Hydra-Matic drive, with Nash exclusive Selecto-Lift Starting—nothing to do but lift a lever and *go!*

Yes—compare Nash with *any* car at *any* price. Drive the car that's built to *stay* new. Let your Nash dealer show you the many features which assure you better motoring today, higher resale value tomorrow.

Nash AIRFLYTE
The Statesman · The Ambassador
Great Cars Since 1902

There's Much of Tomorrow In All Nash Does Today

Nash Motors, Division Nash-Kelvinator Corporation, Detroit, Mich.

STAYS NEW YEARS LONGER

Airflyte Construction, in Nash alone. The entire frame and body, floor, roof, pillars, are built as a single, rigid, welded unit—squeak-free, rattle-proof. Twice as rigid as ordinary construction, it gives new economy, new safety, makes possible a softer, smoother ride—stays new years longer, adds to resale value.

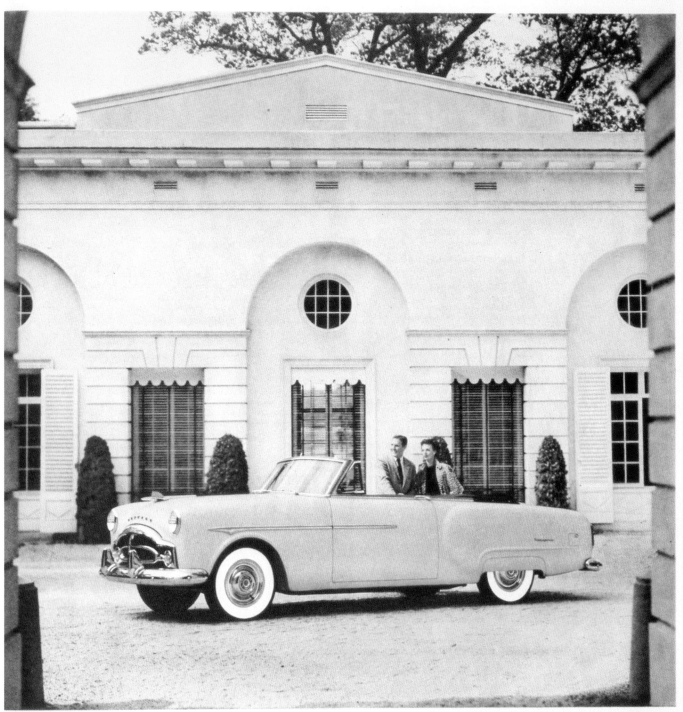

New 1951 Packard Convertible—one of nine all-new models

Pride of Possession is Standard Equipment

How can we put a price tag on your neighbors' look of envy . . . or on your own feeling of well-being . . . as you drive your new 1951 Packard home for the first time?

We can't, of course. So—*Pride of Possession is Standard Equipment*. Like the exclusiveness of Packard beauty—and the years-ahead superiority of Packard engineering—you can't buy a new 1951 Packard without it. And you never can match it— no matter how much you may be willing to pay—in *any other car!*

It's more than a car...it's a

PACKARD

ASK THE MAN WHO OWNS ONE

'51 Packard

Dollar for Dollar you can't beat a
Pontiac

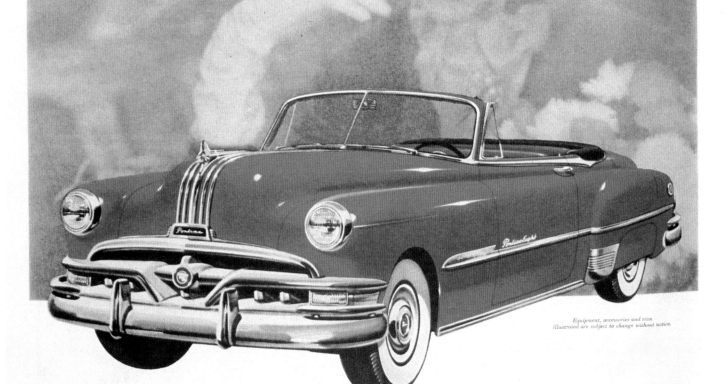

Equipment, accessories and trim
illustrated are subject to change without notice.

A Beautiful Dream That <u>Can</u> Come True!

PONTIAC MOTOR DIVISION OF GENERAL MOTORS CORPORATION

'51 Pontiac

49

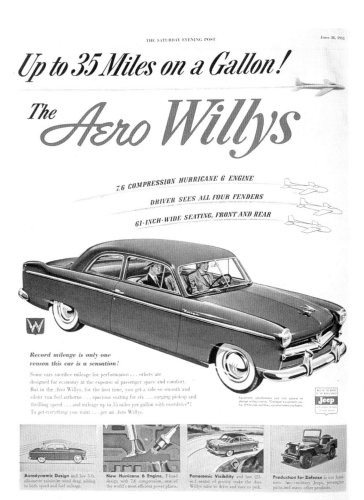

'52 Aero Willys

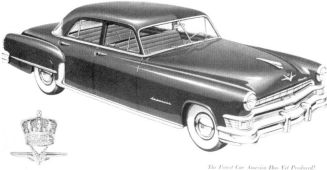
'52 Imperial

Stretch Out and See

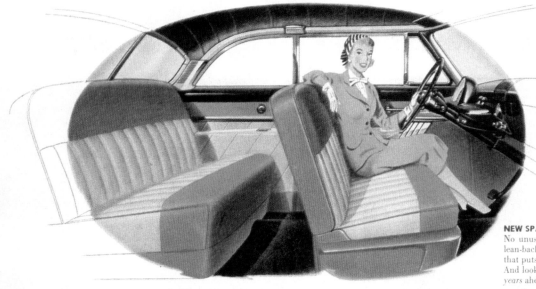

NEW SPACE-PLANNED DESIGN—No unused space—this is the new lean-back-and-take-it-easy Mercury that puts every inch of car to work. And looks? "Forerunner" styling is years ahead.

Why It Challenges Them All

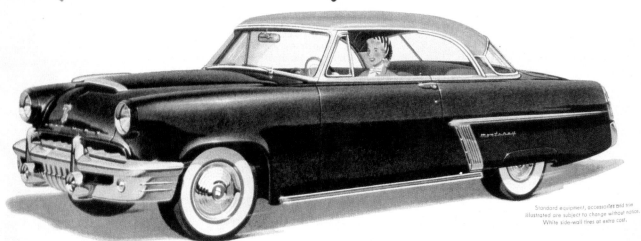

Standard equipment, accessories and trim illustrated are subject to change without notice. White side-wall tires at extra cost.

NEW SEA-TINT* GLASS reduces heat, glare, and eyestrain. New larger windows permit safety-sure visibility all around. *Every* view proves that Mercury is new—in looks, in power, in extra value.

WE BUILT A NEW CAR and made this challenge: Match Mercury *if you can*. Now we know we've got the sweetest thing on wheels since the ladies began to drive.

For all America is falling in love with a car.

No wonder. It's big and beautiful, inside, outside, and all over. With a host of Future Features—Forerunner styling, Jet-scoop hood, suspension-mounted brake pedal, Interceptor instrument panel, higher horsepower V-8 engine—the new Mercury is the most challenging car that ever came down the *American Road*

See it, drive it. You'll fall in love, too. And with Mercury's famous economy—*proved* in official tests—this is a love affair you can afford.

MERCURY DIVISION • FORD MOTOR COMPANY

The New 1952
MERCURY
WITH MERC-O-MATIC DRIVE

3-WAY CHOICE—Mercury presents three dependable, performance-proved drives: silent-ease, standard transmission; thrifty Touch-O-Matic Overdrive,* and Merc-O-Matic,* greatest of all automatic drives.
*Optional at extra cost

'52 Mercury

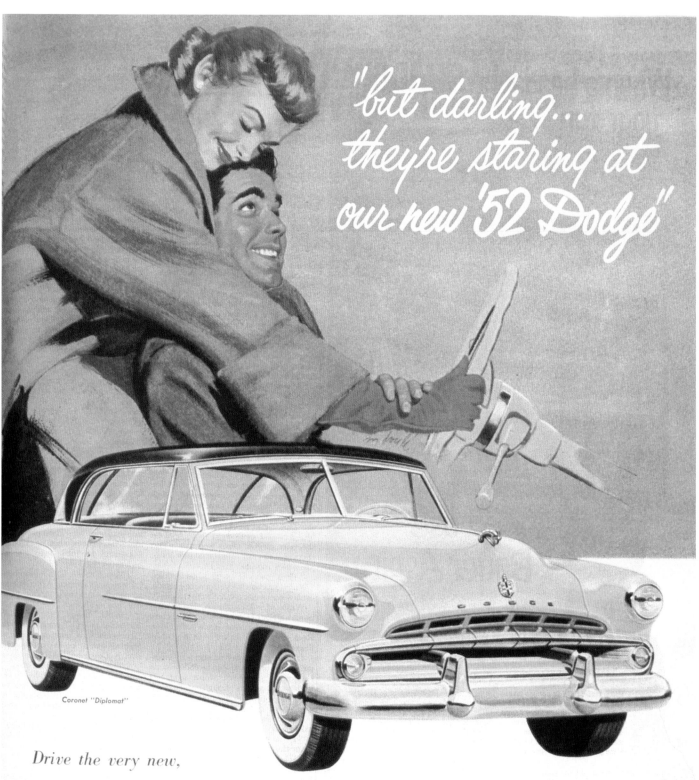

"but darling...
they're staring at
our new '52 Dodge"

Coronet "Diplomat"

Drive the very new,

 very beautiful '52 Dodge

Enjoy greater all 'round visibility, smoother riding, extra roominess,
the pride and satisfaction of having spent your money wisely and well.

Big, new, dependable '52 DODGE

Specifications and equipment subject to change without notice.

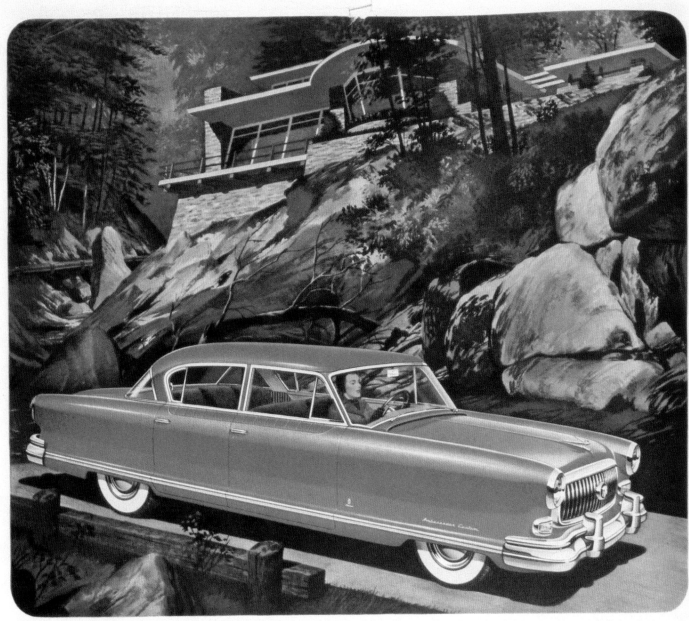

This 1952 Nash Ambassador is upholstered in Mediterranean Blue needle point and striped homespun. Reclining Seats, Twin Beds, Hood Ornament, glare-free tinted Solex glass and White Sidewalls optional extras. Your choice of three transmissions including Automatic Overdrive and new Dual-Range Hydra-Matic, at extra cost.

THERE'S A NEW "WHO'S WHO" OF THE HIGHWAY

YOU ARE NOT ALONE when you admire the picture above.

Because never before has any new car won such instant acclaim as the Nash Golden Air-flyte—*already* the new choice of thousands of distinguished Americans!

Here you see beauty that is *entirely new* . . . the swift, clean, continental styling of Pinin Farina, world's most famous custom designer.

Look inside. You'll find the widest seats, the greatest Eye-Level visibility and the most luxurious interior ever built into one car! You'll enjoy *double* Reclining Seats, with new Twin Bed arrangements . . . and thrill to a new view

of the road over the low, racy hood and distinctive Road-Guide Fenders!

Performance? Who could ask for more than a Super Jetfire engine even more powerful than the Nash Jetfire that set last year's stock-car speed record! Riding Ease? There's the un-matched magic of new Airflex suspension and safer, rattle-free Airflyte Construction!

Yes, there's a new standard of fine-car value on the highway today—a new "Who's Who". See your Nash dealer and learn how easily your golden dreams can come true!

TV Fun—*Watch Paul Whiteman's TV Teen Club. See your paper for time and station.*

Nash Motors, Division Nash-Kelvinator Corp., Detroit, Michigan

Nash Golden Airflytes

AMBASSADOR · STATESMAN · RAMBLER · THE FINEST OF OUR FIFTY YEARS

'52 Nash

WOW!

—SOME CHARIOT!

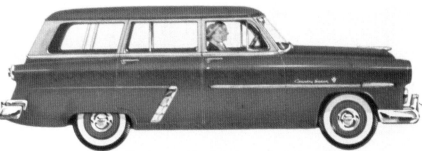

Handsome and handy is the new Ford Country Sedan! Use it to tote 8 people in style or a half ton of freight! The back seat lifts right out, the center seat folds flush with the floor! Powered by 110-h.p. Strato-Star V-8. Fordomatic or Overdrive if you choose.

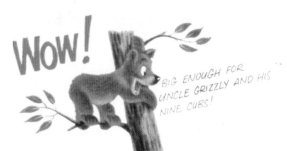

WOW!

BIG ENOUGH FOR UNCLE GRIZZLY AND HIS NINE CUBS!

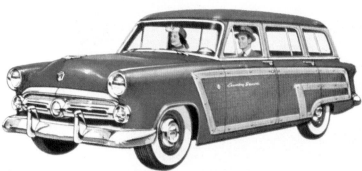

We call this 4-door beauty the Country Squire. You'll call it wonderful. Has all the new Country Sedan features... *plus* real maple or birch trim, framing mahogany-finished steel panels.

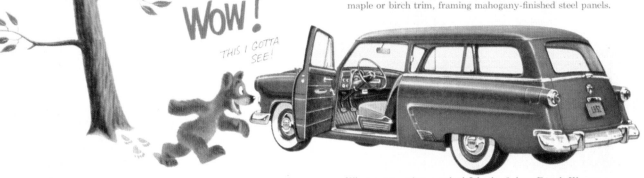

WOW!

THIS I GOTTA SEE!

What a car—what a value! It's the 2-door Ranch Wagon . . . the lowest priced station wagon in its field . . . with a choice of 110-h.p. Strato-Star V-8 or 101-h.p. Mileage Maker Six.

WOW!

WHOTTA WAGON MATES!

White sidewall tires, Fordomatic Drive and Overdrive optional at extra cost. Equipment, accessories and trim subject to change without notice.

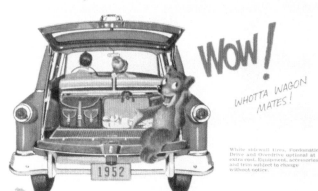

1952

Whichever Ford station wagon you choose you're hitched to a star with more "can do" than any other in the low-price field!

The greatest line of station wagons in the industry

WOWING 'EM EVERYWHERE! '52 FORD

You can pay more but you can't buy better!

'52 Ford

54

LIVABLE COMFORT OF A NEW-DAY PLAYROOM

THE LIVELY ACTION OF TODAY'S SPORTSMEN

LINCOLN

lets you take modern living with you

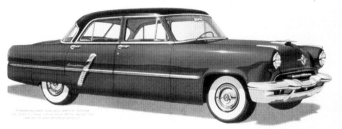

The
ACTION CAR
FOR
Active Americans

New 140-h.p. Red Ram V-8, most efficient auto engine design in America.

New sleek, trim Beauty-Action Styling, with distinctive Jet Air-Flow hood.

New Gyro-Torque Drive with flash-action "Scat" gear for safer passing.

New colors and combinations... in lasting enamel that keeps its lustre.

New road-hugging, curve-holding ride, with new "Stabilizer" suspension.

New Travel-Lounge comfort with more hip-room, head-room and elbow-room.

New "Pilot View" curved windshield and wide wrap-around rear window.

New "Cargo Carrier" rear deck has up to 11 cubic feet more carrying capacity.

New steering ease, with controls centered between the two front wheels.

Announcing the
New—All New '53 Dodge

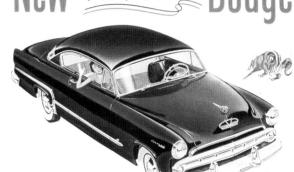

You'll Want to Get Your Hands On This
Power Packed Beauty

On Display Now! Visit Your Nearest Dodge Dealer and Thrill to a 'Road Test' Ride

Sensational New
140 Horsepower RED RAM V-8 ENGINE!

Packs more power punch per cubic inch displacement... delivers a full 140-h.p. on "regular" gasoline. Brings you the triple power advantages of hemispherical combustion chamber... short stroke design... high-lift lateral valves. More fuel energy goes into power, less is wasted on heat, friction. Most efficient engine design in any American car!

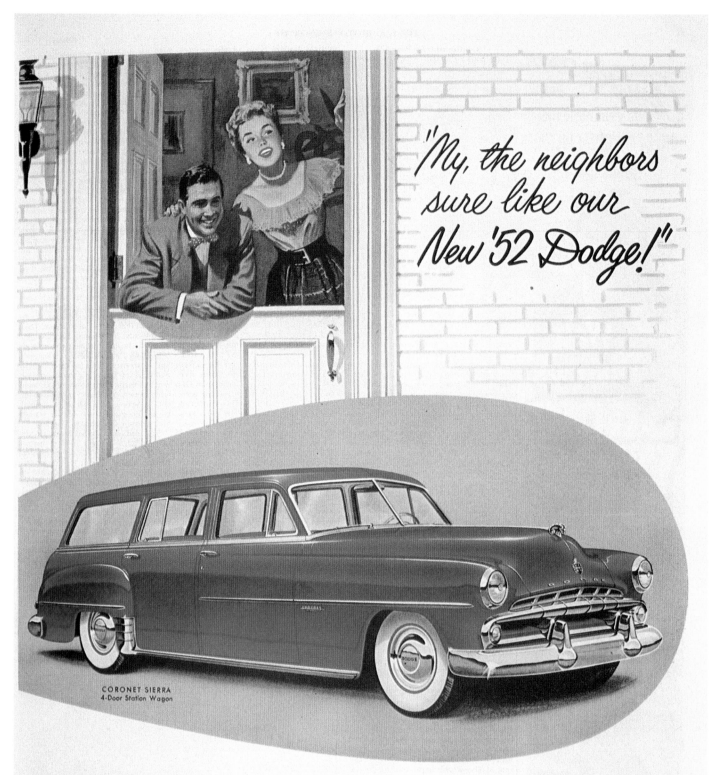

"My, the neighbors sure like our New '52 Dodge!"

CORONET SIERRA
4-Door Station Wagon

Let the "Show Down" Way show you why Dodge is so popular

This smart, new Dodge wins admirers with its looks . . . wins hearts with its dependable day-in, day-out performance. You get modern styling—advanced engineering that protects your investment for years ahead. Among its many exciting features is the amazing Dodge Oriflow Ride that makes every mile you travel boulevard-smooth. And if you think this is just sales talk—your Dodge dealer can give you *proof!* Before you buy a car in *any* price class, ask him for a free copy of the "Show Down" Plan. It lets you compare Dodge feature by feature against other cars for greater driving ease, comfort and safety . . . greater value. Once you've made this comparison test, we're sure you'll see why "You could pay hundreds of dollars more and still not get all Dodge gives you!"

Specifications and Equipment Subject to Change Without Notice

Big, new, dependable '52 **DODGE**

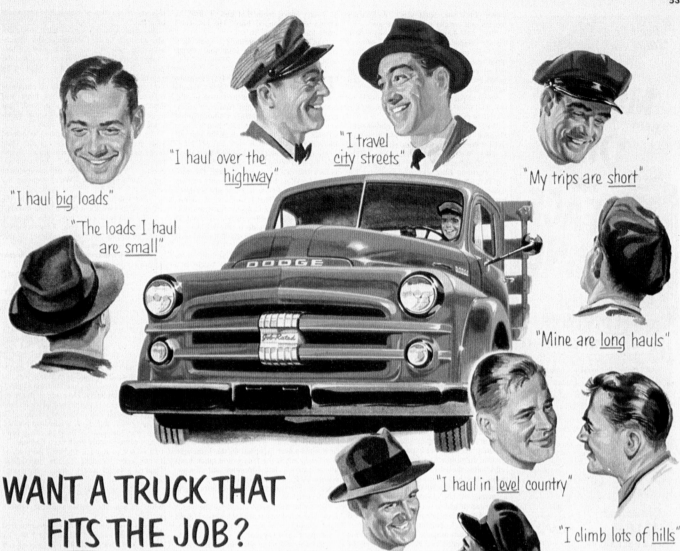

"I haul big loads"

"I haul over the highway"

"I travel city streets"

"My trips are short"

"The loads I haul are small"

"Mine are long hauls"

"I haul in level country"

"I climb lots of hills"

"I haul light goods"

"Those I haul are heavy"

WANT A TRUCK THAT FITS THE JOB?

Naturally you want a truck that's engineered to haul your loads under your operating conditions. Such a truck will save you money . . . last longer.

A Dodge "*Job-Rated*" truck is that kind of truck! Dodge builds G.V.W. chassis models to meet 98% of all hauling needs. That's why you can be sure there is a Dodge "*Job-Rated*" truck to fit your job.

Every Dodge truck unit from engine to rear axle is "*Job-Rated*"—factory-engineered to haul a specific load under specific operating conditions.

The right units to support the load

Load-supporting units—such as frames, axles, springs, wheels, and tires—are engineered and built right to provide the strength and capacity needed.

The right units to move the load

Load-moving units—such as engines, clutches, and transmissions, as well as types of rear axles and axle ratios—are engineered to provide ample power to move the load under specific operating conditions . . . quickly, dependably, at low cost.

GET A DODGE "Job-Rated" TRUCK

See your nearby Dodge dealer
Let him show you "the trucks that do the most for you"—the only trucks which have gýrol Fluid Drive available (on ½-, ¾-, and 1-ton models).

Your Dodge dealer is as close to you as your telephone. Consult the yellow pages of your phone directory for his name and address. And ask him to tell you how you can get a Dodge "*Job-Rated*" truck that will perform better on your job.

ONLY DODGE BUILDS "*Job-Rated*" TRUCKS

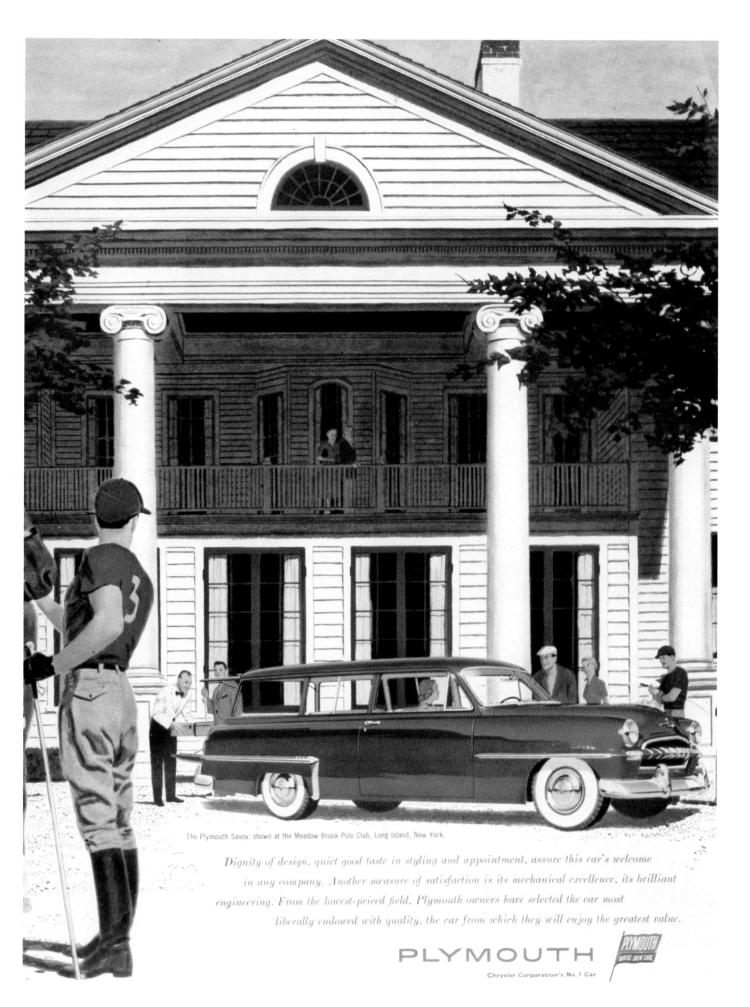

The Plymouth Savoy, shown at the Meadow Brook Polo Club, Long Island, New York.

Dignity of design, quiet good taste in styling and appointment, assure this car's welcome in any company. Another measure of satisfaction is its mechanical excellence, its brilliant engineering. From the lowest-priced field, Plymouth owners have selected the car most liberally endowed with quality, the car from which they will enjoy the greatest value.

PLYMOUTH

Chrysler Corporation's No. 1 Car

'53 Plymouth

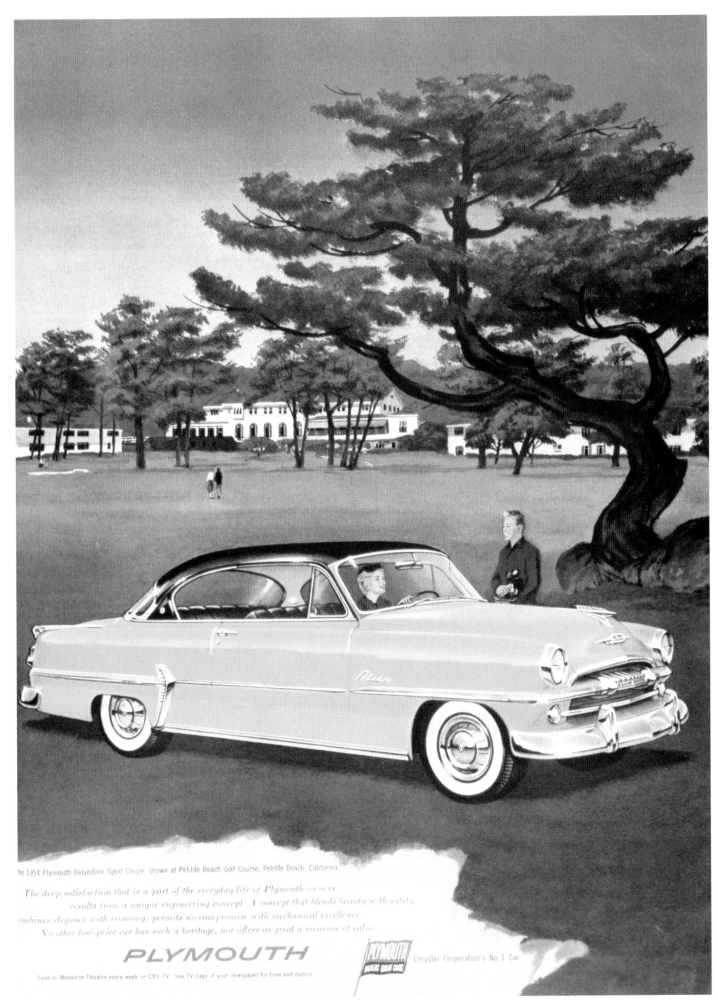

The 1954 Plymouth Belvedere Sport Coupe, shown at Pebble Beach Golf Course, Pebble Beach, California.

The deep satisfaction that is a part of the everyday life of Plymouth owners
results from a unique engineering concept. A concept that blends beauty with safety,
combines elegance with economy, permits no compromise with mechanical excellence.
No other low-price car has such a heritage, nor offers as great a measure of value.

PLYMOUTH

Chrysler Corporation's No. 1 Car

'54 Plymouth

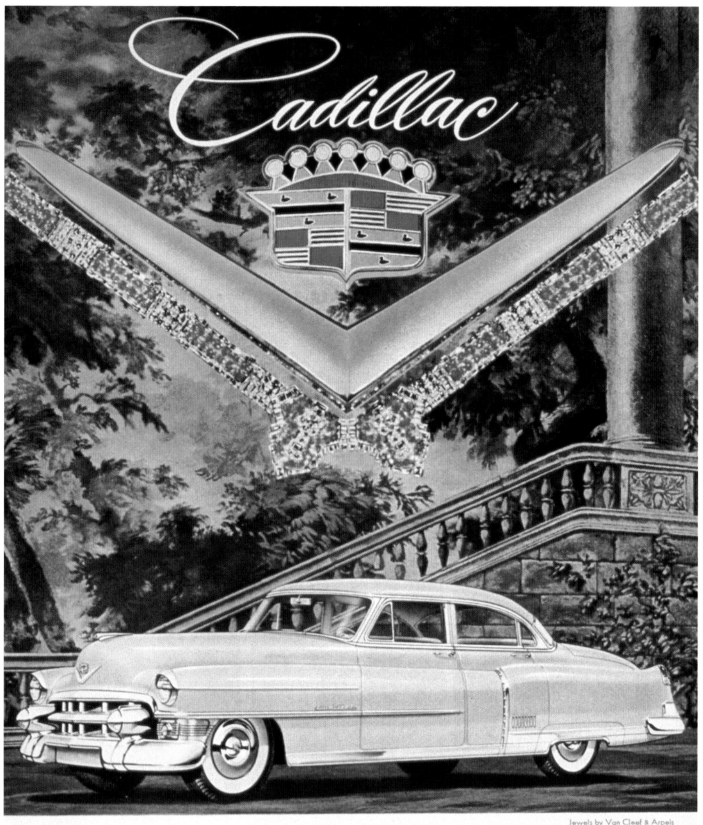

Jewels by Van Cleef & Arpels

The year 1953 marks the beginning of Cadillac's *second* half-century of progress in the automotive world. And there's no denying that it's a wonderful, wonderful start! You'll know what we mean the instant you see the 1953 Cadillac—for, beyond all question, it represents one of the greatest strides forward in Cadillac history. Its beauty is breath-taking as never before . . . and its new interiors, together with a new Cadillac Air Conditioner, offer unprecedented luxury and comfort. And when it comes to performance—well, its great new 210 h.p. engine, its improved Hydra-Matic Drive and its advanced Cadillac Power Steering make driving an unbelievable pleasure. Why not see and drive this new Standard of the World at your earliest opportunity? We know you'll agree that it's the perfect start for *another* great era of Cadillac leadership!

CADILLAC MOTOR CAR DIVISION ★ GENERAL MOTORS CORPORATION

'53 Cadillac

60

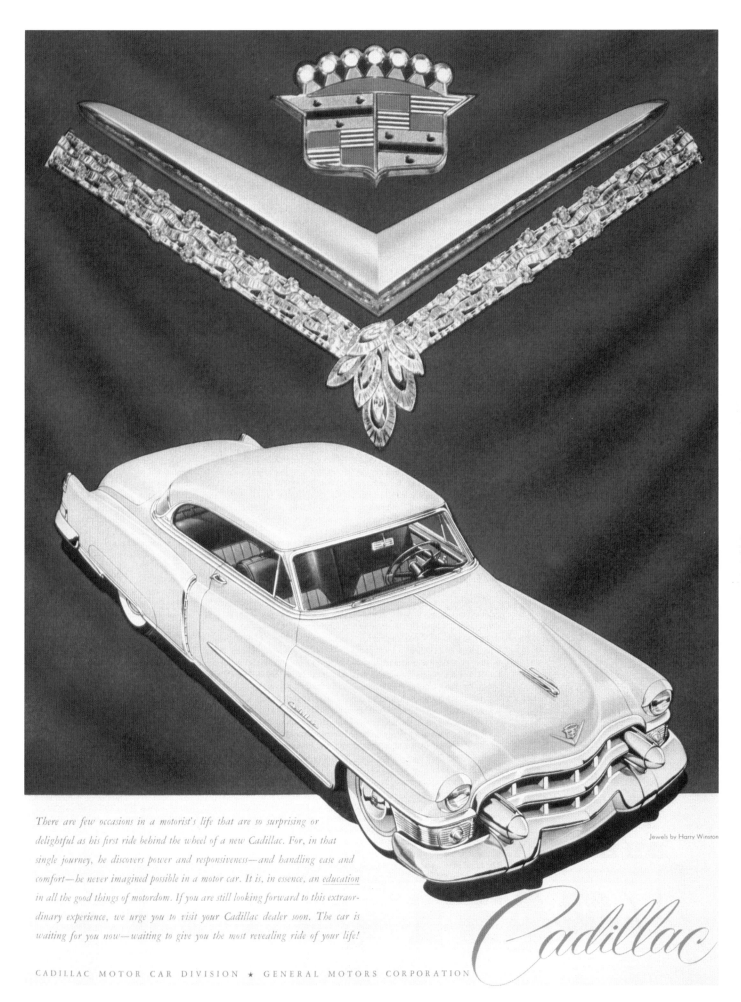

There are few occasions in a motorist's life that are so surprising or delightful as his first ride behind the wheel of a new Cadillac. For, in that single journey, he discovers power and responsiveness—and handling ease and comfort—he never imagined possible in a motor car. It is, in essence, an education in all the good things of motordom. If you are still looking forward to this extraordinary experience, we urge you to visit your Cadillac dealer soon. The car is waiting for you now—waiting to give you the most revealing ride of your life!

Jewels by Harry Winston

Cadillac

CADILLAC MOTOR CAR DIVISION ★ GENERAL MOTORS CORPORATION

'53 Cadillac

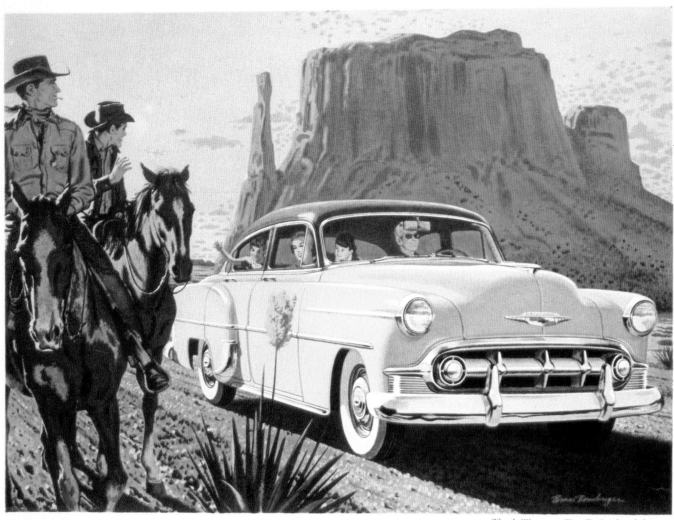

The thrilling new "Two-Ten" 4-door Sedan, one of 16 beautiful models in 3 great new series.

What's back of Chevrolet's
sensational new gasoline economy . . .

The smiling people in this picture have been traveling since early morning; and, much to their pleasure, they are having a remarkably *thrifty* trip.

You see, the 1953 Chevrolet makes gasoline go a *lot* farther—in fact, brings you the most important gain in economy of *any* new Chevrolet in history—due to outstanding improvements made by Chevrolet engineers.

New higher compression ratios in the 115-h.p. "Blue-Flame" engine with Powerglide* and the 108-h.p. "Thrift-King" engine with standard transmission have boosted power output greatly while cutting gasoline consumption sharply.

Consequently, Chevrolet owners everywhere are highly enthusiastic about the twin gains of improved performance and economy in these most advanced cars in the entire low-price field.

We cordially invite you to visit your Chevrolet dealer's and experience the sensational new performance and economy of the 1953 Chevrolet at your earliest convenience.

And also to enjoy the *many other exclusive advantages* which are causing people to pronounce this car the first buy of the land! . . .

Chevrolet's new Powerglide automatic transmission, coupled with the entirely new 115-h.p. valve-in-head engine (highest compression engine in its field) now provides automatic getaway in low and automatic pick-up for passing in traffic. Results: Much fleeter performance, important new gasoline savings, and the finest no-shift driving in Chevrolet's price range.

New Fashion-First Bodies by Fisher bring you beauty, comfort and safety fully as outstanding as

Chevrolet's new performance and economy. Interiors are richer, roomier, and *color-matched* with exteriors in "Two-Ten" and Bel Air models.

You'll park and steer with finger-tip ease, and enjoy greater safety as well, thanks to new Power Steering,* the most vital improvement since automatic driving, and exclusive to Chevrolet in its field.

Improved Velvet-Pressure Jumbo-Drum brakes (largest in Chevrolet's field) and the softer, smoother Knee-Action Ride give maximum comfort and safety. See this wonderful new Chevrolet —America's *lowest-priced* full-size car—at your Chevrolet dealer's now. Chevrolet Division of General Motors, Detroit 2, Michigan.

Optional at extra cost. Combination of Powerglide automatic transmission and 115-h.p. "Blue-Flame" engine available on "Two-Ten" and Bel Air models only. Power Steering available on all models.

MORE PEOPLE BUY CHEVROLETS THAN ANY OTHER CAR!

'53 Chevrolet

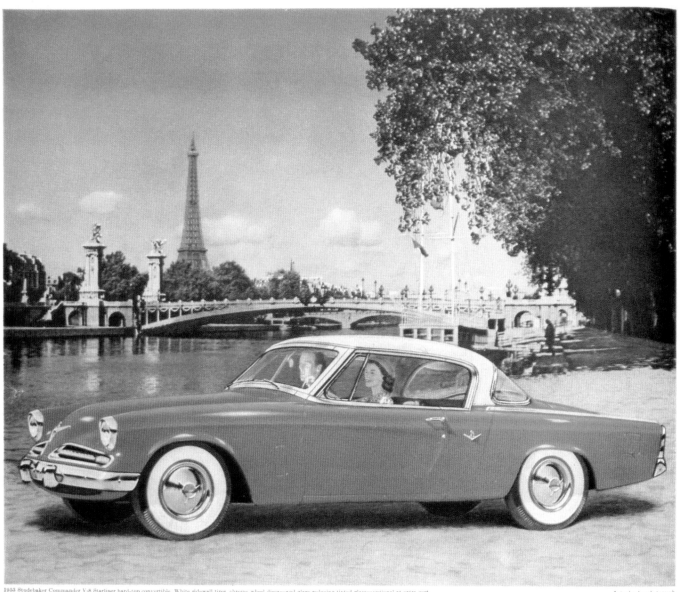

1953 Studebaker Commander V-8 Starliner hard-top convertible. White sidewall tires, chrome wheel discs—and glare-reducing tinted glass—optional at extra cost

Actual color photograph

The new American car with the European look!

It's the breath-taking new 1953 Studebaker!
Excitingly new in continental styling!
Impressively down to earth in price!

THIS dramatic new Studebaker comes to you straight out of the dream book.

It brings you the continental charm of Europe's most distinguished cars. But it's thoroughly American in deep-down comfort and in handling ease.

Long and racy and sparkling with drive appeal, every 1953 Studebaker gleams with an enormous expanse of glass for full vision. Every distinctive body style is completely and spectacularly new both inside and outside.

All this at a down-to-earth price—with Studebaker low operating cost!

Order your Studebaker now. Get a Champion in the lowest price field or a brilliant-performing Commander V-8.

Motoring's finest power steering is available in all Studebaker models at moderate extra cost.

New 1953 Studebaker

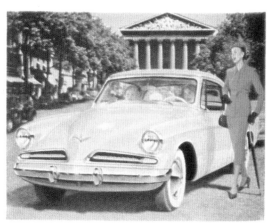

It's a startler! It's a Starliner—the new 1953 Studebaker hard-top! Truly a new flight into the future! Less than five feet high!

'53 Studebaker

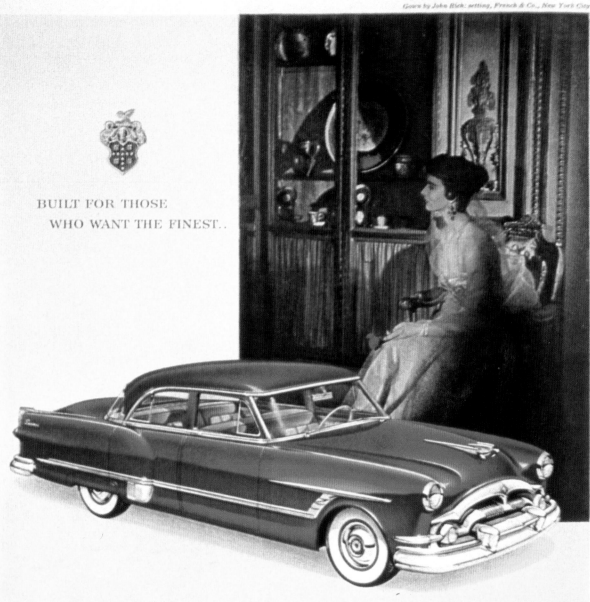

BUILT FOR THOSE
WHO WANT THE FINEST..

America's Most Advanced New Car

PACKARD

DISTINCTION speaks in many ways—but never more eloquently than when you drive America's new choice in the fine-car field—Packard for 1953!

DESIGNED AND BUILT for those who want the very best, Packard offers you a selection of seven distinguished models.

HERE YESTERDAY'S TRADITIONS of craftsmanship join tomorrow's engineering to bring you everything you have desired in a car—the incredible smoothness of the Packard ride, for example . . . and the hush of the world's highest-compression eight when "loafing" at sixty!

IT IS SIGNIFICANT that Packard, which owes allegiance to no other brand name, builds the one car expressing *real individuality*—both its own and that of its owner.

NOW . . . ASK THE MAN WHO OWNS ONE

See The Exciting New Packard CLIPPER For Big-Car Value At Medium-Car Cost

'53 Packard

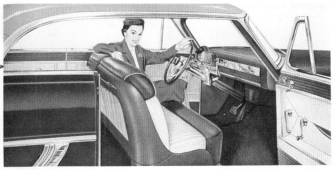
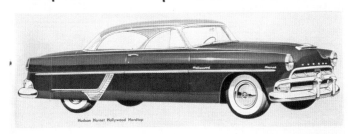
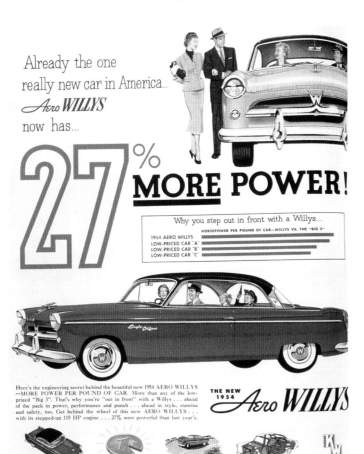
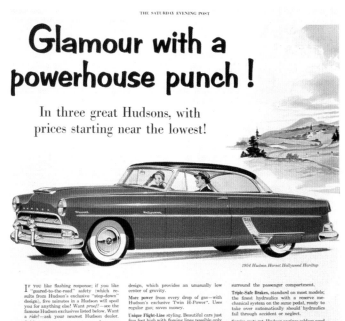

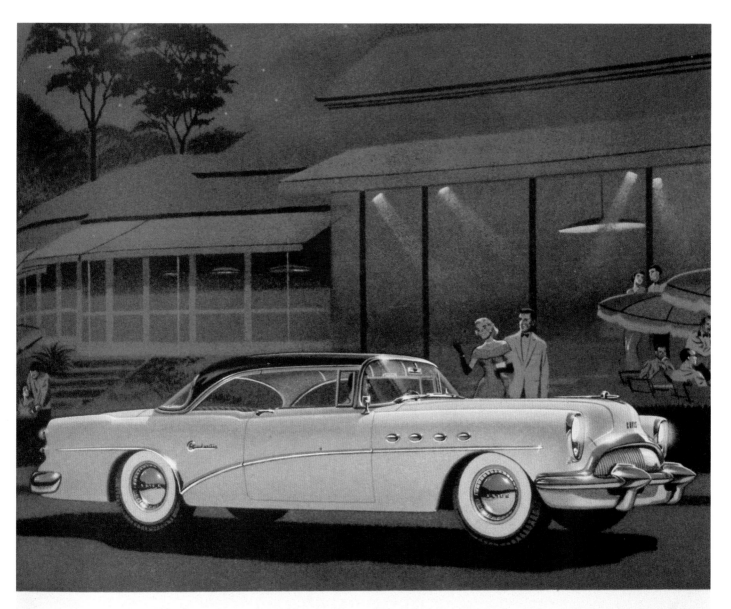

You can make your "someday" come true now

YOU promised yourself, didn't you, that someday you would own a car that came up to your dreams?

That it would be a car of stature and distinction? That it would be luxuriously smooth and supremely able? That it would look and feel and perform the part of the car of a man at the top?

Well, sir—today can be that day.

For such a car is at hand now, more easily attainable than you may think. You see it pictured here, and the name is proudly spelled out on each rear fender: ROADMASTER.

It is custom production. Its appointment is subject to your individual taste. Its quality is the best that Buick builds. *Its price per pound is the lowest in the fine-car field.*

But apart from its impressive length and breadth and breath-taking beauty (it carries the world's newest body, with the panoramic visibility of Buick's famed sweep-back windshield)—this superb automobile is an automobile of supreme command.

When you drive it you will know that this is so.

When you hold reign on ROADMASTER's magnificent V8 power, feel the smooth tranquility of Twin-Turbine Dynaflow, feather your way with the consummate ease of Safety Power Steering, sense the solid velvet of Buick's buoyant ride — then you will know that this is the car you always meant to own "someday."

So why wait? Call your Buick dealer today, or the first thing tomorrow. He'll gladly arrange a ROADMASTER demonstration and you can judge things from there.

BUICK *Division of* GENERAL MOTORS

ROADMASTER *Custom Built by* BUICK

'54 Buick Roadmaster

New Power Braking, Power Steering, Electric Window Lifts, Comfort-Control Seat, Air Conditioning and Dual-Range Hydra-Matic Drive are optional at low extra cost to heighten your pleasure and pride in your Pontiac.

Dollar for Dollar You Can't Beat a

PONTIAC

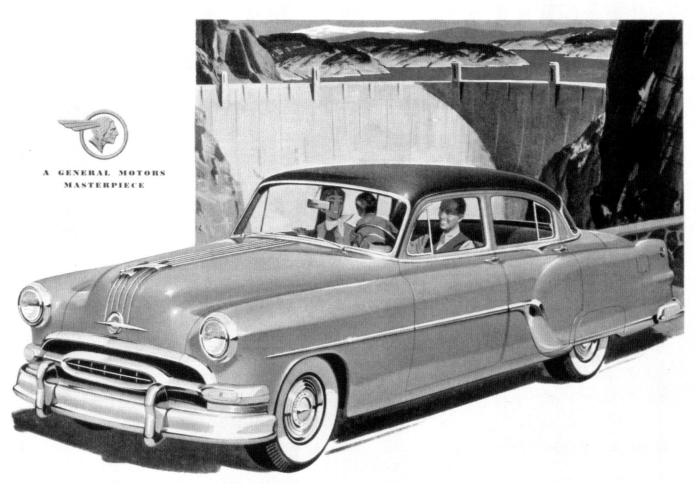

A GENERAL MOTORS
MASTERPIECE

Something Totally New in Pontiac's Low Price Range!

Now you can stay in Pontiac's low price range and still move right up to fine-car ownership. That is the wonderful opportunity presented to you by the new Chieftain Pontiac—the pace-setter for high quality at low cost.

The car is a gem—distinguished enough in line and contour to win applause in any company . . . splendid enough inside to win the hearts of the

most style-minded . . . and roomy enough to carry a carful in luxurious and relaxing comfort for hours and hours on end.

Performance is just as prideful. An even mightier engine for 1954 moves you where you want to be, *when* you want to be there, with an easy, quiet flow of power that keeps you contented every mile of the way. Yet economy is still a con-

spicuous Pontiac virtue—together with a record for reliability unduplicated by any other automobile power plant.

Take a look at General Motors lowest priced eight. Take a ride as well. Note that the price is near the lowest you will pay for any new car. Then let your own good judgment tell you why—dollar for dollar you can't beat a Pontiac.

DON'T MISS DAVE GARROWAY'S NIGHTTIME SHOW—NBC-TV · PONTIAC MOTOR DIVISION OF GENERAL MOTORS CORPORATION

'54 Pontiac

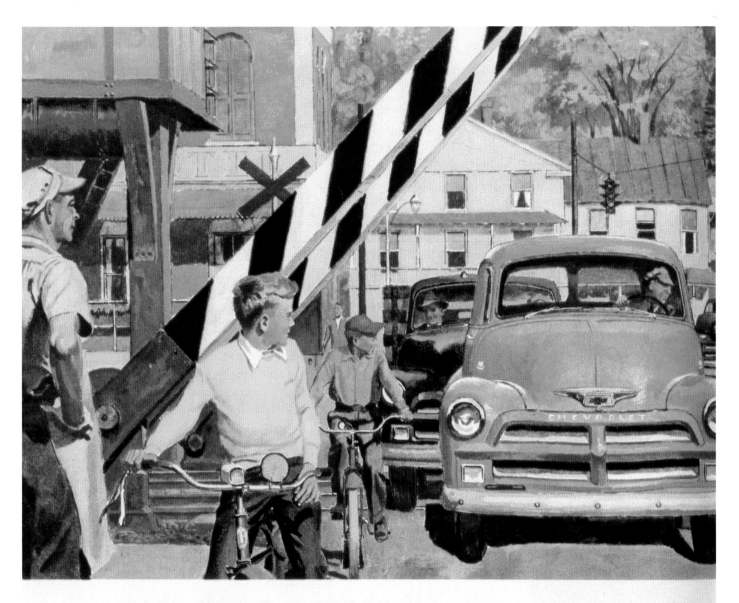

Safest place for your truck dollars—
new Chevrolet trucks!

New Chevrolet trucks handle your dollars with care right from the start. They're America's lowest-priced truck line, you know.

And over the miles, they keep a watchful eye on your dollars right down to the penny. Things like new high-compression power and greater chassis ruggedness in all new Chevrolet trucks mean lower operating and upkeep costs. What truck owner doesn't want that!

When it comes time to trade in your Chevrolet truck, you discover again what a safe and wise investment you made—for Chevrolet trucks traditionally have a high resale value.

Stop in and see your Chevrolet dealer for the safest — and "savingest" — truck deal you ever made! . . . Chevrolet Division of General Motors, Detroit 2, Michigan.

New Chevrolet trucks offer
more advantages you need and want—

New Engine Power: Brawnier "Thriftmaster 235" engine. Rugged "Loadmaster 235." All-new "Jobmaster 261" engine.*

New Comfortmaster Cab: Offers new comfort, safety and convenience. New one-piece curved windshield provides extra visibility.

New Chassis Ruggedness: Heavier axle shafts in 2-ton models . . . newly designed clutches, and more rigid frames in *all* models.

New Ride Control Seat:* Seat cushion and back move as a unit to eliminate back-rubbing. It "floats" you over rough roads with ease.

New Automatic Transmission:* Proved truck Hydra-Matic transmission is offered on 1/2-, 3/4- and 1-ton models.

New, Bigger Load Space: New pickup bodies have deeper sides. New stake and platform bodies are wider, longer and roomier.

*Optional at extra cost. Ride Control Seat is available on all cabs of 1 1/2- and 2-ton models, standard cabs only in other models. "Jobmaster 261" engine available on 2-ton models.

CHEVROLET TRUCKS
Most Trustworthy Trucks on Any Job!

first in demand in value in sales **CHEVROLET**

Chevrolet Truck

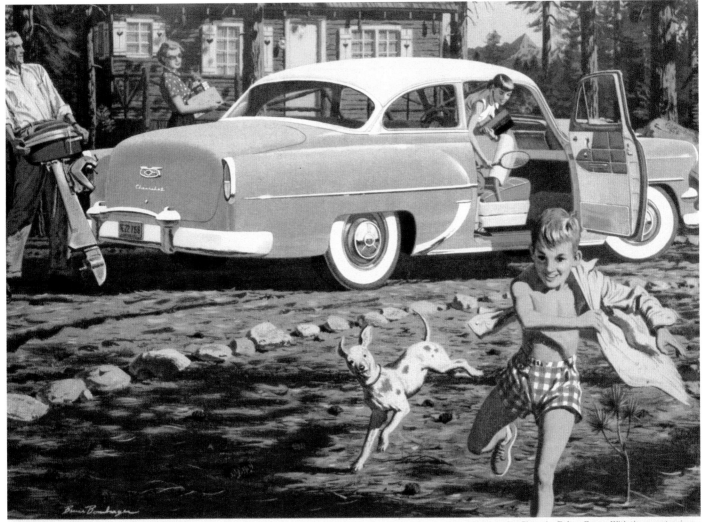

The new 1954 Chevrolet Delray Coupe. With three great series Chevrolet offers the most beautiful choice of models in its field.

Four good reasons why new Chevrolet families are "having a wonderful time". . .

That family up there has everything it takes to enjoy a wonderful vacation—a fine place to go and a fine new Chevrolet to get them there.

In fact, no other car fits so beautifully into all your family activities all the year 'round.

FIRST OF ALL, there's a lot of pride and pleasure for you in Chevrolet's lasting good looks. It's the only low-priced car with Body by Fisher. And *that*, you know, means smarter styling outside and in, and more solid quality through and through. You'll see it in the finer workmanship and materials, the greater comforts and conveniences.

THEN THAT FINE AND THRIFTY Chevrolet performance is always a special pleasure. Chevrolet's high-compression power—highest of any leading low-priced car—brings smoother, quicker response and

important gasoline savings, too. Here's one car that's really easy to handle and park on shopping trips, and that gives you solid and steady big-car comfort on vacation trips.

AND BEST OF ALL, MAYBE, is the eager, quiet, uncomplaining way your Chevrolet keeps on going wherever and whenever you want to go. You can count on it to start quickly and run smoothly night or day, fair weather or foul. You won't find another car with such a great name for serving its owners reliably and economically over a long life.

FOURTH BUT NOT LEAST, your Chevrolet dealer will be glad to show you how beautifully a new Chevrolet will fit your budget, too. For Chevrolet is priced below all other lines of cars. . . . Chevrolet Division of General Motors, Detroit 2, Michigan.

BRIGHT NEW IDEA IN INTERIORS! The interior of the new Chevrolet Delray Club Coupe is all vinyl, in colors that harmonize with the exterior finish. It's as practical as it is beautiful, for the vinyl is easily washable and amazingly resistant to scuffing and wear.

SYMBOL OF SAVINGS
CHEVROLET
EMBLEM OF EXCELLENCE

YEAR AFTER YEAR MORE PEOPLE BUY CHEVROLETS THAN ANY OTHER CAR!

'54 Chevrolet

THE SATURDAY EVENING POST

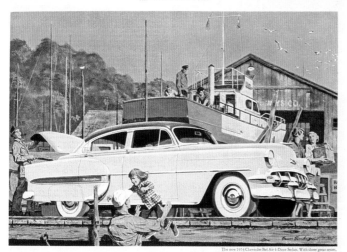

The new 1954 Chevrolet Bel Air 4-Door Sedan. With three great series, Chevrolet offers the most beautiful choice of models in its field.

Some sensible reasons why it's more fun to own a Chevrolet . . .

Maybe we can't all be quite as lucky as the man in our picture. Not everyone has a blue-jeaned daughter with a touch of tomboy in her to take fishin'.

But you can easily share his pleasure in going places in that new Chevrolet. It's engineered to be just plain *fun* to own, from the day you drive it home until the day you trade it in.

IT PUTS THE PLEASURE BACK IN DRIVING. Here's one car that's *easy* to handle in today's traffic. You really get a kick out of its quick, quiet response to your foot on the accelerator (highest compression power of any leading low-priced car). You feel good about the smooth, easy way it stops on a dime (biggest brakes in the low-price field). You sense with relaxing pleasure that you've got a lot of car under you (only car in its field with the extra strength of Fisher Unisteel

Construction and a full length box-girder frame).

IT'S FUN TO BE THRIFTY in a new Chevrolet. And you *are* thrifty. For this line, big Chevrolet is priced below all other lines of cars. And Chevrolet's great name for economy of operation and upkeep is growing even greater this year. That new high-compression power means not only more fun per gallon, but important gasoline savings as well!

SURE AS SEA WATER'S SALTY, your Chevrolet dealer has just the right model to make a gay and care-free companion for your family fun. Let him show you how Chevrolet, as the world's largest builder of automobiles, can give you more car for your money. And while you're there, be sure you *drive* this new Chevrolet — if only for the fun of it. . . . Chevrolet Division of General Motors, Detroit 2, Michigan.

NOW AUTOMATIC WINDOW AND SEAT CONTROLS—This year's Chevrolet offers you any or all of the latest automatic power features and controls. If you like, you can have the extra-cost options of Automatic Front Window and Seat Controls on Bel Air and "Two-Ten" models, and Power Brakes on Powerglide models, as well as Power Steering and zippy, thrifty Powerglide on all models.

MORE PEOPLE BUY CHEVROLETS THAN ANY OTHER CAR!

CHEVROLET EMBLEM OF EXCELLENCE

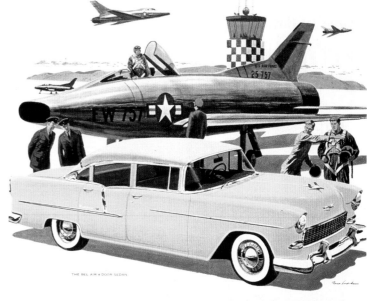

THE BEL AIR 4-DOOR SEDAN

Chevrolet's 3 <u>new</u> engines put new fun <u>under</u> your foot and a great big grin on your face!

You'll want to read about the <u>new</u> V8 and two <u>new</u> 6's here.

But it's even better to let them speak for themselves on the road.

You've got the greatest choice going in the Motoramic Chevrolet! Would you like to boss the new "Turbo-Fire V8" around . . . strictly in charge when the light flashes green . . . calm and confident when the road snakes up a steep grade? (Easy does it—you're handling 162 "horses" with an 8 to 1 compression ratio!) Or would you prefer the equally thrilling performance of one of the two new 6's? There's the new "Blue-Flame 136" teamed with the extra-cost option of a smoother Powerglide. And the new "Blue-Flame 123" with either the new standard transmission or the extra-cost option of new Touch-Down Overdrive. See why Chevrolet is stealing the thunder from the high-priced cars! It has that high-priced, high-fashion look and everything good that goes with it—power, drives, ride, handling ease, *everything.* Let your Chevrolet dealer demonstrate how Chevrolet and General Motors have started a whole new age of low-cost motoring! . . . Chevrolet Division of General Motors, Detroit 2, Michigan.

Motoramic **CHEVROLET** *More than a new car . . . a new* <u>concept</u> *of low-cost motoring!*

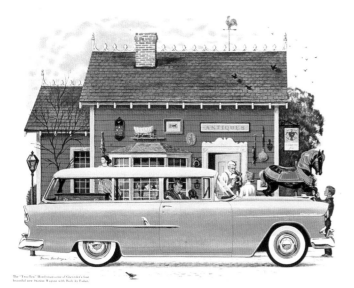

The "Two-Ten" Handyman—one of Chevrolet's four beautiful new Station Wagons with Body by Fisher.

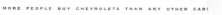

<u>Never</u> have you seen Station Wagons as wonderful as the new Chevrolets!

They're <u>handsome</u> (just look!). They're <u>handy</u> (new seat fold provides nearly 11 inches more cargo deck!).

Two doors or four. V8 or 6. three modern transmissions—and a wagonload of other new things you want.

You <u>can</u> have your cake and eat it, too—with Chevrolet's spanking-new line of Station Wagons! For here is sophisticated big-city style (and the longest look of any Chevrolet) . . . plus pack-horse performance and astonishing new utility features. Now, both the rear seat cushion and the backrest fold flush with the floor to give almost 11 inches more cargo space. Curved rear quarter windows combine with the deep Sweep-Sight Windshield to give visibility unlimited. With this two-in-one versatility you get all of Chevrolet's great engineering advances—the 162-h.p. "Turbo-Fire V8" or the two new "Blue-Flame" 6's, the smoothness of Glide-Ride front suspension, the stability of outrigger rear springs. Anti-Dive braking control, 12-volt electrical system and new Synchro-Mesh transmission. Plus your choice of extra-cost options such as Powerglide automatic transmission or Overdrive, Power Steering, Power Brakes—even Air Conditioning (on V8 models). How versatile can a car be? Why not call your Chevrolet dealer and see? . . . Chevrolet Division of General Motors, Detroit 2, Michigan.

More than a new car **CHEVROLET** *a new* **concept** *of low-cost motoring*

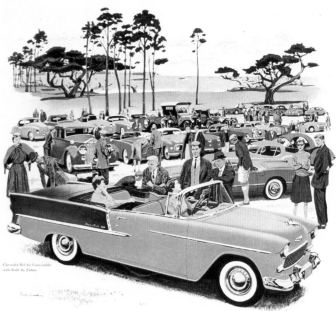

Chevrolet Bel Air Convertible with Body by Fisher.

Blue-ribbon beauty that's stealing the thunder from the high-priced cars!

Wherever outstanding cars are judged . . . for elegance, for comfort, for beauty of line . . . a surprising thing is happening. The spotlight is focusing on the new Chevrolets with body by Fisher.

Surprising—because Chevrolet offers one of America's lowest-priced lines of cars. But not really astonishing when you consider that its team of internationally famous engineers and stylists spent three years creating the 1955 models, and that they had just one goal—to shatter all previous ideas about what a low-priced car could be and do.

The unparalleled manufacturing efficiency of Chevrolet and General Motors provided the *means*—and that's why you have a

low-priced car that looks like a custom creation. That's why you get the thistledown softness of Glide-Ride front suspension—but married to the sports-car stability of outrigger rear springs. That's why you can choose between a hyper-efficient 162-h.p. V8 engine, or two brilliant new 6's. That's why Chevrolet's array of extra-cost options includes every luxury you might want—Powerglide, Overdrive, Power Brakes and Steering, even Air Conditioning on V8 models. And that's why you should try a Chevrolet for the biggest surprise of your motoring life! . . . Chevrolet Division of General Motors, Detroit 2, Michigan

Motoramic **CHEVROLET** *Drive it at your Chevrolet dealer's*

HOLIDAY/MAY

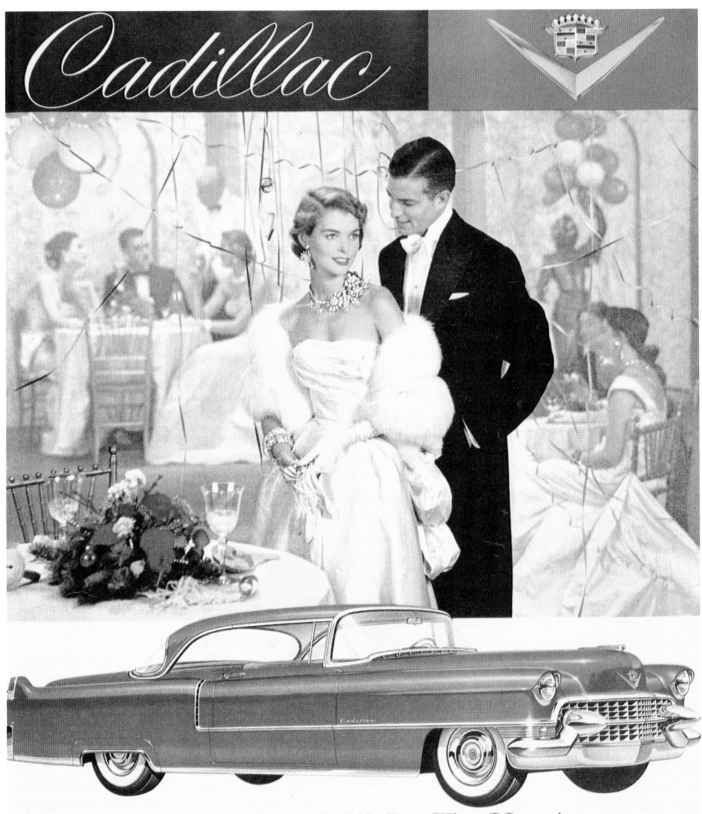

Cadillac

Maybe This Will Be The Year!

The handsome couple you see in the beautiful picture above have just made a very wise decision.

They have decided to get the facts about Cadillac—to see if, perhaps, the time has come for them to make the move to the "car of cars."

And we hope sincerely that 1955 *will* be their Cadillac year. For this, beyond any question, is the

perfect year to discover the joys of Cadillac ownership!

Never before has the car offered so much by way of beauty, or luxury, or performance. It is inspiring to behold . . . and thrilling to drive . . . and wonderful to own—to a degree unprecedented even by Cadillac.

And it is even more practical to own and operate. Its gasoline economy will surprise even the most

veteran Cadillac owner—and it is designed and buil to provide years of dependable, trouble-free servic

If a new Cadillac is high on your list of hopes fo the new year, we think you should give careful con sideration to these facts. And we suggest that you mak a "resolution" now—to drive the 1955 Cadillac!

Your dealer will be happy to see you at any time!

CADILLAC MOTOR CAR DIVISION · GENERAL MOTORS CORPORATION

'55 Cadillac

Avalon Yellow

AND RAVEN BLACK!

Perfect choice for the bright new star of the highway

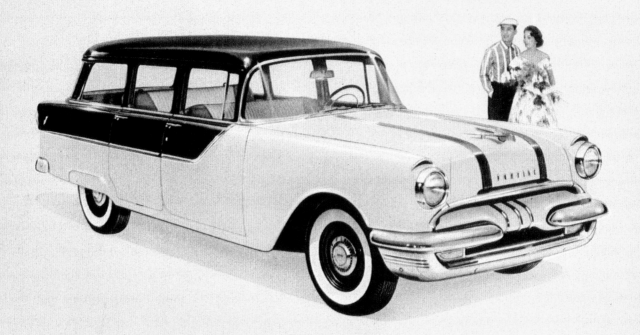

Avalon Yellow, bright omen of the shining hours awaiting
you in a Pontiac, here adorns an American beauty—the Pontiac Station
Wagon. Happiest possible meeting of smartness and utility, this Strato-
Streak powered beauty is also an extraordinarily gifted performer.
There's a pleasant way to prove it. See your Pontiac dealer
and drive the car—today!

Pontiac V8

with the sensational Strato-Streak

PONTIAC MOTOR DIVISION, GENERAL MOTORS CORPORATION

Bolero Red

AND RAVEN BLACK!

Heartlifting hue
for a heartlifting car

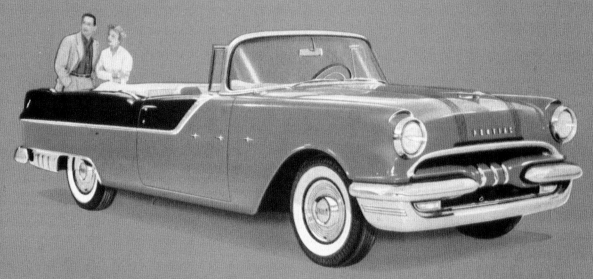

Here's a car that turns heads wherever it goes—a distinguished
Pontiac beauty! You'll approve as heartily of Strato-Streak V-8
performance . . . an achievement as dynamically different as Pontiac's future-
fashioned style. The price is equally appealing. It's way below your
expectations and exactly in line with your hopes. Step straight into
tomorrow—drive a Pontiac, today!

Pontiac V8

with the sensational Strato-Streak

PONTIAC MOTOR DIVISION, GENERAL MOTORS CORPORATION

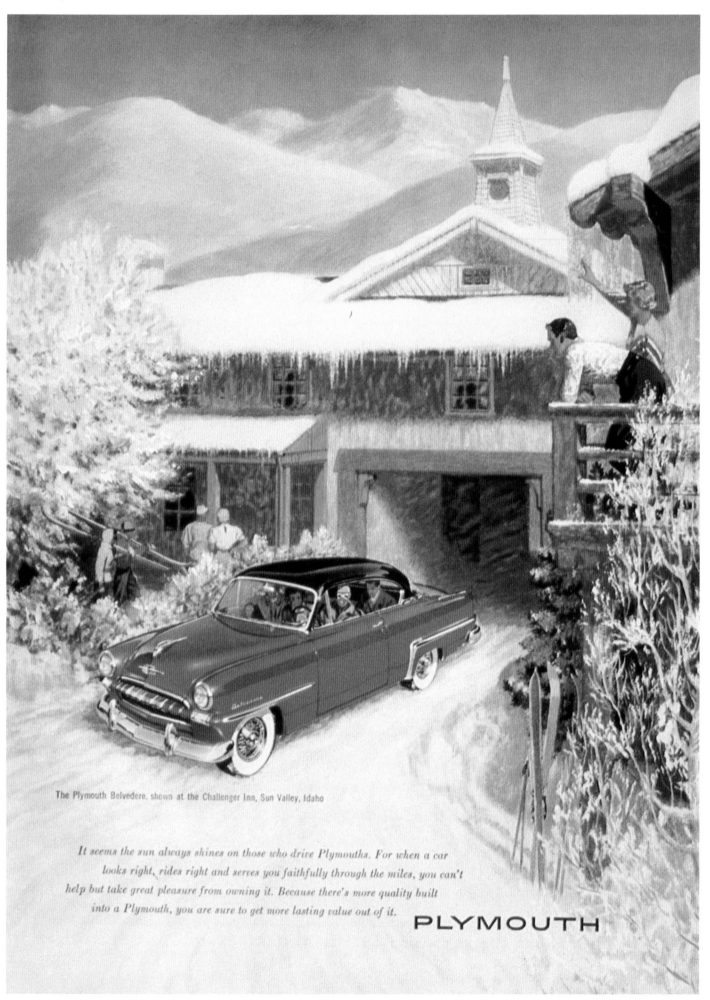

The Plymouth Belvedere, shown at the Challenger Inn, Sun Valley, Idaho

It seems the sun always shines on those who drive Plymouths. For when a car looks right, rides right and serves you faithfully through the miles, you can't help but take great pleasure from owning it. Because there's more quality built into a Plymouth, you are sure to get more lasting value out of it.

PLYMOUTH

'53 Plymouth

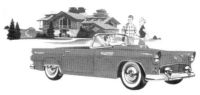

The fabulous Ford Thunderbird which has captured the fancy of America with its long, low, exciting styling and its split-second Trigger-Torque power, has set the pace for all '55 Fords.

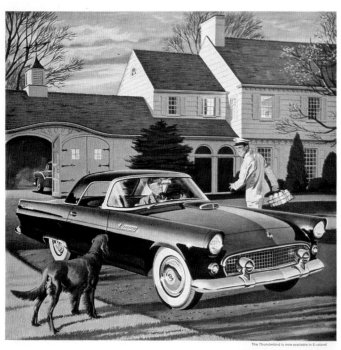

6 a.m. THUNDERBIRD time

Doctor, Lawyer, Merchant, Chief—no matter who you are—you'll find yourself getting up early when your garage is home to a Thunderbird. For here is a truly delightful package of sheer pleasure—all the way from its "let's go" look to the "let's go" performance of its Thunderbird Special Y-block V-8.

What's more—that seat is nearly *five* feet wide and it's power-operated. A touch of a switch moves it *up, down*—forward or back to suit your requirements for driving comfort. The steering wheel is another comfort feature—adjust it as *you* like it.

As for weather—your Thunderbird can have an easily demountable hard top *and/or* a snug fabric top that folds away completely out of sight. Windows roll up . . . power-operated if you like. Power steering, power brakes, Overdrive and Speed-Trigger Fordomatic are also available. These are important details, but the main thing is the low and mighty car itself. Why don't you obey that urge and try one today? Your Ford Dealer is the man to see.

The Thunderbird is now available in 5 colors!

This is the Thunderbird Special Y-block V-8 4-barrel carburetor, 8.5 to 1 compression ratio, 198-h.p. with Fordomatic . . . try it!

An exciting original by FORD

HOLIDAY/JUNE

There's a touch of Thunderbird in every FORD

● The way it looks . . . the way it goes . . . the way it's built . . . *everything* about the 1955 Ford shows it was cut from the same cloth as the heart-stealing Thunderbird.

You'll see the resemblance in the graceful flair of Ford's long, low lines . . . and in the skillful harmonizing of interior colors.

You'll feel the kinship in the reflex-quick obedience of Ford's Trigger-Torque power

. . . split-second response that makes you feel safer when accelerating, passing and under all driving conditions.

You'll also experience Thunderbird-like ease of handling with Ford's Ball-Joint suspension. You'll find what a smooth difference Ford's Angle-Poised ride makes on all roads.

You'll know how well a Ford is designed and built, too! For Ford shares the same kind of engineering, the same quality standards that have won first place for the Thunderbird in the hearts of so many.

It has that Thunderbird look from stem to stern! You can see the relationship in Ford's low silhouette, visored headlights, distinctive tail fins . . . everywhere.

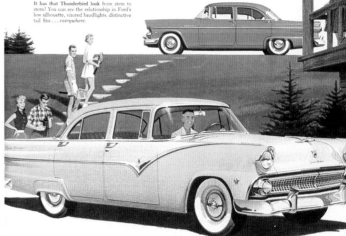

It has Thunderbird "GO" in your choice of two mighty Y-block V-8 engines and the power-packed I-block Six. Each of them offers Trigger-Torque response . . . "GO" that obeys your commands "reflex-quick."

Treat yourself to a Trigger-Torque Test Drive TODAY

Take command . . . get the thrill first hand!

It's dashing! It's dazzling! But don't think for a minute that *flair-fashioned beauty* is the whole Dodge story! Along with its luxury-car length and brilliant style, this new Dodge packs the greatest *thrill of command* on the road today. It more than lives up to its looks in surging power, unbelievable handling ease. It is *dependable* as only a Dodge can be dependable. Want to find out? *Take command . . . get the thrill first hand!*

Drive the New

DODGE

Daringly new for Spring! Dashing Custom Royal Lancer four-door . . . the flair of a hardtop—the roominess of a sedan.

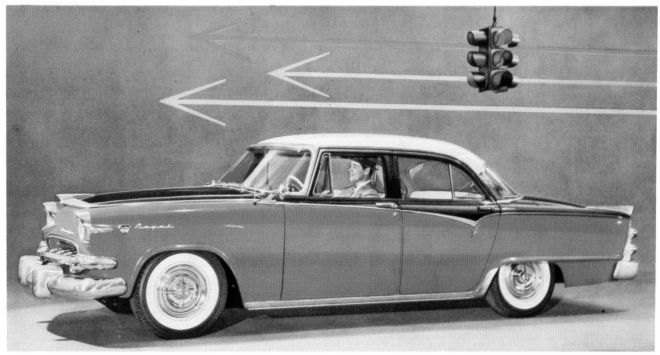

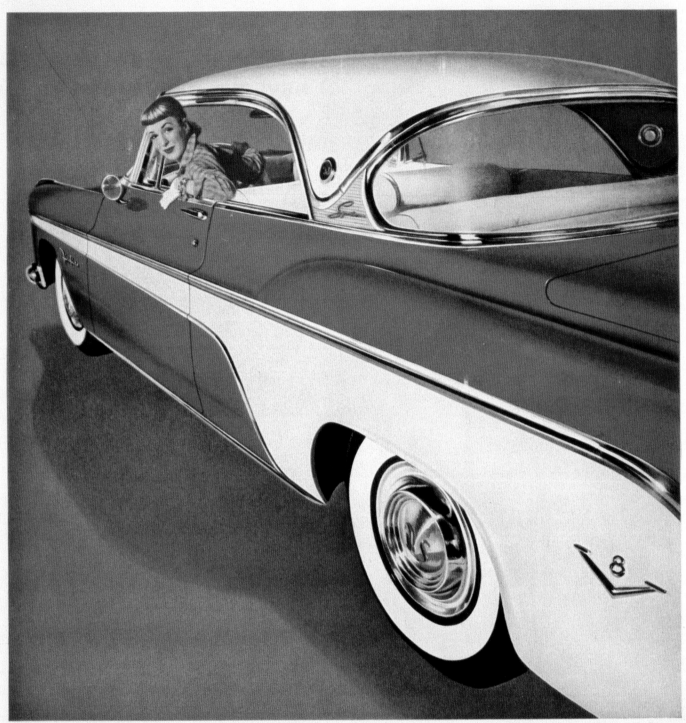

Anne Fogarty, famous fashion designer, drives a De Soto Sportsman.

DRIVE A │ DE SOTO │ BEFORE YOU DECIDE

There is no word in the English language that quite describes the utter satisfaction, the thrill, the delightful ease of driving a De Soto. Here is a car that translates your wishes into action almost with the speed of thought itself. There is an eager, natural response that is quite different from anything you're likely to find in other cars. That is why it is really important that you "drive a De Soto before you decide!" Your De Soto dealer will be delighted to have you take a turn at the wheel of either a Firedome or Fireflite. De Soto Division, Chrysler Corporation.

'55 De Soto

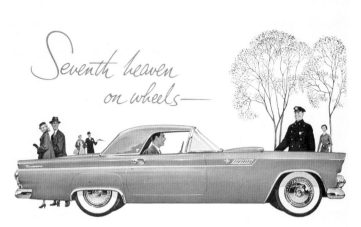

Seventh heaven on wheels—

the Ford THUNDERBIRD

Wherever—whenever—your Thunderbird appears in public, the effect is electric. All eyes turn to its long, low, graceful beauty. All hearts say "That's for me!"

And if they only knew the full story!

If they could spend but half an hour in *your* seat. If they could listen to the dual-throated harmony of its tuned mufflers and twin exhausts. If they could feel the steepest hills melt before the might of the 198-h.p. Thunderbird Special V-8. If they could see the tachometer needle wind up, as the four-barrel carburetor and 8.5 to 1 compression ratio convert gasoline into road-ruling Trigger-Torque "Go!"

Then they'd sample a portion of your pride in *your* personal car. But you could show them more!

You could show them the way it takes the corners as if magnetized to the road. You could let them feel the lightning "take-off" with new Speed-Trigger Fordomatic Drive. You could show them how quickly the convertible top whisks into place—how easily the solid top lifts on and off—the all-steel body—the ample trunk space—the rich interiors—the telescoping steering wheel—the 4-way power seat. And should your Thunderbird have the optional power assists, they could note

the convenience of power steering, power brakes and power window lifts.

You could show them this and more—how even routine driving becomes thrilling entertainment.

Yes, we're daydreaming for you. But why not put yourself in the driver's seat and make this dream come true? The man to see is your Ford Dealer.

An exciting original by FORD

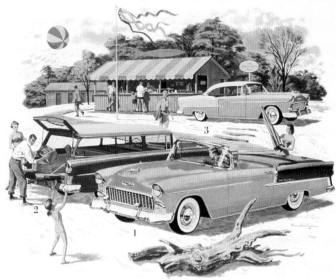

1. The fun-loving Bel Air Convertible 2. The versatile "Two-Ten" Handyman 3. The glamorous Bel Air Sport Coupe

Which one of these Chevrolet sport models would you rather have fun with?

Are you the type that likes to breeze along the open road on a bright summer day with nothing above between you and the blue? Do you like the sound of rain against a snug fabric top? If so, that Chevrolet Convertible in our picture is for you! No question about it. For here's a car that's as young in spirit as you are—and looks it! Even the smart all-vinyl interior is made to live outdoors.

But maybe you like a car that can carry anything from small fry to outboard motors with equal ease. That would be the "Two-Ten" Handyman Station Wagon you see over there (one of five Chevrolet station wagons). Here's one car that's so versatile it practically makes you a two-car family all by itself. So low it sets a new height of

fashion for station wagons! Practical? If the kids track sand inside, you can wash it out in a jiffy.

On the other hand, if you go for hardtops—and like 'em long, low and dashing—that Bel Air Sport Coupe in the background is just your dish. It's a "show car" from the word go!

Whichever Chevrolet you choose, you're bound to have the driving time of your life! You can't miss with Chevrolet's new 162-h.p. "Turbo-Fire V8" under the hood (180 h.p. is an extra-cost option in *all* V8 models), or with one of the two highest powered 6's in the low-price field. Your Chevrolet dealer is the man to see. . . . Chevrolet Division of General Motors, Detroit 2, Michigan.

STEALING THE THUNDER FROM THE HIGH-PRICED CARS! . . . *motoramic* CHEVROLET

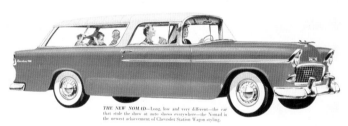

THE NEW NOMAD—Long, low and very different—the car that stole the show at auto shows everywhere—the Nomad is the newest achievement of Chevrolet Station Wagon styling.

Stylish Wagons by Chevrolet!

More and more people are joining the Station-Wagon set—and no wonder, with this spanking quintet of Motoramic Chevrolet wagons to choose from! Beautifully styled inside and out and with space to spare . . . from

the luxurious Nomad to the rugged Handyman, an entirely new concept of stylish low-priced Station Wagons. See them soon at your Chevrolet dealer's. . . . Chevrolet Division of General Motors, Detroit 2, Mich.

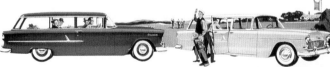

THE "TWO-TEN" HANDYMAN—At work or at play, this 2-door Station Wagon is a pleasure to look at—a joy to drive. Front-seat backs swing way up for easy access to rear seat and cargo area. Interiors—even roof linings—are of colorful, tough and easily washable vinyl.

THE BEL AIR BEAUVILLE—The rakish dash of the Bel Air sport series combines with utility in this sleek 4-door model. Only Chevrolet in the low-price field gives you "Sweep-Sight" vision, fore and aft—shoulder-to-shoulder windshields and curved rear quarter windows.

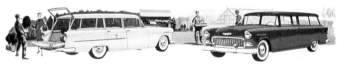

THE "TWO-TEN" TOWNSMAN—Rugged and handsome in every detail—because Chevrolet gives you something no other low-priced car can . . . Body by Fisher. Extra tough under the hood, too: your choice of two new "Blue-Flame" 6's or the surging new "Turbo-Fire V8."

THE "ONE-FIFTY" HANDYMAN—Like all Chevrolet Station Wagons, this 2-door boasts more load length than ever—fully ten extra inches, for both rear seat back and cushion fold into the floor. "Glide-Ride" front suspension and outrigger rear springs give new driving ease.

Stealing the thunder from the high-priced cars!

Now, in America, a refreshing new concept in fine motor cars

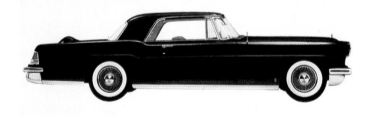

The excitement it stirs in your heart when you see the Continental Mark II lies in the way it has dared to depart from the conventional, the obvious.

And that's as we intended it. For in designing and building this distinguished motor car, we were thinking, especially, of those who admire the beauty of honest, simple lines . . . and of those who must appreciate a car which has been so conscientiously crafted.

The man who owns a Continental Mark II will possess a motor car that is truly distinctive and will *keep* its distinction for years to come.

Continental
Mark II

Continental Division · Ford Motor Company

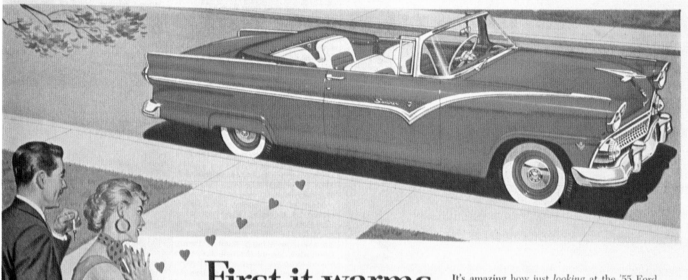

First it warms your heart...

(That Thunderbird Styling!)

It's amazing how just *looking* at the '55 Ford gives so many people that wonderful feeling. Why not? There's "Thunderbird" written in almost every line . . . from the hooded headlights to the flat rear deck. Inside, you'll see exciting color harmonies in durable fabrics. All in all, there isn't a more *pleasing* car in sight.

Then it reads your mind...

(That Trigger-Torque Power!)

Behind the wheel of the new Ford, *you* become a new man. For under your foot lies response so eager and alive, you almost believe it's clairvoyant! This is Ford's Trigger-Torque power . . . and it replies to your driving demands with split-second agility. There's safety in power like this . . . to whizz you out of traffic snarls . . . and to pass you ahead when passing is called for. Three new stout-hearted engines to choose from. And at least a score of other new engineering features. Reading about it is nowhere near the fun of driving the new Ford. So why not visit your dealer today?

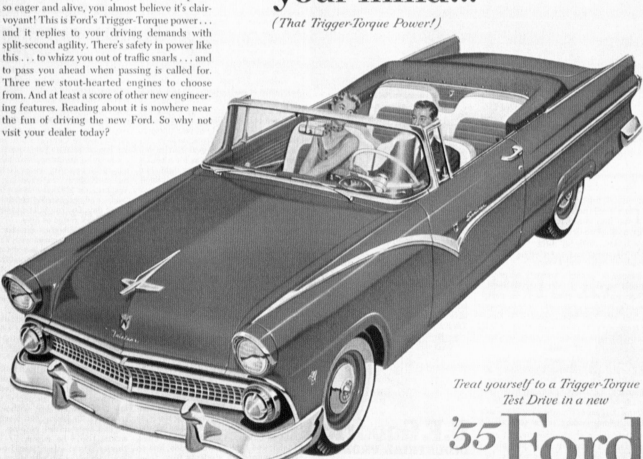

Treat yourself to a Trigger-Torque Test Drive in a new

'55 Ford

'55 Ford Convertible

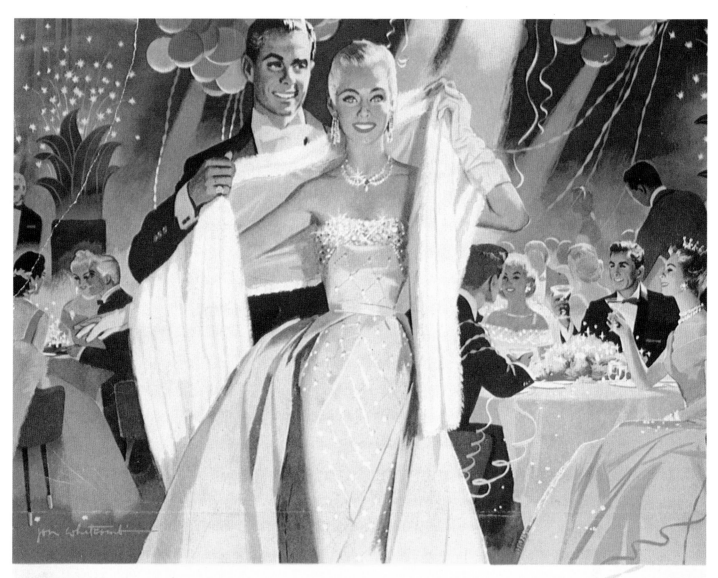

Happy Resolution for a Happy New Year!

Cadillac

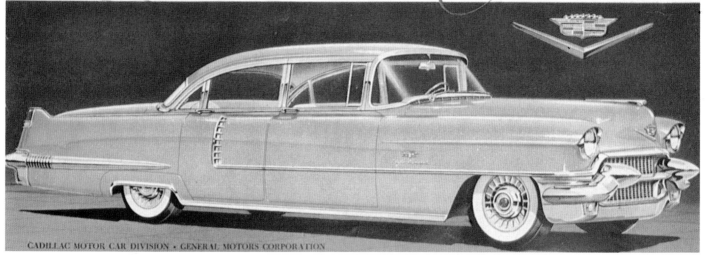

'56 Cadillac

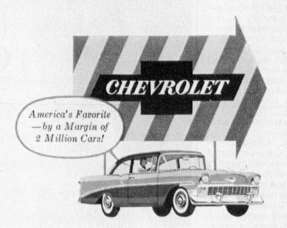

America's Favorite —by a Margin of 2 Million Cars!

Now showing—the happiest "double feature" of the year! One part is bold, new Motoramic styling. The other is record-breaking V8 action.

Hollywood has a heap of words that describe it: colossal, stupendous, magnificent. We'll settle for just the name—Chevrolet.

Because once you've driven this sweet-handling showboat, the adjectives will take care of themselves. Once you've sampled Chevy's hair-trigger reflexes and nailed-down stability, you'll see why it's one of the few great road cars built today!

Horsepower that ranges up to 225 makes hills flatter and saves precious seconds for safer passing. And the way this Chevrolet wheels around tight turns would gladden the heart of a dyed-in-the-wool sports car fan.

See your Chevrolet dealer sometime soon and highway-test this new Chevrolet. . . . Chevrolet Division of General Motors, Detroit 2, Michigan.

youth, beauty, Chevrolet, action !

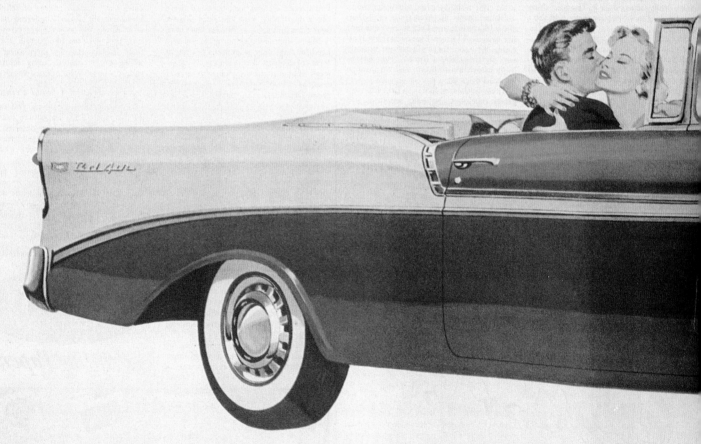

The Bel Air Convertible with Body by Fisher—one of 20 frisky new Chevrolets

'56 Chevrolet

PHOTOGRAPHED IN DISNEYLAND

New Nash Ambassador Country Club with 220 HP Jetfire V-8, Twin Ultramatic Drive, Power Steering, Power Brakes, Power-Lift Windows optional

Make it a <u>Nash</u> Vacation...
in the World's Finest Travel Car!

VACATION in true comfort, safety and style . . . in Nash! For the World's Finest Travel Car has the exclusive features that make any trip—across town or across country—a genuine pleasure.

Here you enjoy the greatest shoulder room ever built into an automobile . . . the widest front seat, the most legroom. Here you enjoy the "finest shockproof ride in the industry." Even Airliner Reclining Seats for perfect relaxation every driving mile and Twin Travel Beds that let you forget lodging worries.

Traditional Nash economy means you save as you drive. And Single Unit Car Construction—the Biggest Difference In Cars Today—affords the greatest protection for you and your family.

Backed by $25,000 Personal Automobile Accident Insurance against fatal injury

When you buy a new Nash, you receive automatically a total of $25,000 Insurance, divided equally between husband and wife, providing for payment of $12,500 to estate of either—a total of $25,000 —if either or both should be fatally injured while driving or riding in their new private passenger Nash anywhere in the world during first year of ownership. Applies only where state insurance laws permit. Here is true backing to support our confidence that Nash, the world's finest travel car, is the safest car you can drive!

Nash for 1956

AMBASSADOR • STATESMAN • RAMBLER • METROPOLITAN

Division of American Motors Corporation, Detroit 32, Michigan

Hurry! Hurry! Still Time To Win!

$¼ MILLION$$

PRIZES FOR NAMES IN THE BIGGEST CONTEST ON RECORD

Send us a name for American Motors Single Unit Construction (shown at right—the biggest difference in cars today. Your entry may win you the $25,000 Cash First Prize—or a brand-new Air Conditioned Nash or Rambler car—or any one of 1141 wonderful prizes. Hurry! Contest closes May 20th.

Get complete information and free entry blank with easy rules for winning at your Nash Dealer's!

See DISNEYLAND—great TV for all the family over ABC Network

SEE THE DIFFERENCE

Cadillac

DEL MONTE LODGE

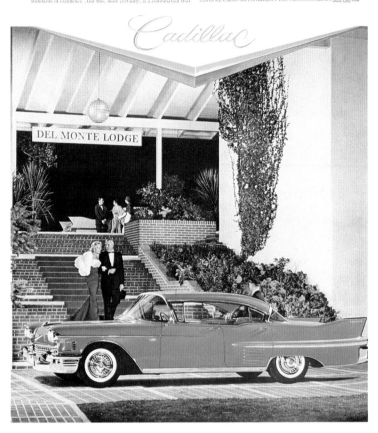

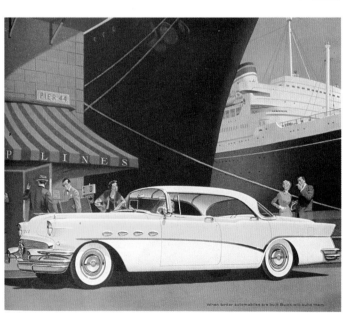

PIER 44

PLINES

When better automobiles are built Buick will build them

What's the true measure of a fine car?

Each man, of course, must name his own values.

With automobiles, some men judge fineness by the price they pay—others, by the worth they find therein.

To those who judge fine cars almost on a best-of-breed basis, ROADMASTER is fast becoming a constant choice.

This is in strict keeping with true astuteness—for ROADMASTER is the very cream of the great line of Buicks that have moved to historic sales heights.

Naturally, as the finest measure of these cars, ROADMASTER starts with the many attributes that have won such huge popularity for Buick.

automobiles—and climbs to its own pedestal.

Thus, when you slip behind the wheel of this Buick of Buicks, you know fine-car motoring as only soaring success can perfect it.

You know it first as a long, low grace of automobile smartly distinguished by its individualized styling.

You know it next as a harmony of fabric and color and decorator taste—fully expressive of your fashion modernity.

You know it finally as a suave and spirited and spine-tingling performer . . .

Buoyant with the ride of all-coil springing and deep-oil cushioning.

Responsive with the might of record-high V8 power . . .

Electrifying with the instant response of an advanced new Variable Pitch Dynaflow—the most modern transmission yet brought to the American scene.

ROADMASTER is the name, luxury is the keynote —custom-tailored to your order. And no man who chooses not merely by symbol alone can ask for more, or finer.

We can promise you a rewarding experience if you will accept a ROADMASTER demonstration at your Buick dealer's. See him soon.

BUICK Division of GENERAL MOTORS

ROADMASTER
Custom-Built by Buick

THE FINE LINE OF DISTINCTION

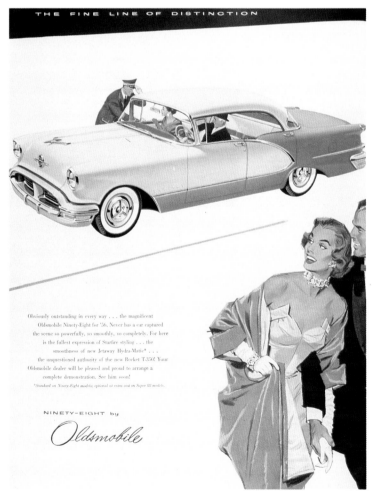

Obviously outstanding in every way . . . the magnificent Oldsmobile Ninety-Eight for '56. Never has a car captured the scene so powerfully, so smoothly, so completely. For here is the fullest expression of Starfire styling . . . the smoothness of new Jetaway Hydra-Matic* . . . the unquestioned authority of the new Rocket T-350! Your Oldsmobile dealer will be pleased and proud to arrange a complete demonstration. See him soon!

Standard on Ninety-Eight models; optional at extra cost on Super 88 models.

NINETY-EIGHT by

Oldsmobile

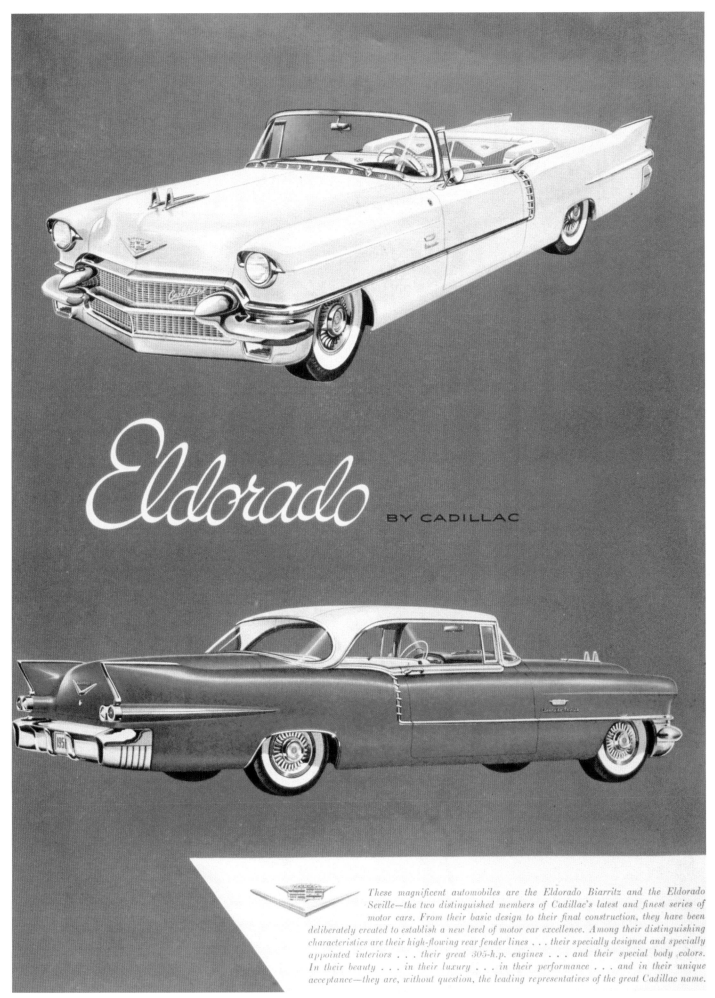

Eldorado

BY CADILLAC

These magnificent automobiles are the Eldorado Biarritz and the Eldorado Seville—the two distinguished members of Cadillac's latest and finest series of motor cars. From their basic design to their final construction, they have been deliberately created to establish a new level of motor car excellence. Among their distinguishing characteristics are their high-flowing rear fender lines . . . their specially designed and specially appointed interiors . . . their great 305-h.p. engines . . . and their special body colors. In their beauty . . . in their luxury . . . in their performance . . . and in their unique acceptance—they are, without question, the leading representatives of the great Cadillac name.

'56 Cadillac Eldorado

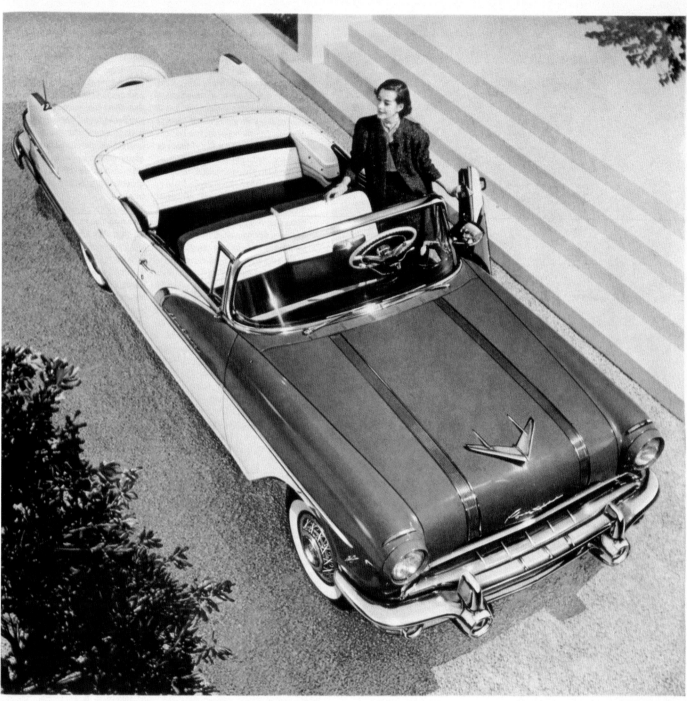

presenting the

STAR CHIEF *Custom Convertible*

A Very Special Car for a Very Special Person!

If you think this long, low creation is America's *handsomest* car, you'll find plenty of support among connoisseurs of such things.

But performance is its forte . . . breath-taking performance that quite literally creates for this great car a class all its own! Cradled under that sleek hoodline is the most advanced power plant of them all, the brilliant 227 h.p. Strato-Streak V-8 (12 more horsepower with low extra-cost dual exhausts)!

And Pontiac's revolutionary oil-smooth Strato-Flight Hydra-Matic* completes the most thrilling power team ever to hit the highway.

For those who demand the first word in *glamour* and the last word in *go*—here is the car you've been waiting for—the magnificent Star Chief Custom Convertible by Pontiac. *An extra-cost option*

PONTIAC

PONTIAC MOTOR DIVISION OF GENERAL MOTORS CORPORATION

HOLIDAY/MAY

'56 Pontiac

84

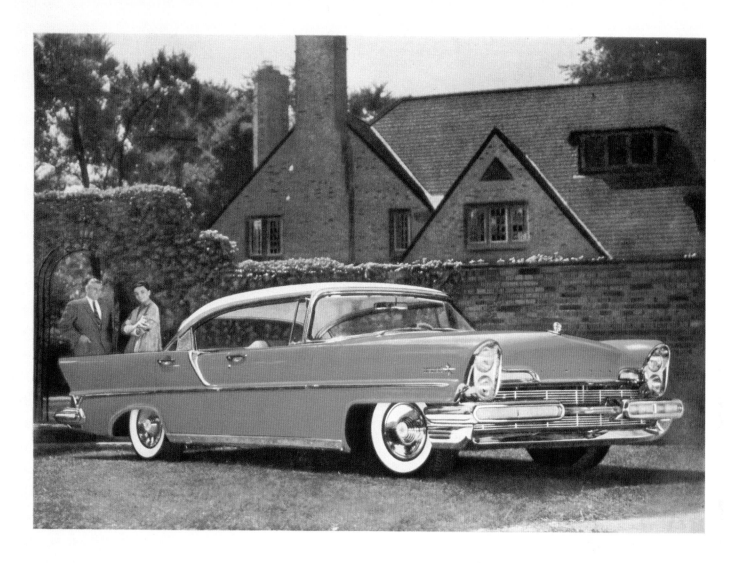

Presenting the dramatically new
LINCOLN FOR 1957

UNMISTAKABLY...THE FINEST IN THE FINE CAR FIELD

Dramatic New Styling Everywhere! From the unmistakable newness of Quadra-Lite Grille to the sweep of canted rear blades, here is the longest, lowest, most *distinctive* Lincoln of all time. Wherever you look—inside and out—you discover bold new ideas in fine car design.

Powerfully New In Fine Car Performance! Behind the wheel, you discover a new kind of swift, silken 300 horsepower in the most powerful Lincoln ever built . . . a new kind of fast-action, Turbo-Drive automatic transmission . . .

a new kind of Hydro-Cushioned ride! Here, you know instantly, is a whole new standard of what fine cars should be and do.

And More . . . Lincoln's new array of power luxuries makes this the most *effortless* driving fine car ever built. Everything you touch turns to power! Electric door locks, 6-way power seats, power window vents, power lubrication . . . these are but a few of the automatic luxuries offered in this Lincoln. Why don't *you* see . . . and drive . . . Lincoln for 1957 *now.*

'57 Lincoln

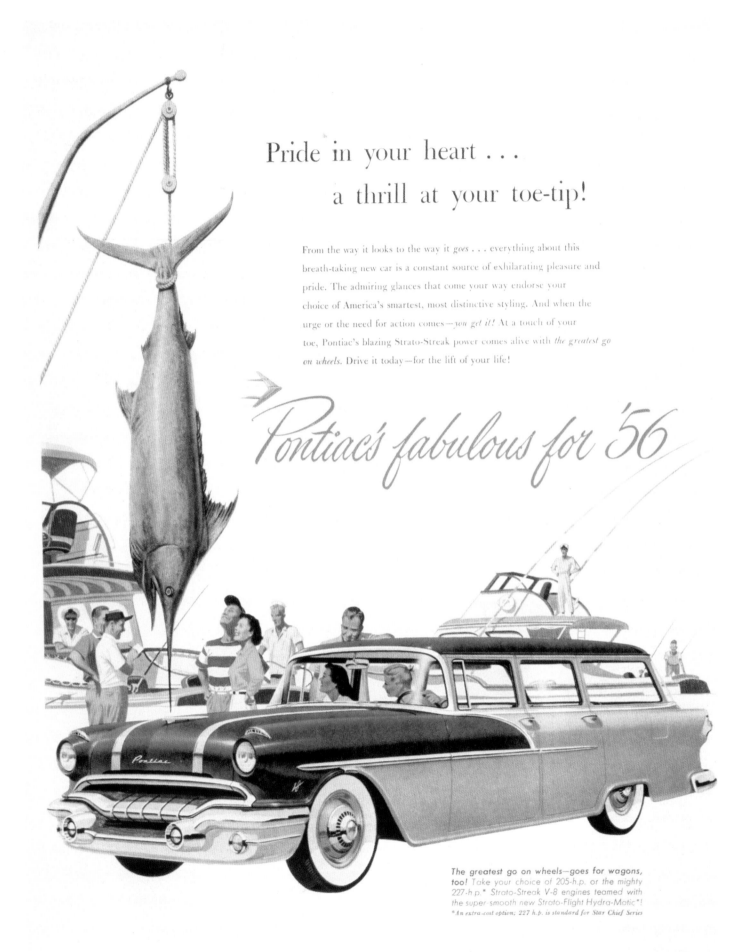

Pride in your heart . . .
a thrill at your toe-tip!

From the way it looks to the way it *goes* . . . everything about this breath-taking new car is a constant source of exhilarating pleasure and pride. The admiring glances that come your way endorse your choice of America's smartest, most distinctive styling. And when the urge or the need for action comes—*you get it!* At a touch of your toe, Pontiac's blazing Strato-Streak power comes alive with *the greatest go on wheels.* Drive it today—for the lift of your life!

Pontiac's fabulous for '56

The greatest go on wheels—goes for wagons, too! Take your choice of 205-h.p. or the mighty 227-h.p.* Strato-Streak V-8 engines teamed with the super-smooth new Strato-Flight Hydra-Matic*!
*An extra-cost option; 227 h.p. is standard for Star Chief Series

PONTIAC MOTOR DIVISION OF GENERAL MOTORS CORPORATION

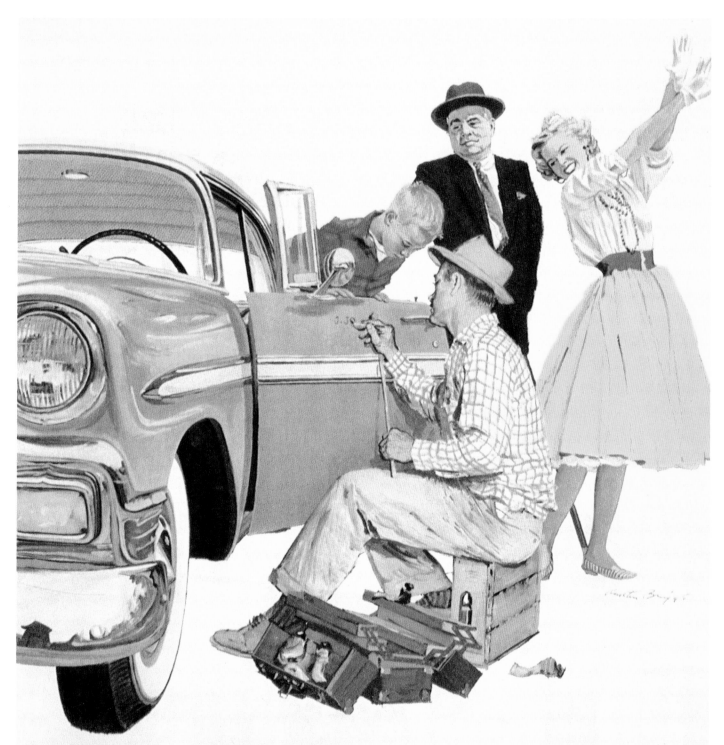

MORE PEOPLE NAMED JONES *
OWN CHEVROLETS THAN ANY OTHER CAR !

(Are you keeping up with the Joneses ?)

*Of course we haven't actually counted all the Joneses. But it seems a safe guess. Because this year—as they have year after year—more people are buying Chevrolets. And 2 million more people drive Chevrolets than any other car. Maybe you ought to stop by your Chevrolet dealer's and see why this is so.... Chevrolet Division of General Motors, Detroit 2, Michigan.

CHEVROLET

America's largest selling car— 2 million more on the road

'56 Chevrolet

Presenting...
an altogether new series
of fine cars

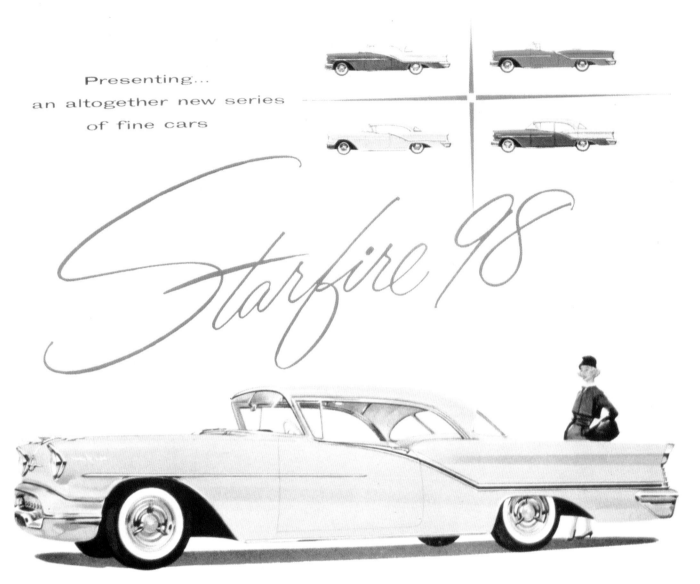

Starfire 98

..WITH THE ACCENT ON LUXURY!

Here, luxuriously yours, is the splendid new Starfire
98 . . . the finest expression of Oldsmobile distinction
and engineering leadership. Here is the alert perform-
ance of the great new 277-h.p. Rocket T-400 Engine
. . . the smooth-riding qualities of Oldsmobile's Wide-
Stance Chassis . . . the stunning styling of the newest
"low-level" look. Your Oldsmobile Quality Dealer
invites you to inspect these magnificent new
Starfire 98 models at your earliest opportunity.

OLDSMOBILE THE CAR THAT PUTS THE ACCENT ON YOU!

Glamorously new inside, too!
And all models are fully equipped
with Jetaway Hydra-Matic, Power
Steering and Power Brakes.

'57 Oldsmobile

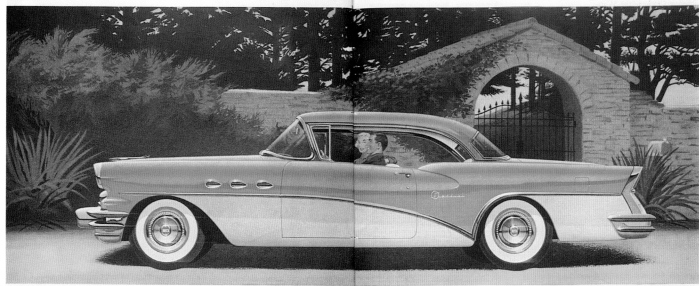

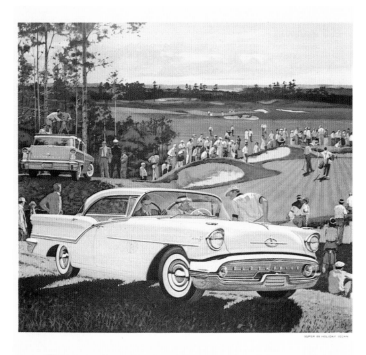

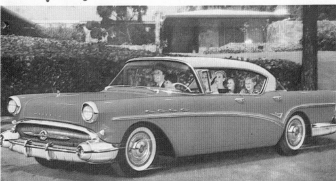

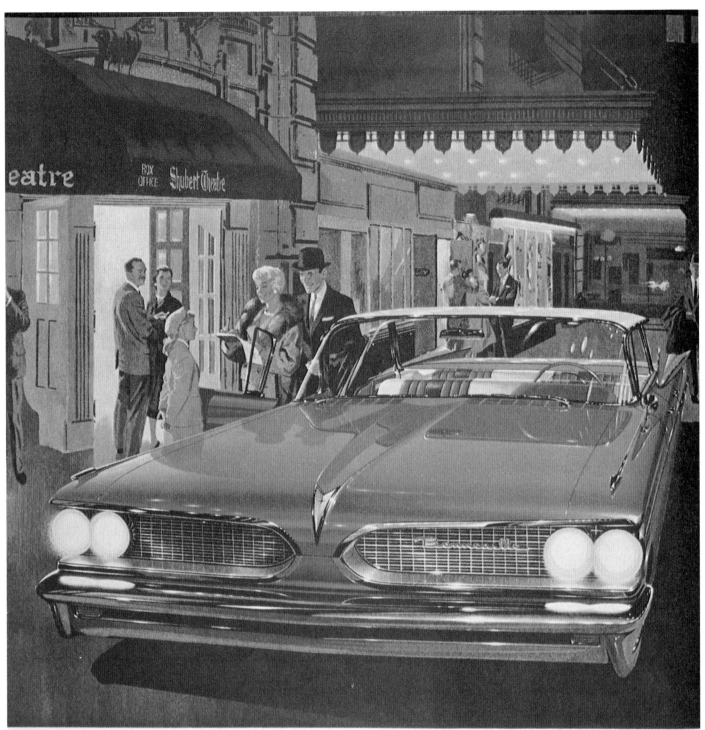

You get the solid quality of Body by Fisher.

Sparkling showcase for the year's hottest advances!

It would be a hit on its looks alone!

But there's so much more beneath Pontiac's crisply sculptured styling that it's nothing short of sensational.

For one, the wonderful roadability and ride of exclusive Wide-Track Wheels, which have won the acclaim of car experts as the year's top engineering advance.

For another, its choice of the industry's two most advanced V-8's: the Tempest 420 for the ultimate in

easygoing response and its companion, the Tempest 420E, which made V-8 history by setting a NASCAR supervised coast-to-coast economy mark on regular gas—*only 1½¢ per mile!*

You could go on and on with the many engineering wonders Pontiac alone provides. But the best evidence is a test drive. Why not take one soon?

PONTIAC MOTOR DIVISION · GENERAL MOTORS CORPORATION

PONTIAC! America's Number ① Road Car!

3 Totally New Series · Catalina · Star Chief · Bonneville

ONLY CAR WITH *WIDE-TRACK* WHEELS!

. . . acclaimed by experts as the year's top engineering advance! The wheels are moved out 5 inches for the widest, steadiest stance in America—lower center of gravity for better grip on the road, safer cornering, smoother ride, easier handling. *Pontiac gives you roadability no narrow gauge car can offer!*

See Phil Silvers on Pontiac Star Parade, Jan. 23—CBS-TV

'59 Pontiac

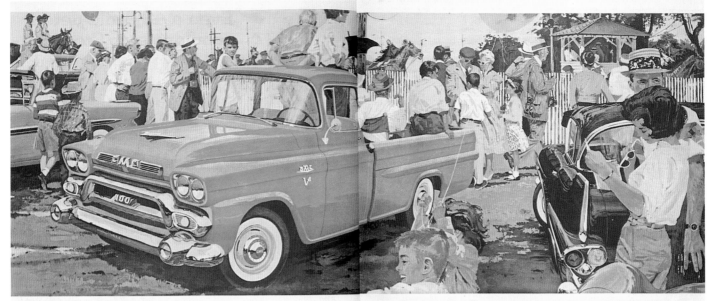

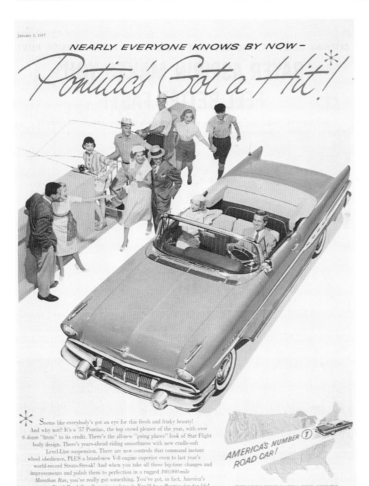
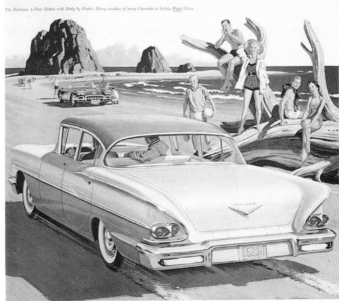

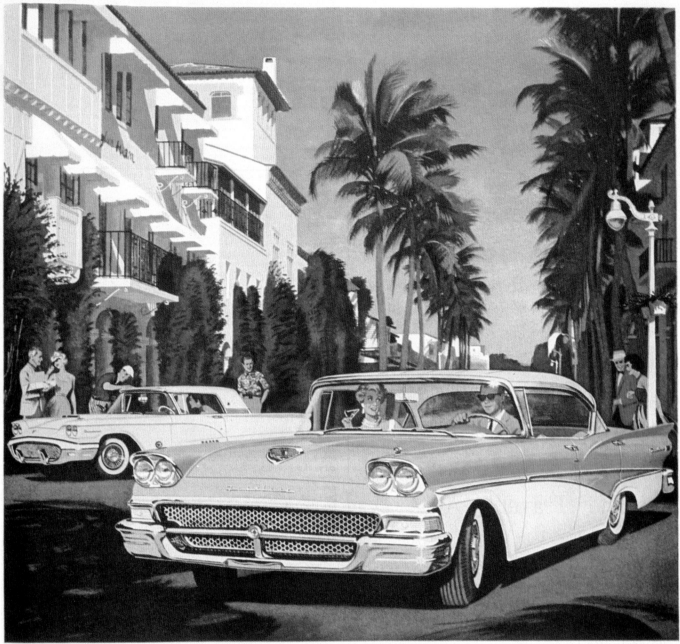

Every Ford has SAFETY GLASS in every window

On Worth Avenue, Palm Beach, Florida, the Ford Fairlane 500 Town Victoria . . . one of 21 new models in which you can enjoy Cruise-O-Matic Drive. In background, *the new 4-passenger Thunderbird* . . . another Cruise-O-Matic Ford that inspired the styling and performance for all 1958 Fords.

Try the Thunderbird magic of a Cruise-O-Matic Ford

It gives you the smoothest, most automatic driving
and turns Thunderbird "go" into gas savings, too!

Long highway haul? It was never so easy! City traffic? *Never* before so effortless! An especially steep hill? A car to pass? Cruise-O-Matic Drive glides into whichever gear is best for *any* driving situation, briskly . . . automatically! And a fluid torque converter keeps these automatic shifts a smooth, silent secret.

Want smooth, sure-footed starts on sand, mud, ice or snow? Shift from D-1 range, where all normal driving's done, to new D-2. This is the Thunderbird's own

automatic drive . . . and you can team it with the T-bird's own V-8 power in any Ford. Together they save up to 15 cents on every gas dollar. That's because of versatile Cruise-O-Matic's exclusive built-in over-drive feature and the Thunderbird V-8's "thrust-boosting," gas-saving Precision Fuel Induction.

And the best news of all . . . No one offers such a premium-performing automatic drive for so little. Come discover Ford's automatic Thunderbird magic for yourself.

58 Nothing
newer
in the
world

FORD

'58 Ford

THUNDERBIRD

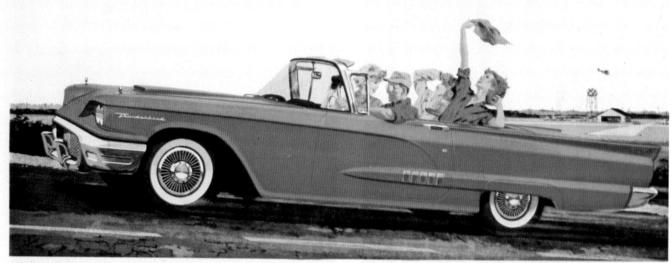

Thunderbird—the most wanted, most admired car in Amer

Another first from Ford — the incomparably exciting new Thunderbird Convertible!

Two magnificent engines—the standard 300-hp and the new, optional 375-hp—make this the greatest performer you've ever handled—bar none!

You've driven this new 4-passenger Thunderbird convertible many times —in your dreams.

Now it's really here—and, as you can see, several light-years ahead of anything else on the road.

For when you take this compact jewel of a car and power it with Thunderbird's magnificent 300-horsepower V-8 engine, you get brilliant performance, of course. Power it with Thunderbird's new 375-horsepower V-8 and you get performance that's nothing short of spectacular.

Acceleration? Merely wonderful. Hills?

What hills? Curves? You'll take 'em like a dream! And, by any standards, the new T-bird is eminently safer in design, in build, in action. Practical, too. You can glide this 4-passenger beauty into places the big cars have to pass up.

All this—and more—for *four* fortunate people, who can share the Thunderbird thrills in deep, individually contoured, lap-of-luxury seats.

To get the details—particularly about Thunderbird's price, which is *far* below that of other luxury cars—see your Ford Dealer soon.

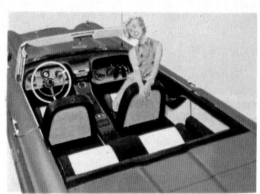

Thunderbird's new hide-away soft top is tastefully color-keyed, disappears completely into the spacious trunk. Top down, the distinctively sculptured rear deck is perfectly flush with the rear seats, forming one smooth, uninterrupted line of Thunderbird beauty!

Every Ford has SAFETY GLASS in every window

AMERICA'S MOST INDIVIDUAL CAR

HOLIDAY/AUGUST

'58 Thunderbird

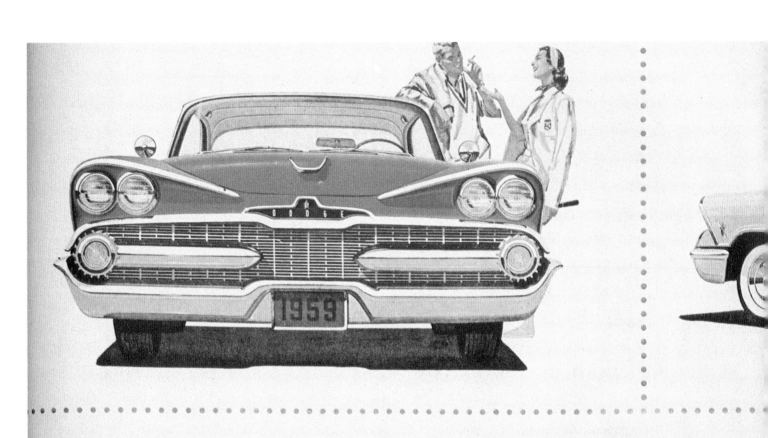

SO MUCH THAT'S NEW ! SO MUCH TH

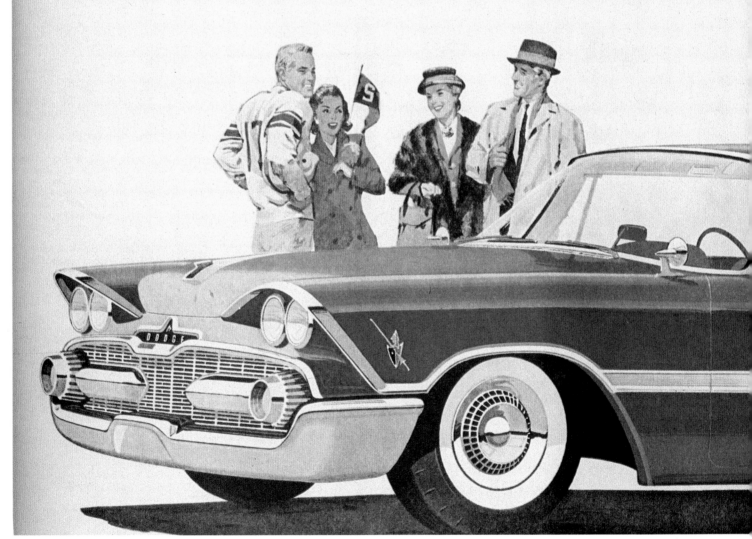

'59 Dodge

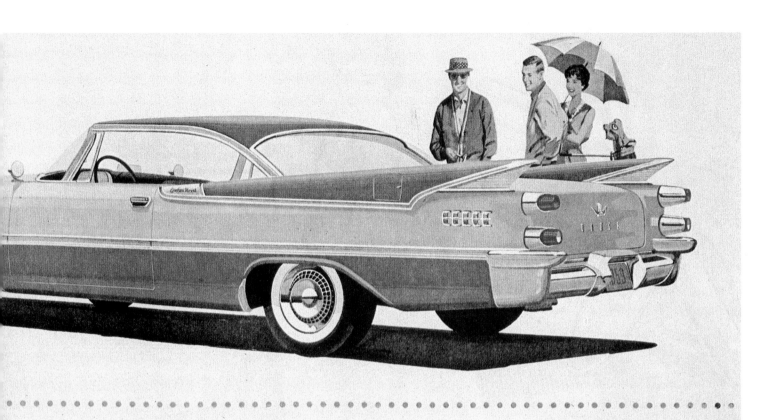

GREAT ! SO MUCH THAT'S DODGE !

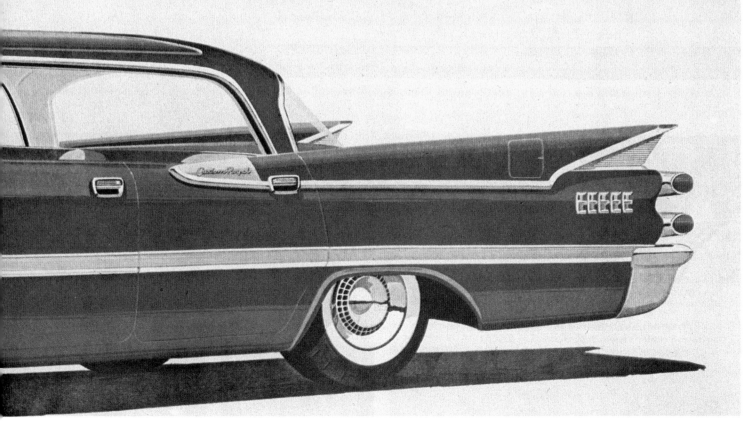

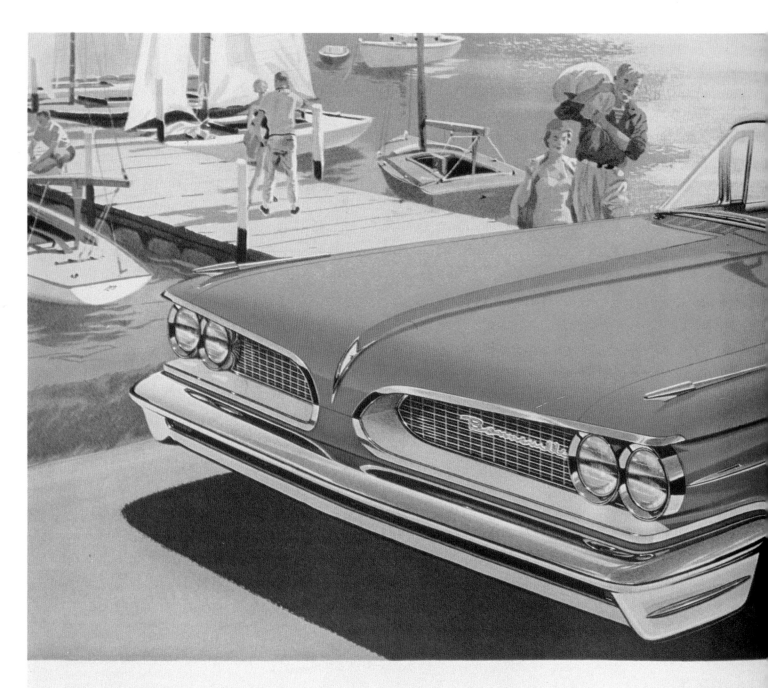

Trim...Tailored...Terrific...and America's Numb

If you like your action taut—and sheathed in clean, crisp lines—Pontiac '59 is the one car that wraps up everything you want on the grandest, most glorious scale you've ever known!

It starts with wide-track wheels for unsurpassed road-hugging stability—and a new, low look no narrow gauge car can hope to imitate. Beneath the glamour you'll find all the best of the new ideas: Air-Cooled True-Contour Brakes for safer stops, unvarying control ...vista-lounge interiors with full 360-degree visibility and seats *wider than a sofa* . . . Vista-Panoramic windshield that curves up into the roof . . . long-lasting Magic-Mirror finish that keeps its new-car luster up to five times longer—the most durable car finish known.

In the performance department, the industry's most modern power plant reaches new perfection in the Tempest 420 V-8, so free of vibration and sound you almost forget it's there. *And there's an amazing new economy engine, optional at no extra cost, that gives you V-8 muscle with the extra mileage of a much smaller engine—and performs its miracles on regular gas!*

But that's only part of the story. Come in and discover *all* the big and wonderful things that have happened to America's Number One Road Car!

On TV—See Pontiac's Victor Borge Show, November 29—CBS-TV

PONTIAC MOTOR DIVISION • GENERAL MOTORS CORPORATION

'59 Pontiac

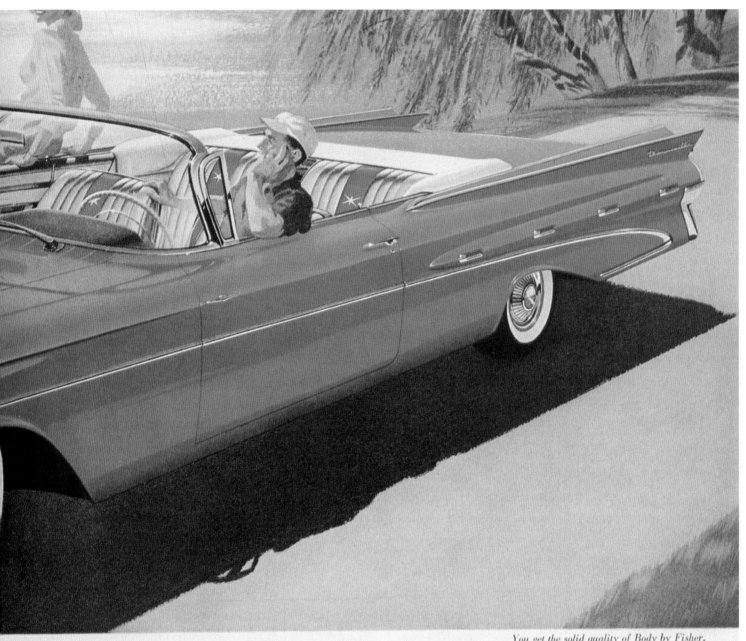

You get the solid quality of Body by Fisher.

Road Car!

EXCLUSIVELY YOURS—*WIDE-TRACK* WHEELS

The wheels are moved out 5 inches for the widest, steadiest stance in America—better cooling for engine and brakes, far better grip on the road, safer cornering, smoother ride, easier handling. *You get the most beautiful roadability you've ever known—in America's Number ① Road Car!*

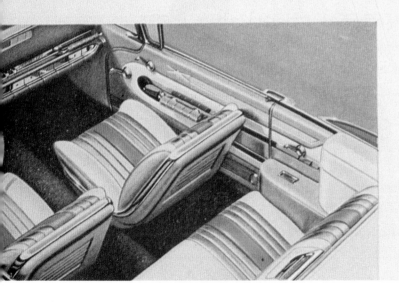

PONTIAC!

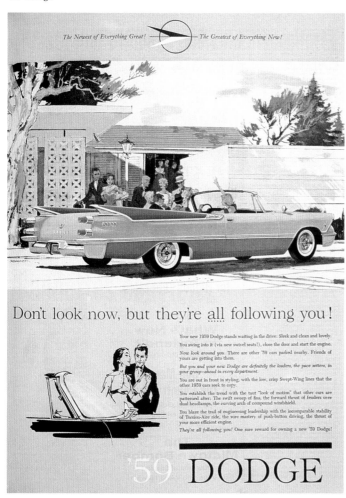

Don't look now, but they're all following you!

Your new 1959 Dodge stands waiting in the drive: Sleek and clean and lovely.

You swing into it (via new swivel seats!), close the door and start the engine.

Now look around you. There are other '59 cars parked nearby. Friends of yours are getting into them.

But you and your new Dodge are definitely the leaders, the pace setters, in your group—ahead in every department.

You are out in front in styling, with the low, crisp Swept-Wing lines that the other 1959 cars seek to copy.

You establish the trend with the taut "look of motion" that other cars are patterned after; The swift sweep of fins, the forward thrust of fenders over dual headlamps, the curving arch of compound windshield.

You blaze the trail of engineering leadership with the incomparable stability of Torsion-Aire ride, the sure mastery of push-button driving, the thrust of your more efficient engine.

They're all following you! One sure reward for owning a new '59 Dodge!

'59 DODGE

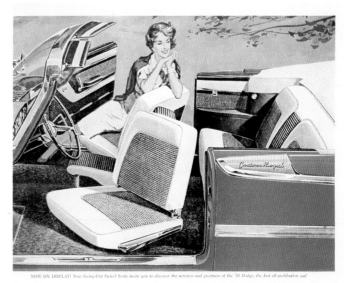

NOW ON DISPLAY! New Swing-Out Swivel Seats invite you to discover the newness and greatness of the '59 Dodge, the first all-pushbutton car!

The Newest of Everything Great!

The Greatest of Everything New! New things, great things, reward you in the '59 Dodge. Seats swing out to invite you in. New HC-HE engines deliver more thrust, use less gas. New Level-Flite Torsion-Aire introduces you to three dimensional comfort—ride control, road control, load control. Outside mirrors adjust from the inside. Inside mirrors adjust themselves electronically. But the final reward is the deep-down greatness built into this '59 Dodge. See and drive it today.

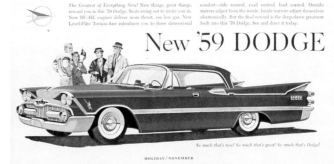

New '59 DODGE

So much that's new! So much that's great! So much that's Dodge!

HOLIDAY/NOVEMBER

August 9, 1958

The year's biggest selling convertible...the luxurious Chevrolet Impala!

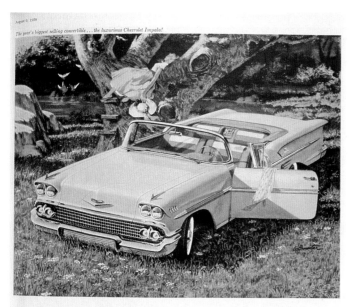

SERENITY...BY DESIGN! *A car is more than just the sum of good engineering. Here, in the new* CHEVROLET, *superlative design has created a new dimension ... a harmony of behavior, a serene personality that glorifies every mile you travel.*

Chevrolet design merely begins with the marvelous ingenuity of Full Coil suspension, the advanced power of Turbo-Thrust "V8's," the low-slung heft of Safety-Girder frame. For these are just building blocks—the rest is endless hours of testing, perfecting, refining.

This devotion to balance in design is one of the major reasons why Chevrolet has been the most successful car the world has ever seen. It is the real reason behind the solid satisfaction of Body by Fisher—the day-after-day pleasure of doors that close with a smooth "click," the really thorough sound-proofing that bottles up tiring vibration, the enduring elegance of substantial hardware, of

upholstery fabrics that last and last. It is the reason why Chevy's steering is so true-running, why its roadability is world-famous, why its balance and stability leave you so remarkably refreshed after a long day's journey. This emphasis on perfection is also the basic reason why Chevrolet's engines purr out such silken power, so thriftily and for so many thousand miles.

This multitude of details all adds up to one big thing: a serenity of motion, a balance of design that is unduplicated. Why not experience it? Your Chevrolet dealer has a car waiting. *Chevrolet Division of General Motors, Detroit 2, Michigan.*

Optional at extra cost.

CHEVROLET

Poetry on wheels!

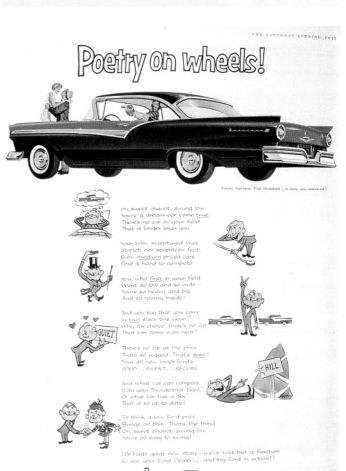

Ford Fairlane Five Hundred (in case you wondered)

Oh, sweet chariot, swung low
You're a dream-car come true.
There's no car in your field
That is longer than you.

Your trim, sculptured lines
Stretch o'er seventeen feet.
Even *medium* priced cars
Find it hard to compete.

You, who first in your field
Went so low and so wide—
You're so heavy and big
And so roomy inside!

And you say that you come
In *two* sizes this year?
Why for choice, there's no car
That can come even near!

There's no car at the price
That's so rugged. That's *sure*!
Your all new Inner Ford's
SOLID... SILENT... SECURE

And what car can compare
With your Thunderbird 'Eight'
Or what car has a 'Six'
That is so up-to-date!

To think a low Ford price
Brings all this. That's the thing
Oh, sweet chariot, swung low
You're so easy to swing!

(Of Ford's great new story—we've told but a fraction
So see your Ford Dealer... and try Ford in action!)

'57 FORD

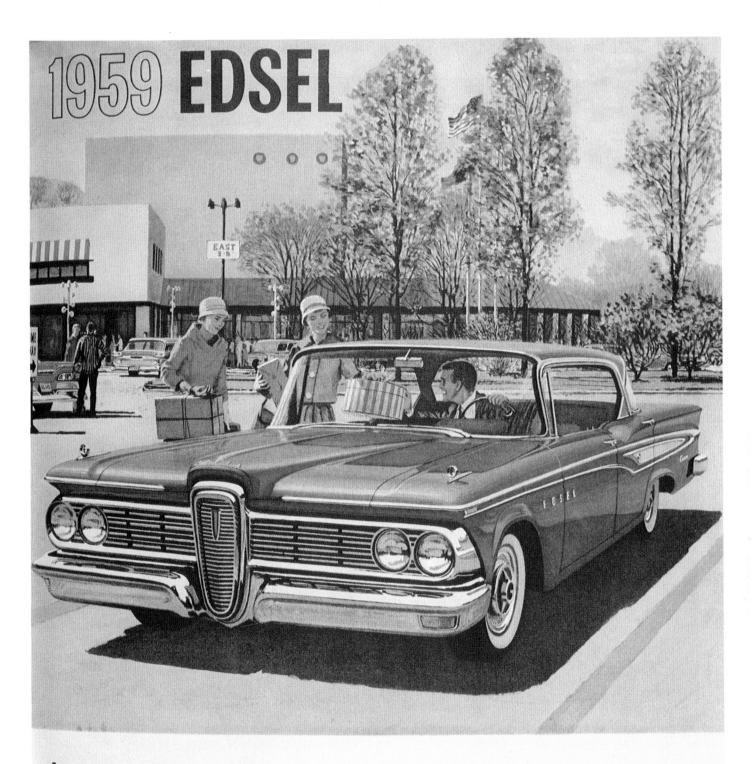

1959 EDSEL

An exciting new kind of car!

Makes history by making sense

Here's the car you hoped would happen. A full-size car that makes sense. Styled to last. Built to last. Beautifully efficient. And priced with the most popular three!

At last—a full-size car that makes sense. It looks right, works right. And it's priced right. The beautifully efficient Edsel for '59 is a car that slips easily into tight parking spaces—fits any normal garage. Same spacious room inside as before—*but less length outside!* It's a car that's powered to save. Edsel's four new engines include not only a thrifty six but a new economy V-8 that turns *regular* gas into spirited performance! It's a car that's distinctively styled to last. And carefully built to last. *Yet, the Edsel is actually priced with the most popular three!* See your Edsel Dealer.

EDSEL DIVISION · FORD MOTOR COMPANY

'59 Oldsmobile illustration — Super 88 Holiday SportSedan

Come see how new driving can be . . . at the wheel of a '59 Olds! Revel in *spaciousness* . . . these are the roomiest Rockets ever! Try the *quiet power* of a smooth, new Rocket Engine . . . the *extra safety* of Air-Scoop Brakes on all four wheels. Relax in the *comfort* of the new "Glide" Ride . . . rakishly styled in Oldsmobile's exciting "Linear Look." Everything about these '59 Oldsmobiles is an invitation to come in . . . get *That Olds Feeling!* ➤ OLDSMOBILE

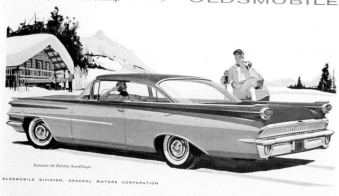

Dynamic 88 Holiday SceniCoupe

OLDSMOBILE DIVISION, GENERAL MOTORS CORPORATION

FAIRLANE *Town Sedan*

SAFETY

THE WORLD-WIDE FORD COMPANIES

present a brilliant new version of a great classic . . .

THE 4-PASSENGER
THUNDERBIRD

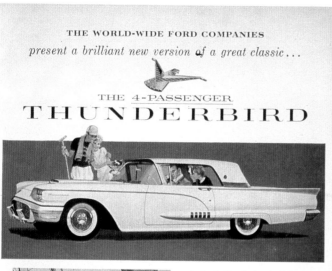

Another first from Ford — a jewel of a car — pure Thunderbird in design, spirit and performance . . . with full fine-car room, comfort and luxury for four.

● In the 1958 Thunderbird, Ford has created a wholly new size and type of fine car. It gives you compactness, low road-hugging good looks. It handles and parks like a dream.

Yet — miraculously — it gives you leg room and head room for four large men. Exceptionally wide doors allow you to step in or out with ease and grace.

And now — the all-new Thunderbird V-8 Engine gives you even livelier response and performance. Drive the new 4-passenger Thunderbird soon.

THE WORLD-WIDE
FORD
COMPANIES

Thunderbird 58 gives you full fine-car room for four people — with interior appointments that are unbelievably imaginative and luxurious.

Thunderbird's unitized body resists extra space . . . gives more comfortable seating. Top body and frame are all molded into one single piece of sculptured steel.

The silhouette is low, the graceful lines are distinctively long and crisp. Yet the Thunderbird provides luxurious head, shoulder and leg room in all four seats.

Wherever you live . . . you get more for your money in any Ford-built product
Ford-built products include cars, trucks, tractors, industrial engines, genuine replacement parts: Meteor / Popular / Anglia / Prefect / Consul / Zephyr / Zodiac / Thames / Fordson Major Tractor / Taunus / FK Truck / Continental Mark III / Lincoln / Mercury / Ford / Thunderbird / Edsel / Ford Tractor and Implements

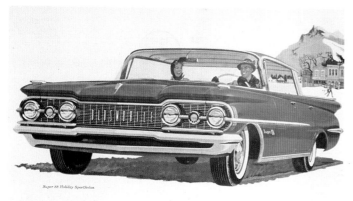

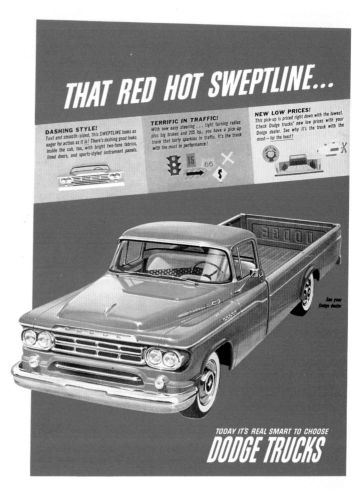

THAT RED HOT SWEPTLINE...

DASHING STYLE!
Taut and smooth-sided, this SWEPTLINE looks as eager for action as it is! There's dashing good looks inside the cab, too, with bright two-tone fabrics, lined doors, and sports-styled instrument panels.

TERRIFIC IN TRAFFIC!
With new easy steering . . . tight turning radius plus big brakes and 205 hp., you have a pick-up truck that fairly sparkles in traffic. It's the truck with the most in performance!

NEW LOW PRICES!
This pick-up is priced right down with the lowest. Check Dodge trucks' new low prices with your Dodge dealer. See why it's the truck with the most — for the least!

See your Dodge dealer

TODAY IT'S REAL SMART TO CHOOSE
DODGE TRUCKS

JUST LOOK AT THE PLYMOUTH FEATURES
THE OTHER LOW-PRICE CARS DON'T HAVE...YET!

SWIVEL FRONT SEATS (standard on Sport Fury models) make getting in and out easier. A wide armrest pulls down between the seats when two ride in front instead of three.

PUSH-BUTTON CONTROL CENTER groups instruments in plain sight, controls in easy reach. Pushbuttons on left control automatic shift∗. On right of the wheel: Push-Button Heater and Defroster∗.

REAR SPORT DECK (standard on Sport Fury models) is one of the many features that give the low-price '59 Plymouth such a high-price appearance. No other car looks so refreshingly youthful — nor runs so nimbly!

MIRROR-MATIC rear-view mirror∗ eases tensions of night-time driving by electronically dimming the glare from headlights of the cars behind you.

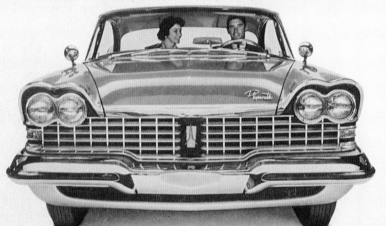

These are only a few of the many new convenience, safety and performance features you'll find on the '59 Plymouth. Don't look for them on any other low-price car . . . only *Plymouth offers them.* Before you buy *any* '59 car, see Plymouth. It's exactly what you've always wanted! Let your Plymouth dealer prove it—soon.

∗ *optional at low extra cost.*

Plymouth
today's best buy, tomorrow's best trade

Introducing NEW SWEPT·WING 58
(So advanced it leaves the rest behind !)

A MOST UNUSUAL NEW CAR is on display for the first time. It is very low, very daring, beautifully proportioned. "Swept-Wing 58" is the successor to the 1957 Swept-Wing Dodge which launched a "buying revolution" against the high, boxy design. Significant advances include an Electronic Fuel Injection Engine, a new Constant-Control power steering system, a "Sure-Grip" differential for better traction on snow and ice, and a vast new "picture window" windshield which curves up, back and around. To own a Swept-Wing 58 is a new adventure.

Costumes by Bonnie Cashin for Philip Sills

SWEPT·WING 58 *by* DODGE

The new 1959 Cadillac car speaks so eloquently—in so many ways—of the man who sits at its wheel. Simply because it *is* a Cadillac, for instance, it indicates his high level of *personal achievement*. Because it is so beautiful and so majestic, it bespeaks his fine sense of taste and his uncompromising standards. Because it is so luxurious and so regally appointed, it reveals his consideration for the comfort of his fellow passengers. And because it is so economical to own and to operate, it testifies to his great practical wisdom. The magnificent 1959 Cadillac will tell this wonderful story about *you*. So delay no longer. Make the decision now and visit your Cadillac dealer. In fact, the car's extraordinary reception has made it imperative that you place your order soon. Why not stop in tomorrow and make the arrangements?

CADILLAC MOTOR CAR DIVISION • GENERAL MOTORS CORPORATION
EVERY WINDOW OF EVERY CADILLAC IS SAFETY PLATE GLASS

Cadillac ...universal symbol of achievement

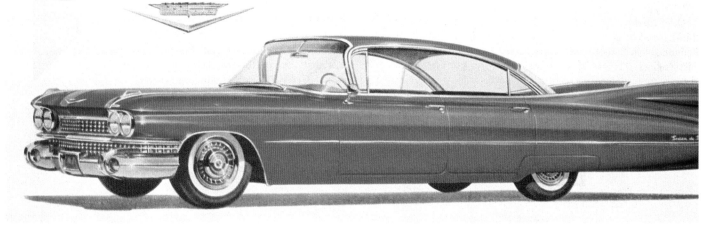

'59 Cadillac

The CONTINENTAL Mark IV

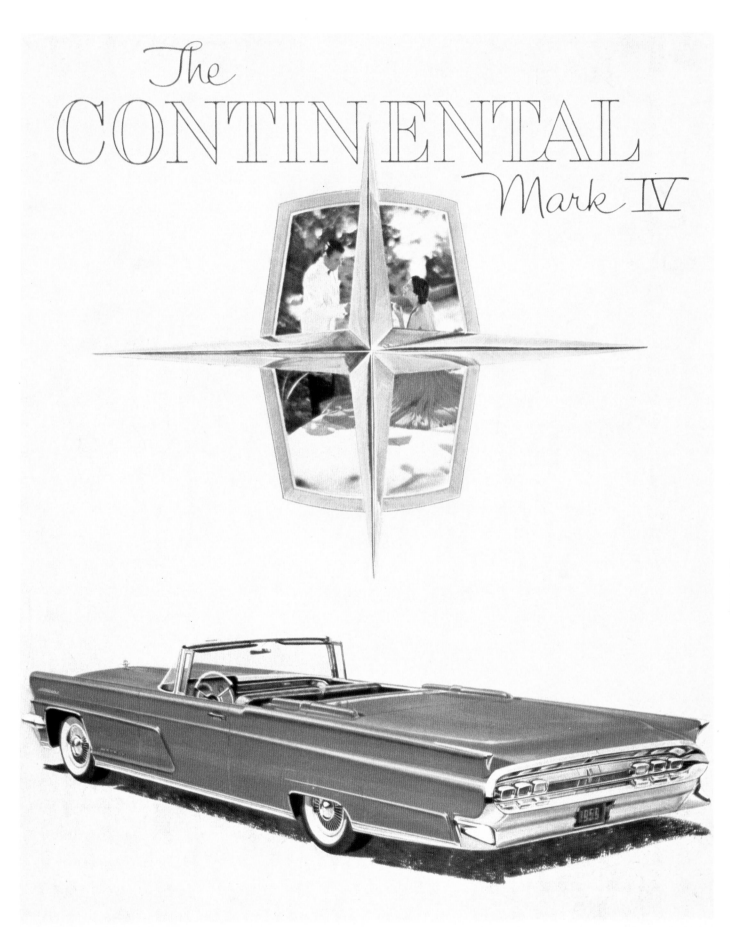

LINCOLN DIVISION · FORD MOTOR COMPANY

"Nothing is more simple than greatness..."

RALPH WALDO EMERSON

'59 Continental Mark IV

103

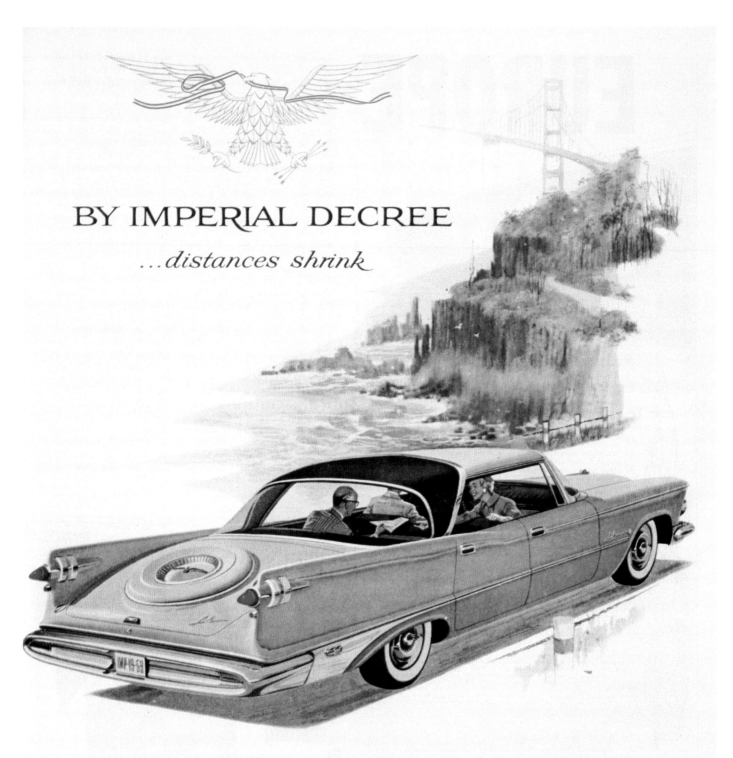

BY IMPERIAL DECREE

...distances shrink

Imperial gives you a wider world to discover, puts far-off, long-dreamed-of sights in comfortable reach.

It's not sheer speed that works this magic (though Imperial has speed you'll rarely use).

It is decreed by the anatomy of the car itself. Seats which mold themselves to the way you sit, which adjust through an infinite number of positions (specially installed swivel seats swing doorward to let you in and out easily). A steering wheel and pedals so deftly positioned that your hands and feet fall naturally into place. Remarkable optional Auto-Pilot that frees your right foot from the accelerator.

It is decreed by the size and silence of Imperial's Royal Coach Body . . . where the loudest sound you hear is the soft and pleasant whispering of the wind. It is decreed by skilled craftsmen working carefully in America's finest, most efficient automotive plant.

You feel this car a part of you . . . an extension of your own personal driving pattern. It is so restful, so easy to guide and stop and maneuver you can spend hundreds of miles longer at the luxurious task of driving it . . . without fatigue.

When your Imperial is delivered . . . keep in mind that almost nothing will ever be too far away again.

FINEST PRODUCT OF CHRYSLER CORPORATION

IMPERIAL
...excellence without equal

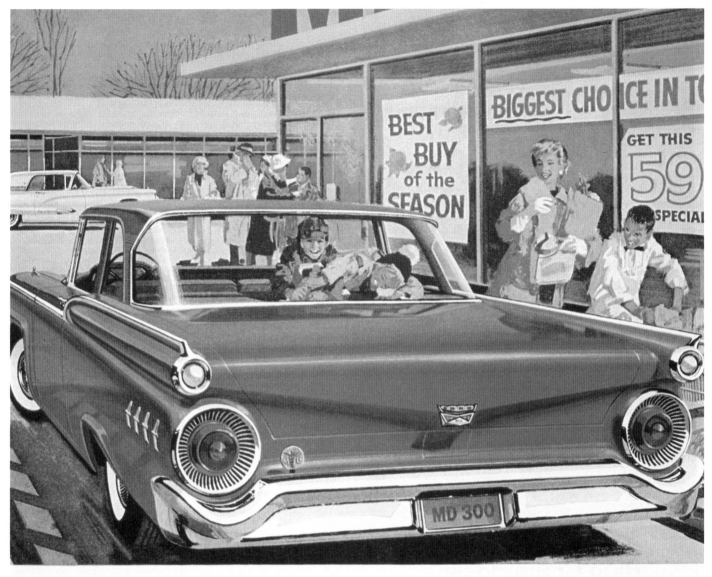

Best buy in the market . . .

We'll bet you a gross of trading stamps you can't beat this 59 Ford Custom 300 when it comes to value.

Styling? Fords are beautifully proportioned for *people* . . . doors are easier to get in and out of. Inside,

there's more space for legs, hips, heads—and hats. Performance? Six or Thunderbird V-8 engines give you

peak response at *normal* driving speeds . . . where you can use it! Economy? Fords use *regular* gas, so you

save up to a dollar every tankful. *Savings*, after all, are a Ford specialty. Shop the market . . . you'll see.

ROOMY 59 FORD RANCH WAGON—LOWEST PRICED WAGON OF THE "MOST POPULAR THREE"

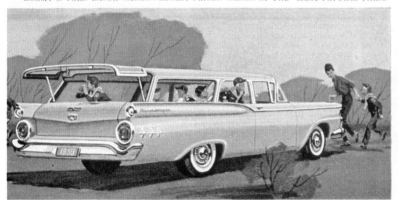

Beautiful new award-winning proportions · Exclusive luxury
lounge interiors · New Diamond Lustre finish never needs
waxing · Safety Glass all around · Standard aluminized muf-
flers for twice the life · 4000 miles between oil changes · The
most models in the industry · Elegant Thunderbird styling

WORLD'S MOST BEAUTIFULLY PROPORTIONED CARS

'59 Ford

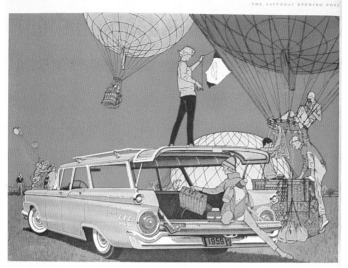

Gas goes a whole lot farther...

Savings reach new heights in this new Ford Ranch Wagon...designed for families living it up on a budget. All six Ford Wagons—Standard Six or Thunderbird V-8—use *regular* gas, save you up to $40 a year on fuel alone! America's wagon specialists have designed them *new*, like a hardtop. Living room comfortable...with sofa-soft seats for up to nine. A stratospheric 92 cu. ft. of cargo space is push-button easy to load with single-operation tailgate. Biggest, most elegant Ford wagons ever. Want a lift?

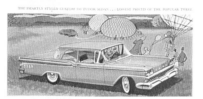

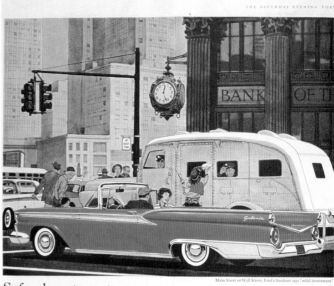

Safe place to put your money...

Right from the starting price, the 59 Fords save your money. Ford prices start at the very lowest of the most popular three. And you'll find surprising facts like these in your new Ford Owners Manual: "Regular gasoline is recommended for standard engines, Six and Thunderbird V-8...go 4000 miles without changing oil...your Ford muffler is aluminized to normally last twice as long." This same economy manual is yours in any one of Ford's 23 best-selling models. Savings? Ford wrote the book.

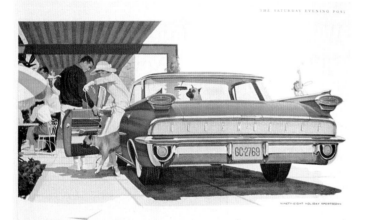

Make a date with the leader ... Oldsmobile for '59. Its trim, modern style is an open invitation to get out and go. Off and away with a Rocket Engine that's alert and eager. Riding smooth and so secure. Steering was never easier—stopping never surer! It's a wonderful feeling...a quality feeling...*That Olds Feeling!* And it should (and easily can) be yours. First port of call, your local quality dealer's to take *your* turn at the wheel. OLDSMOBILE DIVISION. GENERAL MOTORS CORPORATION

OLDSMOBILE

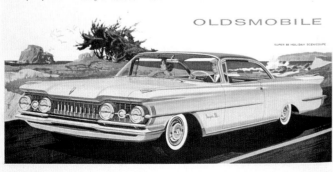

This '59 Oldsmobile wheel in your hands will introduce you to That New Olds Feeling. A feeling of quality and refinement... a feeling of unexcelled comfort and handling ease. Visit your Oldsmobile Quality Dealer and drive the smartest looking Rocket Engine Olds ever built!*

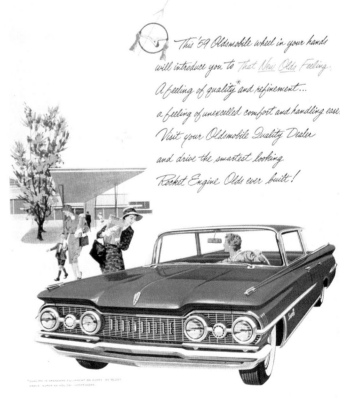

OLDSMOBILE

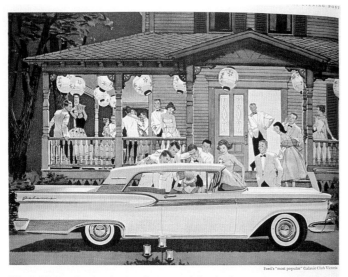

The price of popularity is surprisingly low...

Unwrapped just 6 months ago, the Galaxie is today's most desired car. This figures. For the Galaxie is beautifully Thunderbird in looks, power and luxury... yet typically Ford in its big 6-passenger comfort, low price and never-ending economy. Consider: gas and oil savings *alone* can mount to $55 a year. You save because Ford's Diamond Lustre finish never needs waxing. Surprisingly, the Thunderbird-inspired Galaxie sports a price tag only $50 away from a Fairlane 500 Ford. Only $50!

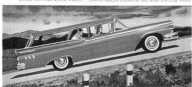

ROOMY NEW FORD RANCH WAGON... LOWEST PRICED WAGON OF THE MOST POPULAR THREE

Get *extra* savings now during dividend days at your Ford Dealer's. Special saving dividends plus Ford's built-for-people dividends. Deep springing and cushioning in every seat. Wider door openings are easier to get in and out of. Save up to $25 on double-lasting aluminized mufflers.

'59 FORDS
WORLD'S MOST BEAUTIFULLY PROPORTIONED CARS

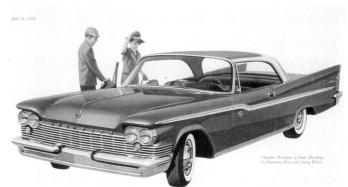

Chrysler Windsor 2-Door Hardtop in Nocturne Blue and Ivory White.

SPACE TRAVEL
...it's pushbutton driving ease with room to spare!

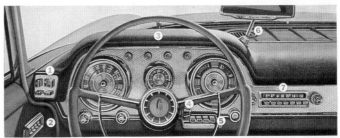

Start your own count-down—at Chrysler's unique control center! **7** Touch button or bar—be with music. **6** Mirror-Matic—flips headlight glare out of your eyes... electronically. **5** Your finger—selects warmth, or air-conditioned comfort. **4** Auto-Pilot selector —dial your speed, push the button, forget the gas pedal. **3** Automatic Beam-Changer— politely dims your lights. **2** Control panel for all windows. **1** TorqueFlite pushbuttons —just touch... and go! There's space-age magic in each of these wonderful Chrysler options. And for the space-minded traveler: hat-wearing, stretch-out roominess for relaxed adventuring. Enjoy Chrysler's quiet, quality ride, too. It's a lasting tribute to Chrysler's rugged construction. Try it yourself. Drive America's most fully automated car...

lion-hearted **CHRYSLER**
...setting the pace in convenience and comfort

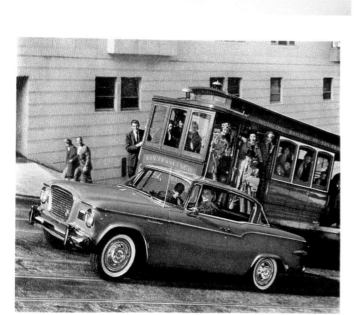

SCADS OF SCAMPER, STUNNING STYLE
MARATHON MILEAGE
COMMON SENSE COST

THE *LARK* BY STUDEBAKER

➤ Best performance-to-weight ratio of any U.S. car ➤ Best economy-to-performance ratio of any U.S. car; cuts insurance, gas, upkeep and repair costs ➤ More luxury and good taste per dollar ➤ And more inner room to outer size than any car known WHAT ELSE DO YOU NEED WHERE ELSE CAN YOU GET SO MUCH OF IT FOR SO LITTLE? Drive The Lark at your Studebaker Dealer's and discover for yourself.

Other models—2-Door Sedan, 4-Door Sedan, Station Wagon. Prices start under $2000. Automatic transmission optional on all models.

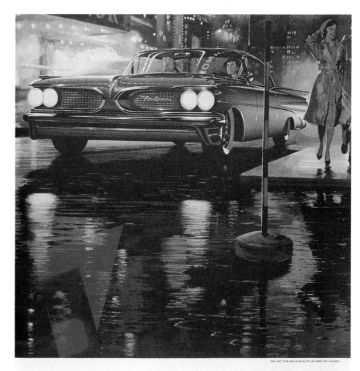

YOU GET THE SOLID QUALITY OF BODY BY FISHER.

Why Pontiac has captured the imagination of so many, many people
(a very *complete* story)

Why does a person take to one make of car, admire it, talk about it and desire it, yet feel no affinity at all for many others?

The answer, we feel, lies in the complete car. The car as a total unit, a composite of *all* the elements of style and operation.

Pontiac this year is winning a *complete* victory as a *complete* car. The sleek, restrained styling has a completely pleasant effect. No gaudy gingerbread. No bizarre bric-a-brac. Just delightful harmony. *Complete* harmony.

Mechanically, it is a most satisfying car to handle and ride in. The Wide-Track Wheel design makes every driving movement easier, more secure, solid. There's a feeling of confidence and authority on Wide-Track Wheels.

Have your nearest dealer bring a bright, brand-spanking new one by your house this week. For the complete effect, drive it well and long. (Demand is heavy, but we can have yours to you in time for plenty of summer driving pleasure.)

PONTIAC MOTOR DIVISION—GENERAL MOTORS CORPORATION

THE ONLY CAR WITH WIDE-TRACK WHEELS
Dotted lines show conventional wheel positions. Pontiac's wheels are five inches farther apart. This widens the stance, not the car. Pontiac hugs tighter on curves and corners. Sway and lean are considerably reduced, ride is smoother, balanced, steadier.

PONTIAC! America's Number ① Road Car!

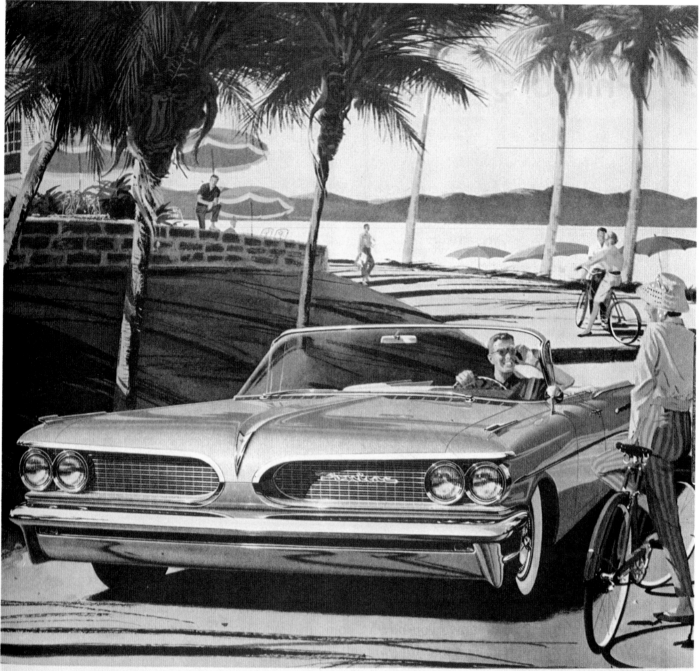

YOU GET THE SOLID QUALITY OF BODY BY FISHER.

Pontiac surrounds a man with beauty
and the solid security of wide-track wheels

We've been noticing something interesting about our men customers. When a man becomes the owner of a 1959 Pontiac he slices a few years off his age, becomes enthusiastic about driving almost anywhere any time, and holds his head a bit higher, a lot more proudly. It's not our imagination. It actually happens.

Unofficial psychology explains it this way: A man who works hard and gives his all to profession and family has earned the right to drive a great automobile. A Wide-Track Pontiac is a perfect reward.

Its trim, sleek lines gratify your sense of good taste and refinement. Yet they're well-defined lines, positive but uncluttered, consistent and clean. The unique grille is a good example; different but highly imaginative and pleasing.

Man is born to be a master and Pontiac gives you masterful control of this car with the security and stability of Wide-Track Wheels; wheels moved five inches farther apart. This widens the stance, not the car. You're balanced, with less lean and sway.

We assure all well-deserving men that this automobile will give you a vigorously fresh outlook on life, a feeling of youth, accomplishment and much, much pride. Show your wife this advertisement; she deserves a Pontiac, too.

PONTIAC MOTOR DIVISION · GENERAL MOTORS CORPORATION

THE ONLY CAR WITH *WIDE-TRACK* WHEELS

Dotted lines show conventional wheel positions. Pontiac's wheels are five inches farther apart. This widens the stance, not the car. Pontiac hugs tighter on curves and corners. Sway and lean are considerably reduced, ride is smoother, balanced, steadier.

PONTIAC! America's Number ① Road Car!

3 Totally New Series • Catalina • Star Chief • Bonneville

'59 Pontiac

Beautiful Wreaths

Contributing Writers & Wreath Designers

Sylvia Montroy
Betty Valle

Publications International, Ltd.

ISBN 1-56173-743-7

Contributing Writers & Wreath Designers:
Sylvia Montroy is a freelance designer and member of the Society of Craft Designers. She teaches adult craft workshops and has written extensively on crafts for publications including *Better Homes and Gardens, Crafts Magazine,* and *Country Handcrafts.*

Betty Valle is a member and past president of the Society of Craft Designers and author of 25 craft instruction books. She has demonstrated craft projects on television and her craft designs have been published in *Redbook, Crafts 'N Things,* and *Crafttrends.*

Photography: Sacco Productions Limited/Chicago
 Chris Brooks
 Tom O'Connell
Photo Production: Roberta Ellis
Model: Karen Blaschek/Royal Model Management

Special acknowledgments to:
Ad-Tech™, Hampton, NH (Crafty Magic Melt Low Temp Bonder glue gun)
Aleene's Div. of Artis, Inc., Buellton, CA (all tacky glue; Right On-gloss for Welcome Wreath)

American Oak Preserving Co., Inc., North Judson, IN (glittered galaxy gyp for Paper Twist Baby Shower Wreath; rosebuds, German statice for Dried Floral Heart Swag; Spanish moss, statice sinuata, yarrow, cockscomb blossoms, globe amaranth, caspia, straw flowers for Candle Ring of Dried Flowers; Spanish moss, caspia, birch branches for Pastel Spring Wreath; cedar, boxwood, spruce, yarrow for Williamsburg-Inspired Christmas Swag)
Bleyer Industries, Inc., Valley Stream, NY (easter grass for Easter Bunny Wreath)
Cappel's Inc., Cincinnati, OH (other craft supplies)
DecoArt™, Stanford, KY (acrylic paint for Welcome Wreath; Snow-Tex™ Textural Medium for Musical Holiday Wreath)
Design Master® Color Tool, Inc., Boulder, CO (Super Surface Sealer for Herb Pinwheel Wreath and Candle Ring of Dried Flowers; Glossy Wood Tone Spray for Prize Recipe Wreath and Pine Cone Wreath; metallic spray for Victorian Wreath and Pine Cone Wreath)
Fibre-Craft® Materials Corp., Niles, IL (straw wreaths, floral pins, wire, floral tape, floral picks for most projects; cloth flowers, nylon butterflies, abaca baskets, chicks, doll hats, eggs for Easter Bunny Wreath; broom for Prize Recipe Wreath; strung beads, plastic instruments, red berries for Musical Holiday Wreath; cardinals, berries for Pine Cone Wreath; foam heart, pearl beadstring, cloth rose leaves for Simply Elegant Lace Heart Wreath)
Lion Ribbon Co., Inc., Secausus, NJ (ribbon for Candy Heart, Braided Bread Dough, Cinnamon Apple, Autumn Glow, Southwest Chili Pepper, Musical Holiday, Pine Cone, Simply Elegant Lace Heart, Pastel Spring wreaths, Dried Floral Heart Swag)
MPR Associates, Inc., High Point, NC (paper twist for Prize Recipe Wreath, Fruit & Ivy Country Wreath, Back-To-School Wreath)
Natures Medley, Charlotte, NC (potpourri for Potpourri Heart Wreath)
C.M. Offray & Son, Inc., Chester, NJ (ribbon for Batty Hattie Witch Wreath, Easter Bunny Wreath, Victorian Wreath, Fruit & Ivy Country Wreath)
Plaid Enterprises, Norcross, GA (Treasure Crystal Cote for Braided Bread Dough Wreath; paper twist for Paper Twist Baby Shower Wreath)
St. Louis Trimming, Inc., St. Louis, MO (ruffled lace for Simply Elegant Lace Heart Wreath)

CONTENTS

INTRODUCTION

For many of us, home decor is high on our list of priorities. Whether we have a house or an apartment, our ultimate goal is to create a pleasant, comfortable atmosphere for everyday living.

The visual impact you can add to each room in your home is at your fingertips, and what better place to start than by making your own handcrafted wreaths from the wide selection in this book? There are wreaths to choose from for every season, for most holidays, and for special occasions. Complete them for your use or give them as gifts; experience the satisfaction of having made them yourself.

As you leaf through these pages, notice the clearly photographed, step-by-step instructions that will help you to carry out each design. The introduction is packed with valuable information—from a descriptive list of tools and floral aids to selecting wreath bases and ribbon. Have you always wanted to make a pretty bow? Check out the section on bow making. There is even a segment on "Designing Tips." Spread your wings and develop your own original designs! With a little perseverance and lots of pride in your work, you will soon be creating your own beautiful wreaths.

TOOLS AND FLORAL AIDS

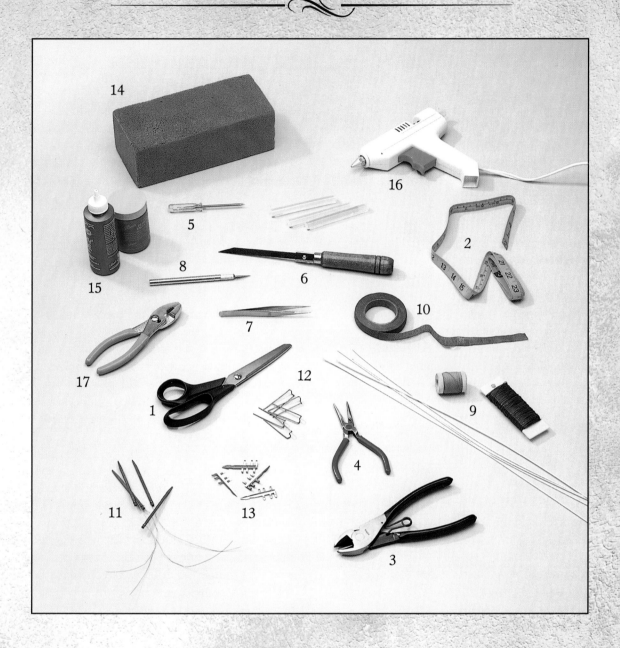

As you begin your wreath-making venture, there are basic tools and floral aids you should be familiar with. Some you may already own, while others you may have to buy.

1. **Scissors** should be sharp and are used mainly for cutting ribbon, fabric, and lace. Keep them handy; you'll reach for them often.

2. A **tape measure** will help you in countless ways, from measuring ribbon to determining the height or width of your design.

3. **Wire cutters** are used to cut wire stems, floral wire, and other objects that cannot be cut by scissors. They will also snip small branches and the stems of dried flowers. You could also use small **garden clippers** for many of the same jobs, though these may be needed for heavier jobs, such as cutting heavy branches.

4. **Needle-nosed pliers** are used to grasp materials that your fingers cannot. They are also helpful when twisting heavier gauge wire. This is an all-purpose tool.

5. An **awl** resembles an ice pick and can be used to make a hole in a straw wreath or into artificial fruit that requires the attachment of a wooden pick.

6. A **serrated knife**, or steak knife, is used to cut and shape floral and plastic foam.

7. **Tweezers** are occasionally needed to handle small items.

8. A **small craft knife** is not an essential tool, but it may come in handy. It can be used in place of scissors to cut materials, such as corrugated cardboard.

9. **Floral wire** comes in many gauges. The higher the gauge number, the finer the wire. Wire hangers can be fashioned from 16-gauge wire, while 18- and 20-gauge wire are used to strengthen flower stems. The finer gauges, from 28 to 32 gauge, can be used for making bows.

Wire is sold in 12" and 18" straight lengths as well as on spools and paddles. If it is to be used for stems, straight lengths are best. Wrap the finer spool or paddle wire around preserved or dried materials when attaching them to a wreath or garland.

Cloth-covered wire is available in several colors and gauges and serves many purposes. When securing the gathers of a bow, 30- or 32-gauge wire that matches the ribbon is easily camouflaged. This wire comes in one yard lengths and on spools.

10. **Floral tape** is a waxy crepe paper that will stick only to itself when stretched. It is available in many colors. Choose the shade closest to the materials you are working with, you may need several different colors, and use it to cover stems and to reinforce wired floral picks.

11. **Wired floral picks** are made of wood and come in several lengths. Use them to reinforce or lengthen stems that are to be inserted in floral and plastic foam or into a straw wreath.

12. **Greening** or **fern pins** are *U*-shaped pins. They are also known as **pole, craft,** or **floral pins.** Use them to attach materials to foam or straw wreaths. We have called them floral pins throughout this book.

13. **Steel floral picks,** made for a florist's pick machine, can be used manually by attaching the pick to the flower stem and squeezing the prongs around the stem with pliers.

14. **Dry floral foam,** made specifically for dried or silk flowers, is strong enough to hold the stems yet soft enough to allow penetration without wire or pick reinforcement. Do not confuse it with wet floral foam, which is designed to absorb water while keeping fresh flowers alive. Although this latter type may work for some florals, it usually crumbles and the materials will loosen and can fall out.

15. **Craft glue** ranges in consistency from thick to thin. You usually have to wait between steps for the glue to dry. Always have some on hand and select those that dry clear.

16. **Glue guns** are one of the most timesaving of all craft tools. There are guns for hot glue, low temperature glue, and those that dispense either type at the flip of a switch. There is no need to wait between steps because the glue sets up in seconds. NOTE: *When selecting a gun that requires its own special glue, be sure you have a source for the purchase of additional glue.*

Hot glue guns melt glue at up to 380° and can cause severe burns. They are not recommended for use by children, but they are useful. If used correctly, their advantages far outweigh this one disadvantage.

Low temperature glue guns dispense glue at a much lower temperature. The chances of being burned are slim. Avoid hanging your wreath outdoors where the hot sun could melt the glue, which would loosen the materials. Low temperature glue is ideal for indoor use, and you can glue plastic and floral foam without melting it.

Regardless of which glue gun you use, work quickly once you've applied the melted glue. The glue looses its adhesiveness as it cools. Hold the glued object in place for a few seconds while the glue cools and adheres. Fine webs of glue will hang from your completed wreath. Remove them with tweezers from fragile dried materials. From sturdy materials, such as pine cone wreaths, a hand-held hair dryer will melt them away.

17. **Pliers** are used to manually attach steel floral picks to dried stems.

WREATH BASES

Now that you have gathered your tools, you are ready to select materials to complete the design. Choosing the wreath base will be one decision to make. When determining the size, remember that the larger the base, the more materials and time will be required to complete it. Also keep proportion in mind. Large flowers, for example, are not appropriate when placed on a tiny wreath and small items may be lost on a large wreath.

The choice of wreath bases is endless, and each type offers a variety of shapes. From round, to hearts, to basket-shaped, to arches, these bases will often dictate the type of design. **Straw wreaths** and those made of **grapevines** or **twigs** are attractive, and when left partially exposed will add to the design. Conversely, **plastic foam** and **wire bases** must be completely concealed, which requires an all-over design and more materials. In addition to those mentioned, **excelsior** and **willow wreaths** are also exciting options.

RIBBON

Ribbon plays an important role in wreath design. When selecting it for your project, consideration should be given to the theme and style of the wreath. An informal wreath should sport a casual ribbon, while a more sophisticated wreath will be enhanced by something elegant. Choose colors and styles to complement your home decor.

Ribbons are sold in many widths, and using more than one width of coordinated ribbons on the same wreath will add a lovely accent. Ribbons range from velvet and polyester to cotton and satin. For elegance, there are metallics and laces. Wire-edge ribbons allow you to shape your bows in a unique fashion. The versatility of paper ribbon, both twisted and flat, is astounding. New and exciting paper products are constantly being introduced. With all of these choices, it becomes a challenge to select your favorite. Let your imagination lead you!

NATURAL MATERIALS

There are countless varieties of natural materials on the market that will highlight a wreath or become a major part of the design. A Christmas wreath may be highlighted with cones, while an herb wreath is made up of preserved or dried naturals. Materials that are air dried or dried with a desiccant, such as silica gel, are more brittle and will shed. There are spray sealers available to help preserve their natural beauty. Materials preserved with glycerine are soft and pliable and remain so indefinitely.

The texture and beauty of mosses should not be overlooked. Whether you cover the entire wreath or glue tiny accent pieces at random, the design is enhanced by its use. Spanish moss, found hanging from trees in the southern U.S. and in tropical America, is a light feathery gray moss commonly used in making wreaths. Commercially processed, it is free of insects. Lovely green mosses, such as

sheet moss and spaghnum, will add texture and color to your wreath. Another option is a commercially made thin plastic sheet that is flocked with a layer of fine green moss. It is pliable, easy to work with, and lends itself well to small florals.

Don't forget the versatility of cones and pods, whether you make an entire wreath of them or use them as embellishments. Acorns, magnolia pods, sweet gum balls, casuarina pods, and cones of every size and description grow in the wild. If you choose to collect your own, it is best to get permission from the property owner. Be aware that it is illegal to gather wild materials on some public lands. After collecting your items, bake them in a 150° oven for no more than one hour, which eliminates insects and eggs. Avoid overbaking. If properly stored, cones and pods will last indefinitely.

HOW-TO FLORAL PROCEDURES

This section explains how to perform several of the steps necessary to complete designs in this book.

HANGING A WREATH

Chenille stem or **pipe cleaner hanger:** Use only on wreaths covered with materials that will conceal this hanger. Bend a 12" length evenly into a *U*. Twist the *U* end into a 1" or 2" oval loop. Wrap and twist the ends around the wreath tightly, positioning the loop at the top. VARIATION: Use the same technique to wrap the chenille stem tightly around a wire ring or grapevine wreath, far enough down on the back so it is not visible from the front. You can also use this technique with wired paper twist.

Wire-loop hanger: Use only on straw or plastic foam wreaths. Bend 6" of heavy floral wire into a *U*. Twist the *U* end into a 1" oval loop. Bend the cut ends at right angles to the loop and push them into the foam or straw until the loop is flush with the wreath. Secure to the wreath with hot glue placed on the twisted end of the hanger.

FLORAL TAPE

Floral tape will stick only to itself when stretched. To apply it, either break off a length or hook the roll of tape over your little finger. Stretch and wrap it around the stem diagonally. Overlap the tape, allowing it to stick to itself, and break it off at the end.

FLORAL PICKS

Use wired floral picks to lengthen or strengthen weak stems when inserting them into plastic foam, floral foam, or straw. Attach them by overlapping the wired end of the pick with about 1" of the stem end. Spiral wrap the wire tightly around both, working down one inch. Continue wrapping one time around the pick itself, and then back up with the rest of the wire. This helps lock the two together.

As reinforcement, stretch and wrap floral tape on the wired area only. To tape the entire pick may cause friction when inserting it into foam or straw.

LOCK-WRAP STEMS

This method is used to lengthen and reinforce stems while locking the wire and stem together. Wrap about 1" of the stem tightly with floral tape. Lay the floral wire parallel to the stem with the top of the wire even with the top of the wrapped tape. Leaving the top of the wire exposed, wrap the wire and stem together for several inches with tape. Break the tape. With needle-nosed pliers, bend the wire at the top of the stem down flush against the taped stem. Wrap the entire stem with tape, from the bent wire to the bottom.

COVERING A STRAW OR PLASTIC FOAM WREATH

When using Spanish moss: Loosen the Spanish moss and discard tiny twigs. Spread moss evenly on all sides of the wreath and secure with floral pins. Wrap clear monofilament (fishing) line or matching thread around the moss to keep it intact. As you begin wrapping, tie a knot, leaving a 12" length of line hanging. Continue to spiral the long end and use the 12" length to tie off both ends when you finish. With scissors, cut the excess line and trim the stray ends of moss neatly. NOTE: *This same procedure can be used to cover a wreath with Easter grass, excelsior, or similar materials.*

MAKING BOWS

There are many ways to make bows, and the more you make, the easier it becomes. We have given you a number of choices. Follow the instructions, and before long you will be a pro.

To make your bows more professional, here are two ways to cut ribbon ends:

To V-cut ribbon, gently fold the ribbon ends in half lengthwise. Cut from the outside edge up 1½" toward the fold.

To angle-cut ribbon, cut the ends at an angle in either direction.

French bow from paper twist

1. With wire cutters, cut the twisted paper into four lengths: 21", 17", 13", and 6". Untwist the paper, but do not spread it to its full width. From the three largest lengths, make three individual circles by overlapping each 2" and hot gluing. In the same manner, make a knot from the 6" length by overlapping the ends 1", creating a small circle.

2. Stack and glue graduated loops on top of each other, ending with the knot on top (make sure seams are to back of bow). Crimp the centers as you glue. Use floral wire to tighten and hold bow together. To conceal the glued centers, you can insert a 5" strip of untwisted ribbon through the knot. Glue the ends together on the back.

3. To make a streamer, untwist a 14" length of paper twist. Crimp in the middle to form an inverted V. Secure to bow by twisting wire around crimped center of streamer. (If you are putting a bow directly onto a wreath, you can also secure the streamer to a wreath with a floral pin. Glue the bow over the streamer to conceal the pin.) You can V-cut or angle-cut the streamer ends.

INTRODUCTION

E-Z bow

1. This bow is added directly to a wreath. Cut the desired number of ribbon lengths to make the streamers. Angle- or V-cut streamer ends. Crimp the streamers in the middle and attach to the wreath with a floral pin.

2. Cut the desired number of ribbons to make individual clustered loops; angle- or V-cut the ends of each. To make one cluster, fold the end of one strip over 6" with wrong sides together. Crimp the ribbon midway at 3" and continue folding and crimping, making two loops and one end on each side. Place a floral pin over the crimped center and attach to the wreath above the streamer.

3. Place the individual clusters in a tight group. Fluff the loops to conceal the pins.

Multiloop bow

1. Crimp the ribbon between thumb and forefinger at the desired streamer length, with the streamer hanging down. Make an equal number of loops on each side of your thumb by crimping each individually while you guide the ribbon into a loop in a circular direction. Crimp each new loop next to the previous one, rather than on top. Secure the loops in the center with wire twisted tightly on the back, leaving the second streamer pointing up.

2. While holding the bow in the same position, roll 3" of that streamer toward you over your thumb, making a small center loop as a knot. If the ribbon has a right and wrong side, twist the loop right side out and catch the loop under your thumb. The streamer will again be pointing up. Bring one end of wire from the back over that streamer beside the knot and to the back again. Twist the wires. Bring the streamers beneath the bow and V- or angle-cut the ends.

Shoestring bow

This is an alternative to a hand-tied shoestring bow. To make a small bow, glue a toothpick or ⅛" wooden dowel vertically into a 2" x 4" x 2" tall scrap of plastic foam. Bring the ribbon ends around the dowel to the front. Tie the bow loops immediately, eliminating the first knot usually made when tying a shoe. Slip the bow off the dowel. Tighten and shape it. Angle-cut the streamer ends.

DESIGNING TIPS

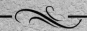

We have created these wreath designs for you and encourage you to duplicate them. We also urge you to develop your own designs. Here are a few suggestions to help stimulate your creativity:

Study wreaths in books, magazines, and even mail order catalogs; analyze those designs. Determine what you like, don't like, and why. Look at color combinations, and how ribbons and florals are arranged. Don't underestimate your own ability to evaluate design objectively. After a time, you will develop your own style that will grow and change as you become more experienced in creating your own wreaths.

As you study various wreaths, notice that your eyes may be drawn to an area of particular interest. It should be pleasing to look at, and it could convey the message of the theme. It is the "focal point" of that wreath. Not all wreaths must have a focal point, but those that do will draw the viewer's attention.

If you can't decide where to begin, start by choosing a theme—a special holiday or season of the year, perhaps. With the wide variety of ribbons available today, you might want to select a ribbon pattern that strikes your fancy. Pick up those ribbon colors in floral accessories for the wreath. Use the ribbon as a springboard for the rest of the design and let your creativity flow. You could take the same approach using flowers as your inspiration and build from there.

After you have chosen a theme and acquired your materials, sketch your design. But do not let your sketch prevent you from changing plans once you've begun. Allow yourself flexibility. An alternative is to attach the materials to the wreath temporarily with T-pins or floral pins, if the design is not too intricate. You may also loosely wire them on. Change the arrangement of materials until something suits you. Leave it for several hours or overnight. Then study it again as though you were seeing it for the first time. If you don't like something, change it. When satisfied, assemble the wreath permanently.

For the best perspective, always try to arrange your wreath in a hanging position. If that is not possible, view it upright between steps. Study it from a distance, or better yet, look at it in a mirror. If materials aren't balanced, appear overpowering, or are crowded, the reflection should tell you that.

If this is your first experience with making a wreath, you may not be aware of the infinite choice of accessories at your disposal. Visit your local floral and craft stores and acquaint yourself with the market. Here are a few suggestions:

There are colorful feathered birds as well as birdhouses, nests, and eggs that all fit in well with spring and summer themes, not to mention autumn and Christmas. In addition, holiday and seasonal ornaments could find a place in your designing. Wood shapes of animals, buildings, and words of greeting can become the focal point of your wreath. An assortment of brooms, hats, and baskets give personality to stuffed animals.

At home, you may already have a collection of old costume jewelry that could be the key to an exquisite wreath. Everyday items such as sewing notions, small toys, and stationery supplies can develop into a special theme. Whether they are fresh or artificial, fruits and vegetables form the basis of a savory culinary wreath. Tucked away in a closet or drawer may be the components for a unique wreath. Do you have cones or sea shells collected while on vacation? Perhaps the shells will inspire a nautical wreath. If you are a gardener, perhaps you have bright new gardening gloves to which you can add a terra cotta pot, a shiny trowel, and other related materials. If a design plan does not evolve immediately, do not be discouraged. Keep your goal in mind, and when you least expect it the idea could surface.

We have unlocked the gate leading to a new creative adventure for you, and you have stepped inside. Now, follow the path to develop your own personal style of design and enjoy your accomplishments.

HERB PINWHEEL WREATH

A classic wreath of fragrant dried herbs placed pinwheel fashion
creates a design of delicate beauty. A variety of herbs give delicate
color and scent to this wreath. Perhaps you could include some herbs
from your own garden. The natural beauty of this wreath will
enhance any area where it is displayed.

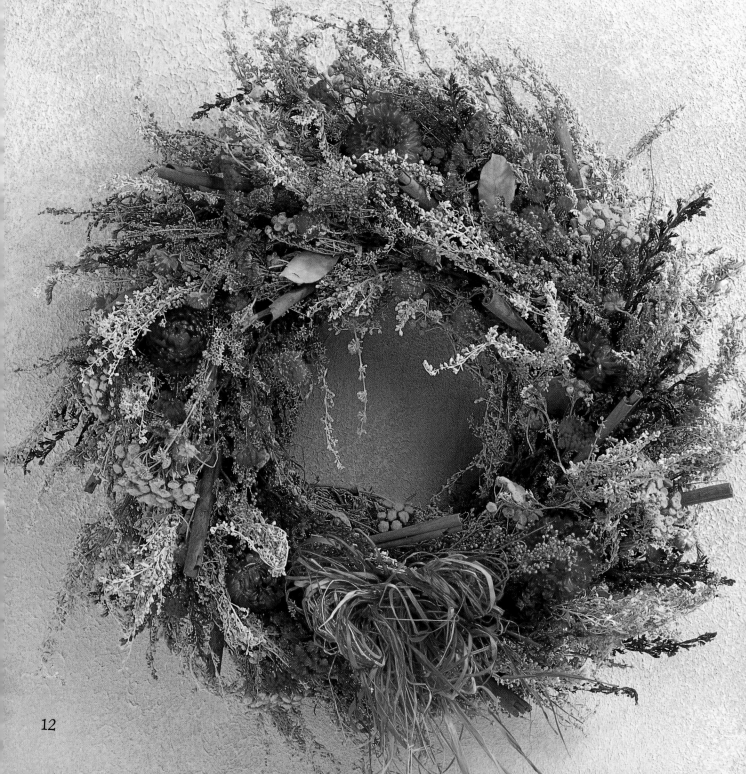

1. Lay straw wreath in bed of Spanish moss. Bring moss around wreath to cover. Secure moss with floral pins. Wrap gray carpet thread around wreath to hold moss in place. Use a piece of raffia to make a chenille stem hanger (see page 8).

2. Lay stem of small cluster of German statice on prongs of steel floral pick. Bend prongs around stems with pliers. Make 30 picks. (Note: Steel picks may be used in pick machine if you have one.) Pick statice into wreath distributing evenly over wreath surface. Direct all materials in the same direction.

3. Repeat process for 30 7" to 8" long clusters of artemisia.

Materials

- 10" straw wreath
- Spanish moss, approx. ½ lb.
- floral pins
- gray carpet thread
- German statice, approx. 30 clusters (6" long)
- steel floral picks
- pliers
- artemisia, approx. 30 clusters (7" to 8" long)
- tacky glue
- 1 pkg. dried pennyroyal
- 1 bunch dried sweet Anne
- 1 bunch dried heather
- 10 to 12 cinnamon sticks (6" long)
- 1 bunch tansy
- 1 pkg. dried globe amaranth, purple
- dried bay leaves
- statice sinuata, purple
- straw flowers, burgundy
- burgundy and mauve raffia
- surface sealer

4. Dip stems of all other materials into tacky glue and place into wreath. Place pennyroyal, sweet Anne, heather, and cinnamon sticks first. Then place tansy, globe amaranth, bay leaves, statice sinuata, and straw flowers.

5. Shred 3 or 4 strands of both burgundy and mauve raffia with a straight pin. Form shredded raffia into bow shape (6" wide, with 6" streamers) and tie in center with a strand of raffia. Slip floral pin through center of raffia strand, dip end of pin into glue, then push into bottom of wreath. Spray wreath with surface sealer to protect dried materials from shattering.

CANDY HEART WREATH

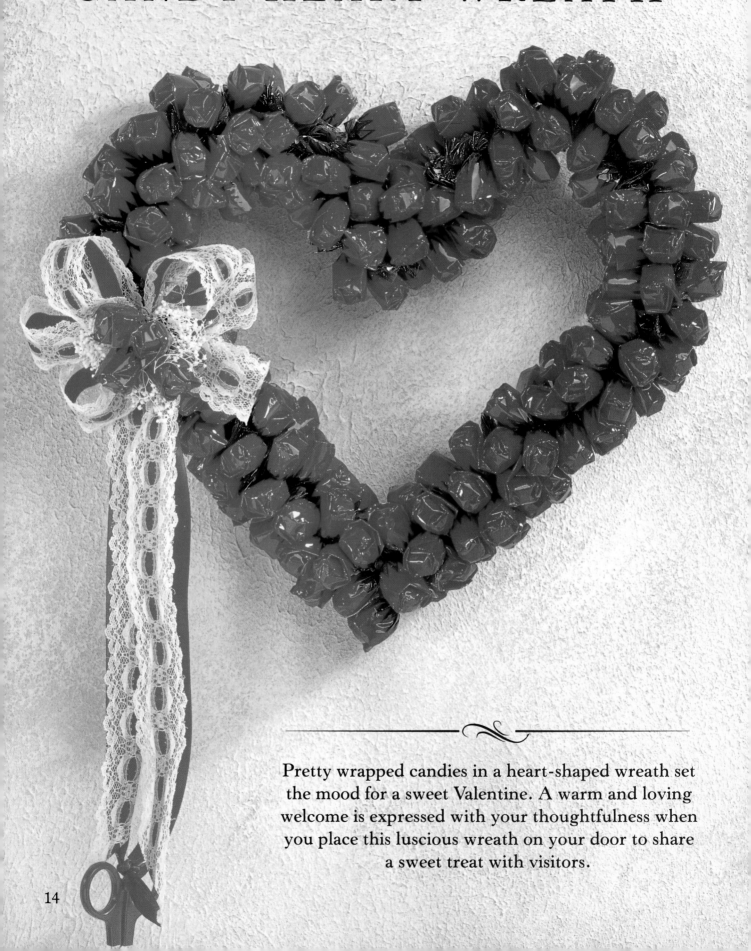

Pretty wrapped candies in a heart-shaped wreath set the mood for a sweet Valentine. A warm and loving welcome is expressed with your thoughtfulness when you place this luscious wreath on your door to share a sweet treat with visitors.

Materials

- 1 strong wire coat hanger (Do not use lightweight shirt hangers)
- 4 lbs. (approx.) of wrapped hard candy
- 28-gauge spool wire
- wire cutters
- 1⅓ yards red satin ribbon
- 1½ yards white lace with red satin ribbon
- scissors
- 1 child's scissors
- glue gun and glue sticks
- bleached, preserved galaxy gypsophila (gyp), 3 or 4 sprigs

1. Shape coat hanger into circle, working out kinks in the wire. Bend down hanger to form deep indent in heart and form point on bottom of circle to form bottom of heart. Bend down hook and form hanger with pliers.

2. Wrap spool wire around one end of wrapped candy several times, pulling wire very tight. Repeat for several more pieces of candy, spacing candy about 1" to 2" apart. Wrap end of wire around heart to secure, then wrap wire with candy around heart. Keep adding candy and wrapping until heart is filled with candy. Pull wire tight and twist ends together.

3. Cut off 12" of satin ribbon and tie around indent of heart. Work ribbon into candy so that it doesn't show. This will keep the indent from giving under weight of candy.

4. Using lace ribbon, make 6 loop bow with no center loop (5" wide, with 12" streamers). Attach one yard of red satin ribbon to back of bow with bow wire. Apply glue to the back of bow and place bow to left side of wreath, bringing bow wire to back of wreath. Pull wire tight and twist ends together. Trim excess wire. Tie scissors onto satin ribbon (make sure satin ribbon is long enough to reach other side of heart).

5. Cluster together 5 pieces of candy with wire. Pull wire tight and twist together to secure. Place glue into center of bow and rest candy cluster into glue, bring wire ends to back of wreath. Twist ends together and trim excess wire. Apply glue to stems of sprigs of gyp and place into candy cluster.

PAPER TWIST BABY
SHOWER WREATH

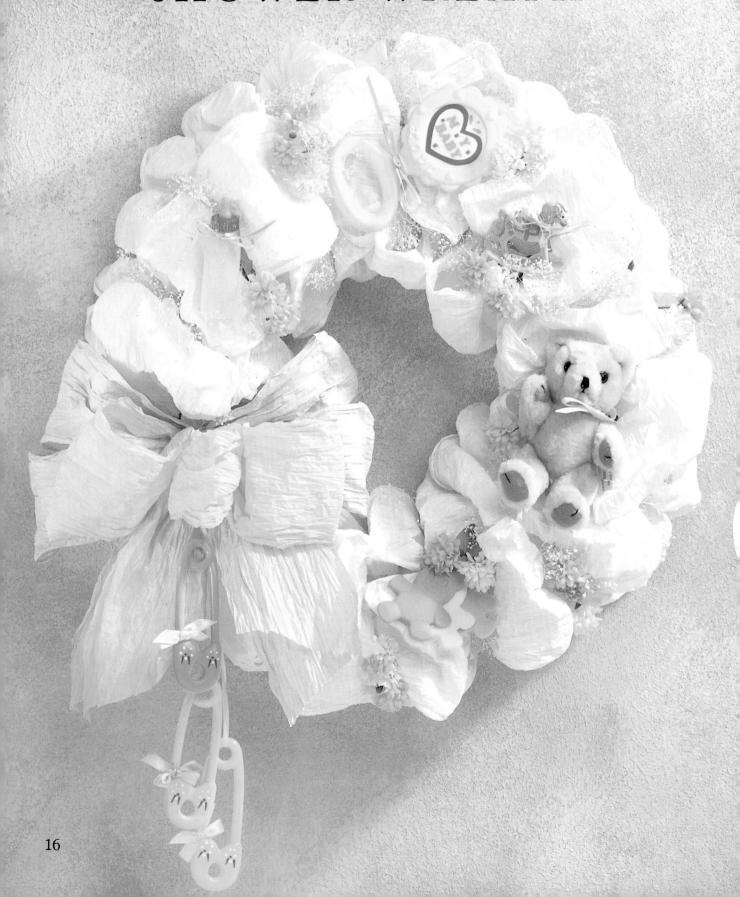

Puffs of white paper twist give a billowy, cloudlike appearance and provide a soft background for baby trinkets and toys. A soft bow of blue and pink paper twist and a cascade of colored plastic safety pin rattles complement the wreath. A lovely decoration for a shower, which can then be given to the mother-to-be for the nursery.

1. Make a chenille stem hanger (see page 8). Untwist all paper twist. Beginning on outside edge of wreath, pin end of white twist to wreath with floral pin. Loop about 6" length of twist and pin into wreath again about 2" from starting point. Continue around outside edge. Then repeat same process for top and inside edge of wreath.

2. Using blue paper twist, make 4 loop bow (10" wide, with 10" streamers). Add 2 loop pink bow in center of blue bow. Tie ribbons to plastic safety pins of corresponding color. Arrange ribbons so safety pins fall at staggered lengths. Attach ribbons to bow wire in back of bow. Wire bow to left side of wreath.

3. Wrap wire around neck of teddy bear, dip ends of wire into glue and insert into foam. (Change ribbon color around teddy's neck to pink.)

4. Dip stems of mini mums into glue and insert stems into foam, clustering several together. Dip stems of glittered gyp into glue and insert into wreath.

5. Attach wire to each baby toy and glue into foam. Add pink or blue ⅛" bow to each toy if desired.

Materials

- 14" extruded foam wreath
- white chenille stem for hanger
- 12 yards 7½" white paper twist
- floral pins
- 1½ yards 4" blue paper twist
- 1½ yards 4" pink paper twist
- ⅛" satin ribbon: ½ yard blue and yellow, 2 yards pink
- scissors
- 3 safety pin rattles
- 6" plush teddy bear
- 18-gauge white covered wire
- wire cutters
- tacky glue
- silk mini mums (8 each of pink, blue, yellow)
- preserved, bleached, glittered galaxy gypsophila (gyp)
- assorted baby toys

DRIED FLORAL HEART SWAG

Velvet ribbon forms the base for this lovely dried swag, accented with tiny twig hearts, German statice, and rosebuds. Wire-edge metallic gold ribbon shapes the perky bows that blend with the brass ring hanger. Try changing the color of the ribbon and rosebuds to match your home decor!

Materials

- 1 yard red velvet craft ribbon, 2½" wide
- 1 yard white scalloped edge lace ribbon, 1½" wide
- tape measure
- scissors
- glue gun and glue sticks
- 29" of ⅛" wooden dowel
- tacky glue
- toothpick
- wire cutters
- 2" diameter gold ring
- three 4" twig hearts
- approx. 26 natural German statice sprigs
- 5 dried red rosebuds
- 2 yards wire-edge metallic gold ribbon, ⅝" wide

1. Cut 30" length from both red velvet and lace ribbon. Glue lace ribbon centered on plush side of the velvet ribbon; use hot glue sparingly. Trim ends of both ribbons evenly. Cut a *V* in bottom by gently folding ribbon in half lengthwise and cut at an angle, about 1½" toward the fold.

2. For stability, glue the wood dowel to the center back of the swag by spreading tacky glue on the dowel with a toothpick. Trim dowel to fit, using wire cutters. Fold top ends of swag back to form two triangles (meeting at dowel). Allow the glue to dry.

3. To make the hanger, cut a strip of velvet ribbon, ¼"×2¾". Put the ribbon through the brass ring and hot glue the ends together. Hot glue those ribbon ends to the dowel on the upper back, allowing only the ring to show from the front.

4. Hot glue three twig heart wreaths to the front of the swag: the first (upper) heart is 1" from the top; the second heart is 10" from the top; the third heart is 19" from the top. There will be 7" at the bottom of the ribbon.

5. At the lower points of each heart and extending up each side, hot glue a 2" to 3" sprig of statice with the stems converging at the point. Leave upper half of each heart uncovered. Glue shorter statice sprigs to fill in. Glue additional statice sprigs to the lace between all hearts and beneath the third heart to the bottom of the swag. Overlap each sprig to conceal the glued stems.

6. Hot glue three rosebuds in a cluster at the lower point of the second heart. Glue one rosebud to each point of the first and third hearts. Cut three 24" lengths of metallic ribbon; make three shoestring bows. Cut each streamer at an angle and gently curl each around your finger. Hot glue a bow to the statice about 2" below each heart.

Feature your cherished family recipe on this novel kitchen wreath as a reminder of fond memories. Accent it with wooden utensils and fruit.

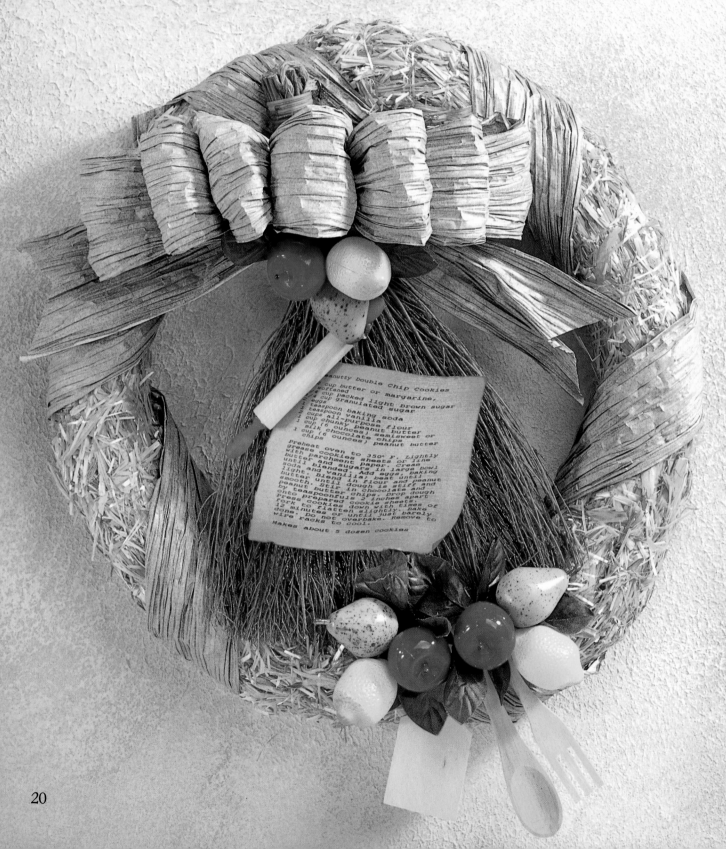

Materials

- 14" straw wreath
- wire cutters
- 6" 16-gauge wire
- glue gun and glue sticks
- scissors
- tape measure
- 3½ yards green paper twist
- 2 floral pins
- 12" flat pine or straw broom
- 1" diameter artificial fruit: 3 apples, 3 lemons, 3 pears (preferably on picks with green cloth leaves)
- 12 2" green cloth leaves, any variety (if not included with fruit)
- 3½" to 4½" miniature wooden utensils: fork, spoon, cutting board, rolling pin (or those of your choice)
- red acrylic paint
- small art brush
- 5" square cardboard
- 8½" × 11" sheet off-white stationery
- copy machine
- wood tone spray
- pencil

1. Following instructions on page 8, make a wire-loop hanger and glue it to the upper back of the wreath. With scissors, neatly trim the stray ends of straw from the wreath. With wire cutters, cut 62" of paper twist. Untwist but don't spread it to its full width. Spiral it evenly around the wreath, bring the ends together on the back and secure with a floral pin. Glue the broom handle to the wreath at the top, just left of center so it falls diagonally.

2. Make a French bow from the remaining paper twist (see page 9). Glue it to the handle to fall horizontally on the wreath. If the fruit is wired, cut the wires off and glue a cluster of four leaves and three different fruits under the bow in the center just below the handle. Glue the remaining leaves and fruit in a cluster centered at the base of the broom, leaving room to attach the wooden utensils. Glue three different utensils in a fan shape to the wreath below the fruit cluster.

3. Paint the rolling pin handles red and allow to dry. To determine the size to make your recipe, measure the space left on the front of the broom. On the wreath pictured, a recipe 4" × 4¾" was used. Cut a piece of cardboard as a guide. On a copy machine and on copy paper, reduce the recipe to fit within your cardboard boundary, then copy the recipe onto stationery. Place cardboard pattern on the back of the stationery, centering it behind the recipe. Draw around the cardboard on the back. Use those lines to fold and tear a jagged edge.

4. In a well-ventilated area, lightly spray both sides of the recipe with the spray. Curl and glue the upper left corner forward over the rolling pin. Roll the lower right corner forward over a pencil. Remove the pencil and glue the rolled paper in place. Glue the rolled corners of the recipe to the broom, arranging a ripple across the paper.

21

WELCOME WREATH

A grapevine wreath is lovely to display outdoors. A friendly welcome
is conveyed by the wild flower and ivy arrangement.

1. Using wired paper twist, attach hanger (see page 8). Wrap two lengths of wired paper twist across bottom half of wreath, twisting ends in back. Loosely weave twist in and out of these and wreath branches to form a loose basket.

2. Line basket with layer of Spanish moss. Place brick foam into moss in basket. Run length of wired paper twist through bottom of basket and bring around foam to secure foam into basket. Cover top of foam with Spanish moss and secure with floral pins.

3. Dip stems of flowers into tacky glue before inserting into foam. Add English ivy into basket area. Cut sprays apart for better distribution. Use 3 sprays in basket and glue remaining ivy sprigs into vine around wreath. Place one spray of peach blossoms to left of center, with blossoms reaching the bottom edge of top of wreath. Divide second blossom spray and place one sprig left and one cascading down from left of center. Place azaleas in center. Pink blush rosebuds are clustered to right of center and mini bright pink rosebuds and baby breath are used to fill arrangement.

Materials

- 20" grapevine wreath
- 6 yards wired paper twist, natural
- wire cutters
- Spanish moss
- 1 brick dry floral foam
- floral pins
- tacky glue
- 5 silk English ivy sprays, 24" long, 3 branches each
- 3 silk blossom sprays, peach
- 2 silk azalea sprays, 6 blossoms, medium yellow
- 3 silk dried-look rosebuds, pink blush
- 2 silk dried-look mini rosebud sprays, deep pink
- 2 silk dried-look baby breath sprays, candlelight
- blue feather butterfly, 3½"
- 2 yards floral chintz ribbon
- 28-gauge white-covered wire
- 3" wood floral pick
- 1 wooden welcome, 10" × 2"
- acrylic paint, buttermilk and light avocado
- ¼" paintbrush
- water base varnish

4. Place butterfly on wire stem right of center among rosebuds and azaleas. Make 6 loop bow from chintz ribbon (9" wide, with 8" streamers) and attach to 3" wood floral pick. Dip floral pick into glue and push into floral foam at center front of wreath.

5. Paint welcome sign with buttermilk acrylic paint (2 coats). When dry, dip brush into water then into light avocado paint. Brush paint across welcome sign and immediately wipe away excess paint for an antiqued look. Let dry, then give several coats of water base varnish. Glue sign to top of wreath. (It may be necessary to wire sign to wreath.)

EASTER BUNNY WREATH

This whimsical wreath renews our fond childhood memories of that busy little rabbit who accomplished a monumental task while we slept. Delight the youngsters in your life by covering a straw wreath with Easter grass; add a bunny and Easter ornaments.

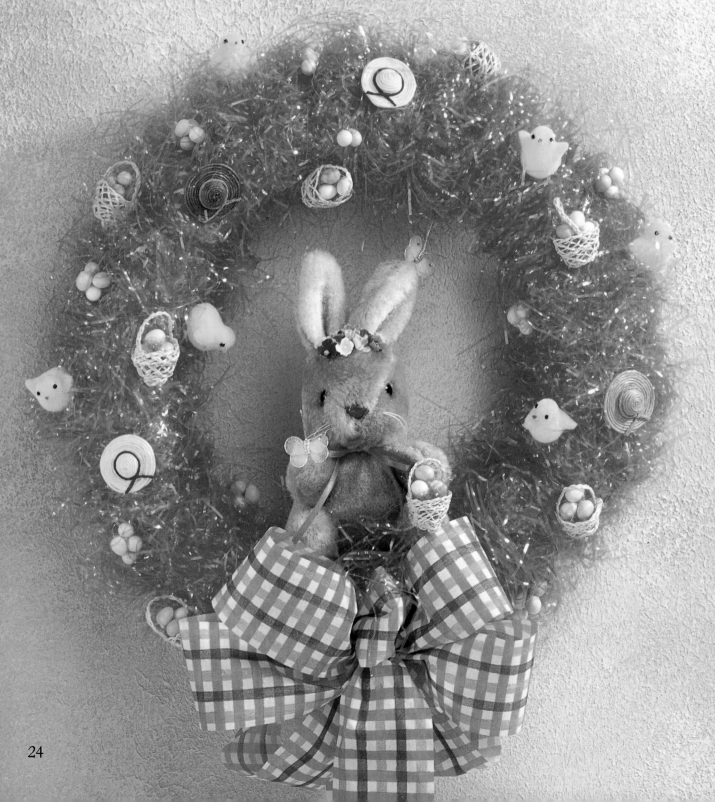

1. Make a wire loop hanger (see page 8). Cut a small section from the plastic wrap on the upper back of the wreath and glue on the hanger. Leave the remaining plastic wrap intact. Cover the wreath with Easter grass, attach with floral pins, and wrap with fishing line. Make a multiloop bow (see page 10) measuring 8" across, with 9" and 10" streamers. Glue bow to the bottom middle of the wreath.

2. Glue 12 cloth flowers in a cluster to the rabbit's head in front of her ears. Tie a shoestring bow and glue it under her chin. Glue a butterfly to her left ear and right front paw.

3. Cut a wooden dowel (with wire cutters) the height of the rabbit's head and body plus 2". Glue the dowel vertically to the back of the head and body with the 2" extending beneath the body. If necessary, use an awl to ream a hole in the straw above the bow. Push the dowel into the straw at the center bottom of the wreath.

4. To make an Easter basket of eggs, wad a small amount of leftover Easter grass and glue it inside the basket. Trim the stray grass. Apply glue to the basket and grass and embed four eggs into the glue. Glue the basket to the rabbit's left front paw. Make six more Easter baskets of eggs and glue them to the wreath at various angles. Make certain to glue some to the outside edges and also the inside edge near the rabbit.

5. Glue the chicks and hats, evenly distributing the variety and colors. Place a small puddle of glue in the grass and embed a cluster of five eggs into the glue. Glue seven egg clusters evenly around the wreath.

Materials

- 14" plastic wrapped straw wreath
- 6" 16-gauge wire
- wire cutters
- glue gun and glue sticks
- 4 oz. pink Easter grass
- 30 floral pins
- scissors
- 8 yards clear monofilament fishing line or pink thread
- tape measure
- 2⅓ yards cotton print ribbon
- 6" 32-gauge white cloth-covered wire
- 7" plush stuffed sitting rabbit
- 12 2" cloth flowers
- 2 1" yellow nylon butterflies
- 12" ⅛" rose ribbon
- 1/16" wood dowel
- awl
- 7 1¾" abaca baskets
- 63 ½" pastel Easter eggs
- 6 1¼" flocked yellow chicks
- 4 1¼" assorted doll hats

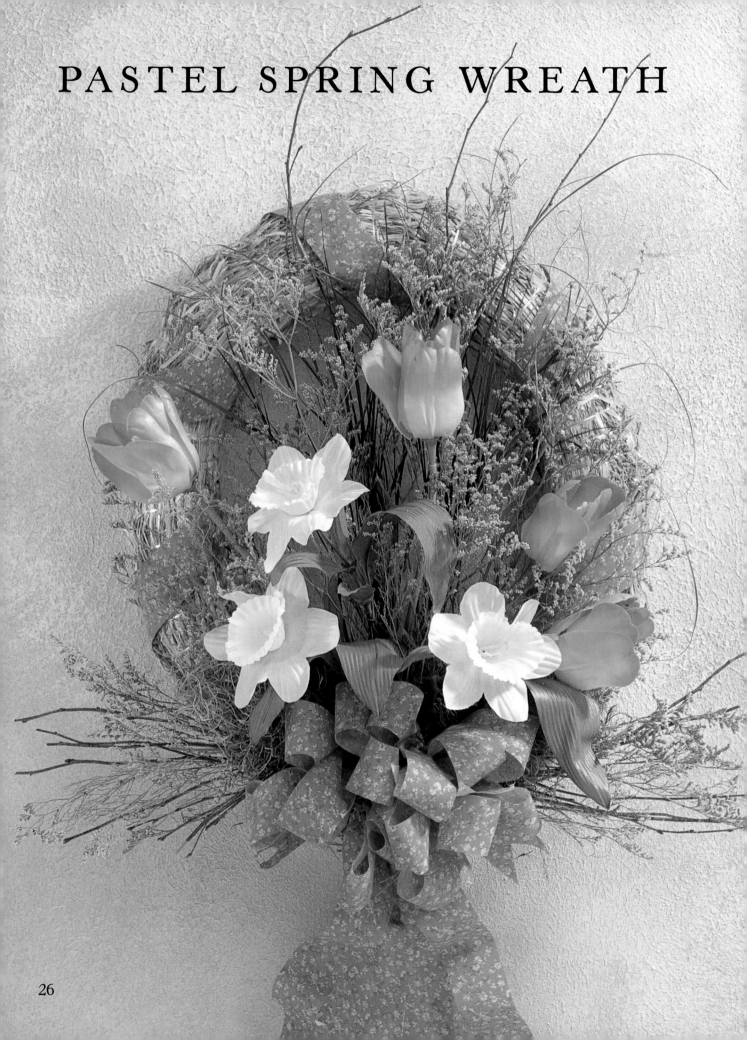

Announce the coming of spring with this carefree wreath of tulips and daffodils. Dried caspia, birch branches, and isolepsis grass create an airy backdrop for the soft pastel flowers. Silk tulips come in many shades—change the color to match your decor.

Materials

- 14" round straw wreath
- wire cutters
- 6" 16-gauge wire
- glue gun and glue sticks
- scissors
- tape measure
- 14 floral pins
- 8 yards rose cotton print ribbon
- 20 2½" wired floral picks
- green floral tape
- needle-nosed pliers
- awl
- 2 clusters green isolepsis grass
- 20 18" fine tips of birch branches (with several attached to a main branch)
- 7 14" branches of natural dried caspia
- silk flowers with leaves on 12" stems: 4 rose or pink tulips, 3 white daffodils
- sundrop yellow spray paint (optional)
- 1 oz. Spanish moss

1. Make a wire-loop hanger (see page 8); glue it to the top back of wreath. Trim stray straw ends from wreath. Spiral about 2 yards of ribbon evenly around the wreath, bringing the ends together on the back with a floral pin. Leave the bottom center of wreath free of ribbon to insert florals.

2. Attach floral picks to materials (see page 8) as needed. When inserting florals, angle stems to converge at bottom. With needle-nosed pliers, grasp the pick and insert isolepsis grass in the center, extreme back of the wreath. If necessary, use an awl to make a hole in the straw. Separate blades of grass to fall in a fan.

3. Insert three tall birch branches with fine tips around the grass in a fan shape, permitting some wispy tips to extend 6" to 8" above the wreath. Use wire cutters to clip the branches when necessary. Attach three stems of caspia in a fan shape, one in the center extending 14" from stem to tip and two on each side 12" tall.

4. When attaching tulips to picks, measure from cut stem end to tip as follows: two 10", one 8", and one 6". Remove tulip leaves and reserve. With needle-nosed pliers and an awl, insert one 10" tulip vertically in line with top of wreath. Angle the remaining 10" tulip to fall to the left of the top. Angle the 8" tulip toward the right side, and the 6" farther toward the right.

5. Attach picks to 9", 6", and 5" daffodils. Leave the daffodil leaves attached but slide them up the stem toward the blossom. If desired, spray the flower centers with sundrop yellow. Insert the daffodils in a cluster at various levels.

6. Attach picks to three leaves and insert around the daffodils to cascade over the edge. Glue stems of caspia to fill in spaces among the flowers, keeping within the shape of the wreath.

7. Cut four 33" ribbons for bows. Cut two 24" and one 30" streamers. Crimp streamers in the middle. Place the 24" ones on top of the 30" one. Attach them to bottom of wreath with a floral pin. Position them in a fan shape with the longest in the center and the shorter ones on the outside.

8. Cut a *V* on the ends of the streamers at different levels. Spot glue streamers to the adjoining streamer as close to the wreath as possible. Ripple the two outside streamers by spot gluing each to the adjoining streamer twice. Make an E-Z bow with remaining ribbon (see page 10), making four separate loop clusters.

9. Glue about six fine birch tips behind the bow on each side, to extend 7" to 9" horizontally from bow's center. Glue caspia stems over the birch, filling in with shorter sprigs of caspia.

10. Loosen Spanish moss and lightly pack around the bow to conceal the glued branches; attach moss with floral pins.

POTPOURRI HEART WREATH

Fragrant fabric hearts trimmed with lace, ribbons, and flowers are pinned onto a lace covered wreath base. This versatile wreath is embellished with a lovely silk flower nosegay and a loopy lace bow. The hearts may be removed and given to guests as a bridal shower favor or for afternoon bridge favors. Make an extra set of hearts and give the wreath to the bride-to-be for her new home.

Materials

- flat foam wreath, 12" × 1½" × 1"
- 5 yards French blue moire ribbon
- glue, either cool temp glue gun and clear sticks or tacky glue
- scissors
- 8 yards 3" wide eggshell lace ribbon
- 28-gauge white-covered wire
- wire cutters
- hand stapler and staples
- tracing paper and pencil
- ¼ yard small pink and blue floral print fabric
- sewing machine or needle and thread
- potpourri
- 3 yards ½" wide eggshell lace
- 8 round head pearl corsage pins, 2" long
- small silk flower cluster approx. 5" diameter in shades to match fabric
- green floral tape
- ⅛" satin ribbon, 3 yards French blue and 1¼ yards rose mauve
- 8 small pink silk flowers

1. Using 5 yards of moire ribbon, wrap wreath and secure ends of ribbon with glue. Wrap 3 yards of lace ribbon over moire ribbon. Secure ends with glue. Make wreath hanger from 8" of wire (see page 8); attach to wreath.

2. Using 2 yards of lace ribbon, make ½" pleats and staple. Space pleats approximately an inch apart. Attach pleated ribbon to back edge of wreath with glue.

Potpourri heart pattern

cut 8 on
doubled fabric

Leave open to allow filling with potpourri

Stitch on dotted line

3. Use remaining lace ribbon to make 6 loop bow (about 9" wide, with 8" streamers). No center loop is added to this bow. Attach bow to wreath with glue.

4. Trace heart pattern onto tracing paper with pencil. Cut out and use heart as a pattern piece. Double fabric and cut out 8 hearts.

5. With wrong sides together, stitch around heart ½" from edge; leave 2" unstitched. Fill hearts with 1½ to 2 tablespoons of potpourri. Stitch heart closed and trim edges ¼" from stitching. Glue lace ruffle on top of stitching on front side of heart. Make 8 hearts.

6. Place corsage pin through center of heart and pin to wreath.

7. Make 5" cluster of silk flowers and tape stems together with floral tape. Using 1¼ yards each of French blue and rose-mauve satin ribbon together, make 16 loop bow (4" wide, with 4" to 5" streamers). Wire bow to stem of flower cluster. Glue cluster to center of bow.

8. Make 8 small shoestring bows from blue satin ribbon. Glue small pink flower onto center of each bow. Glue a bow to each heart.

BRAIDED BREAD DOUGH WREATH

This is truly an easy wreath to make, though it looks like quite the chore! In fact, they are so easy you'll want to make some for your friends. A bread wreath is a homey decoration and reminds us of the mouth-watering aroma and warmth that fills the home when bread bakes in the oven.

1. Spray pizza pan with cooking spray, place frozen loaves on pan and allow to defrost and rise until double. Sprinkle flour on working surface, and stretch each loaf until it is 36" long. Lay pieces side by side and braid. Lay braided piece around inside edge of pan, overlapping ends slightly. Spray braid with cooking spray. Let rise until double.

2. Bake in oven, usually 350° for 25 to 30 minutes or until golden brown. Remove bread from oven, reduce temperature of oven to 150°. Let bread cool until you can handle it. Transfer it to a cooling rack and place into 150° oven and leave bread in oven with door ajar for 24 to 30 hours. Bread must be very hard and dry. Remove bread from oven and allow to cool.

3. Spread nonstick paper onto working surface. When wreath is cool, place on prepared surface and spray with clear acrylic sealer spray to seal the bread. Let dry. Elevate wreath so drips will fall on nonstick paper. Brush on one coat of high gloss finish, coating top of wreath, let dry, then coat bottom, watching for drips. Repeat coating. This step seals the wreath and protects it from moisture and mold. Let dry.

Materials

- 14" pizza pan
- cooking spray
- 1 pkg. of 3 frozen loaves of bread dough
- bread board or waxed paper
- flour
- oven
- cooling rack
- nonstick paper
- clear acrylic sealer spray, matte
- 2 bottles high gloss finish
- 1" soft bristled brush
- 28-gauge white covered wire
- 2 silk daisy sprays
- 8 sprigs black bearded wheat
- wire cutters
- ruler
- glue gun and glue sticks
- floral tape, green
- 1 yard wired paper twist, natural
- 3 yards blue check ribbon
- scissors

4. Cluster several daisy sprays together and add 4 wheat stalks. Wire stems together. Make two clusters. Each cluster should measure about 10". Overlap stems of flower clusters, with flowers pointing in opposite directions, and wire together. Cover wired area with floral tape. Apply glue to taped area of cluster and glue to wreath over joined section of bread.

5. Fold wired paper twist in half and twist together 1" from fold. Place loop in back of wreath and bring ends around to front over flower stems and twist together. This forms the hanger and also helps secure the flowers (see page 8). Make a 10 loop bow (8" wide, with 10" streamers). Glue bow over center of flowers. Drape streamers to sides and glue to wreath. If needed, glue several extra daisies and leaves above and below bow to cover hanger and bow wire.

SIMPLY ELEGANT
LACE HEART WREATH

Simple elegance describes this lovely wreath made from printed
ruffled lace. Embellish your treasure with pearls and flowers and
recreate the beauty of days gone by.

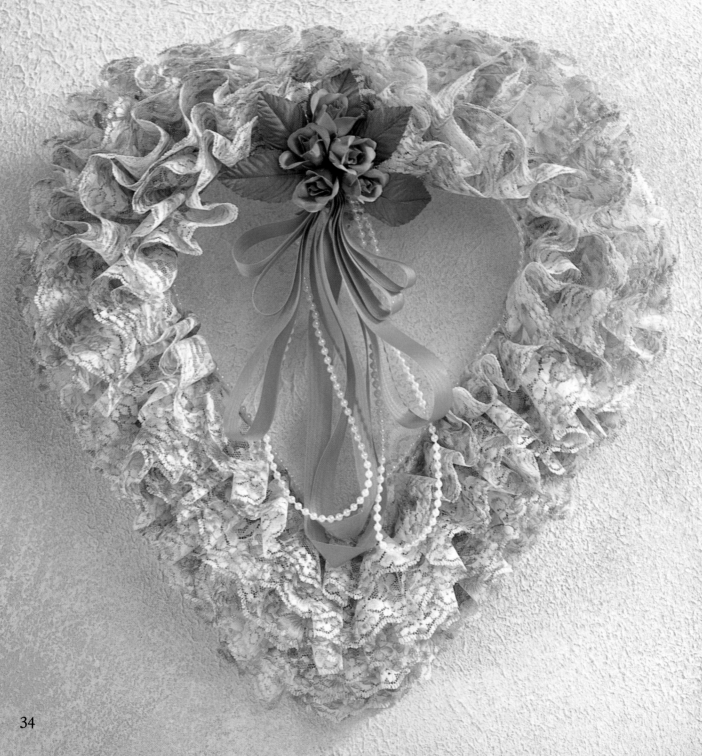

Materials

- 11" plastic foam heart
- wire cutters
- 6" 16-gauge wire
- glue gun and glue sticks
- pointed metal nail file
- tape measure
- 11 yards 2½" mauve/blue printed ruffled lace
- scissors
- 1 yard 1" white nylon ruffled lace trim
- 1⅔ yard string of 4mm white pearl beads
- 5 2" wired green cloth rose leaves
- green floral tape
- dressmaker's pin
- 2⅔ yards mauve moire ribbon
- 6" 32-gauge green cloth-covered wire
- 5 mauve silk rosebuds, ½"

1. Make a wire loop hanger (see page 8) and glue it to the upper back of the wreath. With the nail file point, push (tuck) the lace into the foam in six continuous rows. Make sure right side of lace is up. Begin with the outside row and go counterclockwise from the center top, leaving ½" of the foam on the back of the heart exposed. Move the file over 1", catch the lace in the point, back up ¼" and push the lace in until it is taut. Be sure not to pull the previous tuck out.

2. When you complete the first row at the center top, move over and continue in the same direction for the second row without cutting the lace. Tuck close to the first row to avoid gaps. In the same manner, complete a total of five rows, ending at the center top. Continue in the same direction for the sixth and final row on the inside center of the wreath. Position the row leaving ½" of foam on the back of the heart exposed as in Step 1. End the tucking at the center top of the heart by cutting the lace and leaving enough to make the final tuck at the center top *V*.

3. To conceal the visible foam in the center of the wreath, glue the 1" white lace overlapping the tucked lace about ¹⁄₁₆". Begin and end at the bottom point. View the wreath from all angles. If gaps between the rows reveal foam or if the lace doesn't fall properly, spot glue sparingly near the foam to hold the lace in place.

4. Glue one row of pearls on the inside center where the wide and narrow laces meet. Make them visible from the front. Stack five leaves evenly with right sides up. With floral tape, secure the stems together beginning ½" from the bottom of the leaves. Spread the leaves in a fan shape and glue to the center top. Push a dressmaker's pin through the leaf cluster while glue is still warm to secure cluster.

5. From the ribbon and remaining pearls, make a simple bow. Make two looped streamers and two bow loops on each side of center. Add the pearls in the same manner, making one looped strand on each side. Crimp the ribbon and pearls together in the center and tie with 32-gauge wire. Glue the wired portion at the base of the leaves. Glue a tight cluster of five rosebuds to the leaves above the bow.

BEAUTIFUL BRIDE
WREATH

Delicate silk flowers made into a head wreath with a gathered tulle veil create a vision of sweet innocence and delicate charm. The crowning glory of your wedding ensemble will add the touch of perfection to your special day. How can anything be so lovely, easy to make, and still be so inexpensive?

1. Measure one strand of wire (18 gauge) around bride's head. Overlap wire 2" and cut. Add 2 more strands of wire of the same length and wrap onto circle with white floral tape. Wrap 1 yard of satin ribbon around the circle, over the floral tape. Glue ends of ribbon to the ring.

2. Cut two 3" lengths of wire (28 gauge) and make two small loops. Add to sides of ring by twisting ends around ring (for bobby pins or comb). Hold wreath in both hands between the wire loops. Bend circle downward slightly. This will help the wreath conform to the shape of the head.

3. Place wreath base onto wig head form. (Note: You can also use an inverted mixing bowl.) Use several floral pins to hold the headpiece in place on the wig head form.

Materials

- 3 36" lengths 18-gauge white-covered wire or 6 18" lengths
- wire cutters
- white floral tape
- 1½ yards satin ribbon, eggshell
- glue gun and glue sticks
- scissors
- 28-gauge white-covered wire
- wig head form
- floral pins
- bleached, preserved galaxy gypsophila (gyp)
- 12 silk dried-look mini rosebuds, candlelight
- 1 silk gypsophila (gyp) blossom spray, candlelight
- 12 silk dried-look larkspur, soft white
- 1 silk dried-look hydrangea, blush
- eggshell tulle, 108" wide, desired length (optional)

4. Cut flowers apart, leaving 1" stems. Break gyp into short sprigs. Arrange flowers into separate piles. Beginning at the back of the wreath, put an inch strip of glue to wire and lay sprigs of gyp, rose bud, silk gyp blossoms, and hydrangea blossom. Repeat process until you work your way completely around wreath. You can add the veil in step 5 or stop here.

5. Lay out doubled veil material (measured for desired length) on cutting pad or cardboard. Using rotary cutter, cut away corner on open end of veil. Open up veil and stitch across straight edge of veil to gather. Pull gathers to desired fullness, cover top of veil with remaining eggshell ribbon, and stitch across to secure. Apply hot glue to underside of back of wreath. Lay gathered end of veil into glue and press firmly. (Note: If you get glue on veil, place it between two pieces of paper towel and press with iron. Glue will be absorbed into paper towel.)

SOUTHWESTERN
CHILI PEPPER WREATH

Add a little "zest" to your southwest kitchen decor with sprays of brilliant red chili peppers clustered on a straw wreath base. Raffia bows between the peppers and a multilooped paper-jute bow enhance this festive wreath.

Materials

- 14" straw wreath
- about 64 strands natural raffia (18" long)
- 2 strings of artificial red chili peppers or about 18 clusters (3 peppers per cluster)
- scissors
- tacky glue
- floral pins
- 28-gauge floral wire for bow
- 3 yards paper-jute ribbon

1. Using several strands of raffia, make chenille stem hanger (see page 8). Tie raffia hanger around straw wreath.

2. Remove chili pepper clusters from string and attach clusters to wreath with floral pins hooked over stem of chili peppers. Dip floral pins into glue before inserting into wreath. Direct peppers downward from each side of wreath center.

3. Cluster three or four 18" strands of raffia together and shape into bow. Place floral pin over center of bow and push pin into wreath. Place approximately 12 bows throughout clusters of chili peppers. Trim streamers that are too long.

4. Using paper-jute ribbon, make 12 loop bow (6" wide, with 10" streamers). Apply glue to back of bow and place bow at center top of wreath. Bring bow wires to back of wreath and twist ends together. Trim excess wire. Drape bow streamers to each side of wreath and hold in place with floral pin.

FRUIT & IVY
COUNTRY WREATH

Create this vibrant wreath to brighten your kitchen or family room. Perhaps you might change the colors by substituting a fabric ribbon of your choice with coordinated paper ribbon and fruit. By making changes to suit your taste, the wreath will become uniquely yours.

Materials

- 12" heart straw wreath
- 6" 16-gauge wire
- low temperature glue gun and glue sticks
- scissors
- tape measure
- 4½ yards red paper twist
- 26 floral pins
- 4 yards red/white gingham ribbon
- 15 6" ivy vines (2" leaves or smaller)
- wire cutters
- 3 40mm red lacquered apples
- 24 15mm wired lacquered berries
- 24 10 mm wired lacquered berries
- green floral tape

1. Make a wire loop hanger (see page 8) and glue it to the upper back. Trim the stray ends of straw. Cut, untwist, and spread a 7½-foot length of paper twist. Fold evenly in half lengthwise and cut along the fold. Set one strip aside. Spiral the other evenly around the wreath, beginning and ending on the back at the bottom point. Bring the ends together with a floral pin. Spiral a 7½-foot strip of ribbon over the paper ribbon.

2. Make a French bow (see page 9) of gingham and paper twist. Gingham ribbon is not added to the streamer. Glue the bow and streamer to the top of the wreath. With floral pins, secure four 6" ivy vines to each side of the wreath, overlapping them to converge at the bottom point of the heart. Direct the stem ends toward the bottom point, covering stems with the leaves of the next vine. Cut the stems from two more 6" ivy vines and cross them in an inverted V. Attach with floral pins to the bottom point, with ends falling below the point.

3. Glue a cluster of the three large apples nestled among the leaves at the bottom point. Separate 10mm berries into eight groups with three berries in each. Cluster the three berries together and stretch and wrap floral tape on 2" of the stems; cut excess wire. Make eight clusters of 10mm berries and eight clusters of 15mm berries. Randomly glue four clusters of each size on each side of the heart; tuck stems under leaves.

4. Glue two 6" ivy vines above the bow, concealing glued portions under the bow. Cut apart the remaining ivy and glue individual leaves as needed to conceal floral pins and berry cluster stems.

CANDLE RING OF DRIED FLOWERS

Create a cozy atmosphere for entertaining or add a homey touch to everyday living with this beautiful dried-flower candle ring. Cover a straw wreath with Spanish moss and glue dried flowers and pine cones to the ring. When finished, you'll have a project to be proud of.

1. Cover the wreath with Spanish moss and attach with floral pins. Then wrap loosely with monofilament line. Do not trim the stray ends of moss.

2. Place the hurricane globe in the center of the ring. Prepare the dried materials to glue at random to the Spanish moss. Distribute them evenly for variety and color. Place them from close to the globe to table level. If necessary, remove the stems from the straw flowers before gluing both colors at random to the moss. Leave 1" stems on the statice sinuata. Tuck the glued stems under the moss, making about five large clusters that will give a mass of color. Glue them at different levels and angles.

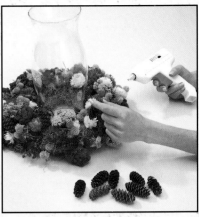

3. Leave short stems on the yarrow and cockscomb. If the blossoms are large, break them apart into 2" flower heads. If they are small, cluster and glue them into 2" flowers. Add the globe amaranth on stems from 1" to 3". Place them in clusters at all levels and angles. Glue the stem ends of the spruce cones at all levels and angles.

Materials

- 10" straw wreath
- 5 oz. Spanish moss
- 24 floral pins
- 5 yards monofilament fishing line or gray thread
- low temperature glue gun and glue sticks
- scissors
- tape measure
- 9" pillar candle, color of your choice
- 12" hurricane globe
- straw flowers: 12 cream and 12 cranberry
- 1 oz. purple statice sinuata
- 2 oz. natural dried yarrow
- 5 2" diameter cranberry cockscomb blossoms
- 65 mauve dried globe amaranth blossoms on natural stems
- 12 white spruce cones (or similar variety)
- 2 oz. natural dried caspia
- surface sealer spray

4. To give airiness to the ring, break off 2" and 3" caspia tips. Tuck the glued stems into the moss between the flowers. Place them at various angles, using their wispy tips to advantage. View the ring from all angles. If necessary, add leftover dried materials to conceal visible glue. Add additional materials to cascade onto the table if needed.

5. In a well-ventilated area, spray the dried materials to help prevent shattering.

CINNAMON APPLE WREATH

A cinnamon stick wreath creates a background for preserved apple slices. A perky bow of crisp windowpane plaid and a decorated wooden spoon accent this kitchen wreath that evokes the delicious, fragrant aroma of fresh baked apple pie.

Materials

- 10" × 2" cardboard or wood ring
- chenille stem for hanger
- approx. 90 cinnamon sticks, 3" to 4" long
- tacky glue (glue gun will not hold cinnamon onto wreath)
- craft stick or glue brush
- 10 preserved apple slices
- 2 yards windowpane plaid ribbon
- 28-gauge floral wire
- wooden spoon, 12" long (If you paint apple onto spoon bowl you will also need acrylic paints: country red, leaf green, ebony, and snow white; ¼" flat brush and liner brush; water; paper towels.)

Recipe
for preserving apple slices

2 cups lemon juice
1 tablespoon salt
large mixing bowl
5 or 6 apples
cutting board
sharp knife
screen or cooling rack
clear acrylic sealer spray

Directions:
1. Mix lemon juice and salt together in mixing bowl.
2. Cut apples into ¼" thick slices.
3. Soak apple slices in lemon juice mixture for 3 minutes.
4. Lay slices on screen or cooling rack and place in 150° oven for 5 to 6 hours or until slices begin to curl and feel leathery. LEAVE OVEN DOOR AJAR.
5. Allow slices to cool, then spray both sides of each slice with a clear acrylic spray.
Note: Treated apple slices may vary in color and will darken over time.

1. Attach chenille stem to top of wreath to form hanger (see page 8). Spread tacky glue over wreath base with craft stick or glue brush and lay cinnamon sticks side by side. You may have to layer sticks in some areas to cover cardboard base.

2. Apply glue to back of apple slices and lay 5 slices down each side of wreath, over cinnamon sticks.

3. Make a 10 loop bow (6" wide, with 5" streamers). Apply glue to back of bow and place bow at top of wreath between apple slices. Bring bow wire to back of wreath and twist ends together. Trim away excess wire.

4. Apply glue to back of the top of the spoon handle and to bowl. Place handle into bow loop and bowl of spoon at bottom of wreath. (Spoon may be decorated with a small apple painted on bowl of spoon.)

BACK-TO-SCHOOL WREATH

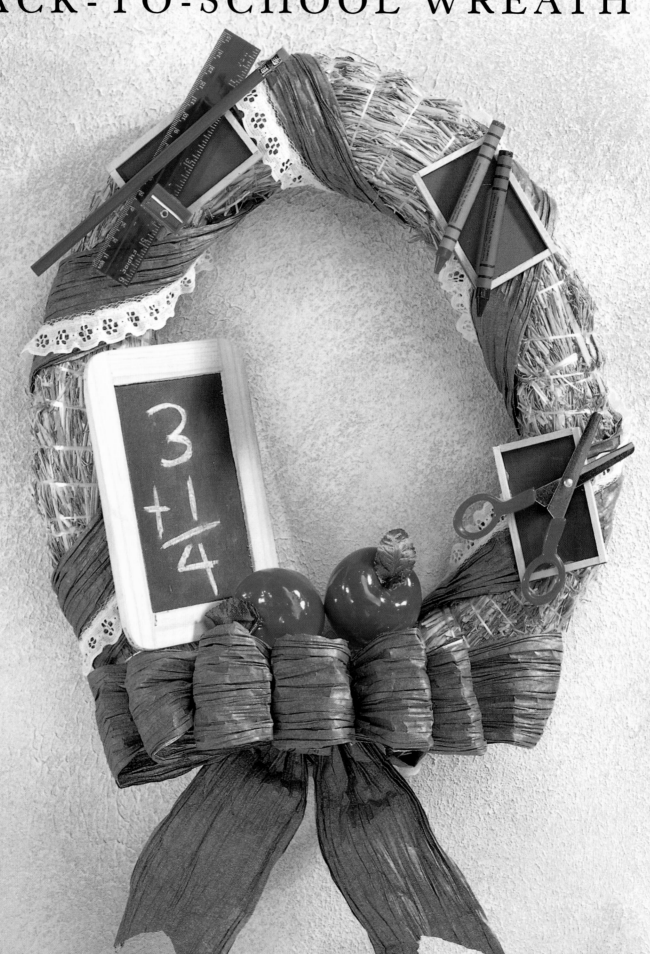

Blue jeans and eyelet-trimmed dresses represent the back-to-school theme for this novelty wreath. Whether you make it for your home or as a gift for your child's teacher, there is a touch of nostalgia in it for everyone. The accessories here are for the young student. If an older child is the subject of your theme, select appropriate materials and add your own blackboard message.

Materials

- 14" round straw wreath
- 6" 16-gauge wire
- wire cutters
- low temperature glue gun and glue sticks
- scissors
- tape measure
- 4¼ yards blue paper twist
- floral pins
- 2 yards ¾" white ruffled eyelet
- one piece chalk
- 5" × 7" blackboard
- 2 2" diameter red lacquered apples
- 3 2" × 3" blackboards
- School supplies (one of each): blue pencil, 6" red ruler, red pencil sharpener, red crayon, blue crayon, blunt scissors

1. Make a wire loop hanger (see page 8) and glue it to the upper back of the wreath. Trim the stray ends of straw from the wreath.

2. Cut off 64" of paper twist. Untwist but don't spread it to its full width. Spiral it evenly around the wreath and bring the ends together on the back; secure with a floral pin. In the same manner, spiral the same amount of eyelet at the edge of the paper ribbon; secure with a floral pin.

3. Make a French bow (see page 9) from the paper twist. Glue it to the bottom middle of the wreath. With chalk, write your message on the blackboard and glue it to the left inside edge of the wreath. Make sure no glue is visible. Glue two apples above the bow, at different angles.

4. To one mini blackboard, glue a pencil, ruler, and sharpener at different angles. To the second, glue two crayons. To the third, glue the opened scissors. Glue the blackboards evenly around the wreath.

5. Face: Nose–cut 5" length of aqua paper twist. Fold in half lengthwise, then in half again. Fold length of the piece in half and twist in center, gluing the two halves together. Fold ¾" from end. Apply glue to folded end and attach to center of face. Cut out two ⅝" circles from index card. Outline circle with black permanent marker and fill in eye leaving white crescent to right side of eye (see pattern). Glue eyes to face just above nose. Draw small crescent for mouth.

6. Hair: Cut three 21" lengths of metallic purple twist. Cut ½" wide slits in each piece. Using a floral pin, pin strips on head to form hair. Trim ends.

7. Hat: Fold black felt square in half across the 12" length. Measure 6" from the folded corner and mark with straight pins (see diagram). Cut along pin line. Form piece into cone and glue overlapping edges together. Cut brim from curve in felt, with center measuring 2" and taper off to point on each end (see diagram). Slash curve of brim ½" along inside edge. Apply glue to slashes and attach to underside of crown, bringing tapered ends to back of hat. Trim hat with orange satin ribbon. Pin hat to head with straight pins.

Cut along pin line

8. Make a 6 loop bow from Halloween ribbon (6" wide, with 5" streamers) and glue to witch's neck. Glue broom into witch's hand.

Eyes

Cut brim along dotted line

Hand

Cut 4

Glue slashes to inside of crown

AUTUMN GLOW WREATH

The warm, vibrant shades of autumn are captured in this straw wreath trimmed with raffia, autumn leaves, pine cones, and plaid ribbon. A colorful, saucy raffia scarecrow is perched in the center of the wreath to give a friendly welcome to all.

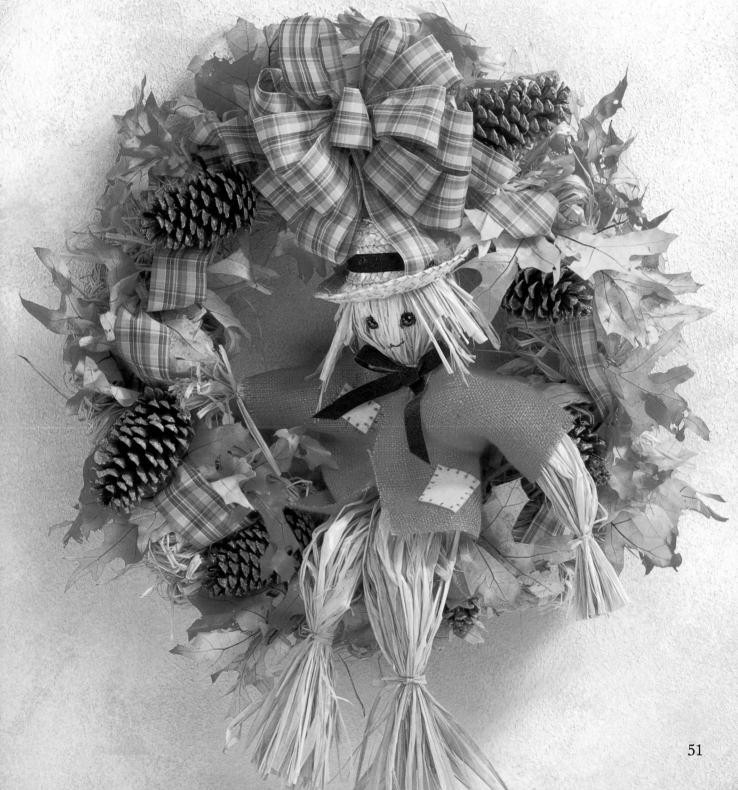

AUTUMN GLOW WREATH

Materials

- 18" straw wreath
- 12 oz. pkg. of natural raffia
- floral pins
- 6 yards ribbon, autumn tones
- scissors
- 28-gauge floral wire
- wire cutters
- preserved fall leaves
- tacky glue
- 8 pine cones, 4" long
- 18-gauge wire
- 12" wood dowel stick, ¼"
- 3" foam ball
- ruler
- 2 12mm solid black doll eyes
- black permanent marking pen
- 12" × 15" orange burlap
- needle and thread
- gold felt square for patches
- 1 yard green velvet ribbon
- 1 orange feather, 4" long
- 6" straw hat

1. Unwrap wreath if wrapped in plastic. Attach several strands of raffia to wreath for hanger according to chenille stem hanger instructions (see page 8). Straighten out raffia strands. Keep all strands tied together in center. Pull off 12 to 15 strands of raffia and tie them around the wreath in a bow, securing with a floral pin. Repeat 3 more times, placing tied raffia in four places around wreath, equal distances apart.

2. Cut 2⅓ yards of ribbon and starting at top back, loop ribbon on top of the wreath. Attach ribbon to wreath with floral pins. With remaining ribbon, make a 12 loop bow (9" wide, with 6" streamers). Attach bow to top of wreath by wrapping bow wire around wreath and twisting ends together in back of wreath. Trim excess wire.

3. Open package of fall leaves and cut branches apart into shorter stems. Glue branches into straw around wreath. Attach 9" of wire to each pine cone, leaving a 3" wire stem. Dip wire stem into glue and place pine cone into wreath, nestled in leaves and raffia.

4. Scarecrow: Dip end of wood dowel into glue and push into foam ball. Using about 60 strands of raffia, fold raffia strands in half and tie together in center with strand of raffia. Center tied area of raffia over foam ball and pull strands smooth over ball and tie together at base of ball around dowel stick. Measure down 18" from top of ball and cut off excess raffia.

5. Use long cut-off strands of raffia to form arms. Tie the center of this cluster with strands of raffia. Arms should measure about 20" long. Place arm between raffia strands, beneath head. Tie all strands together beneath arms, forming waist. Divide strands below waist into two equal sections and tie ends together to form legs. Tie ends of arms together.

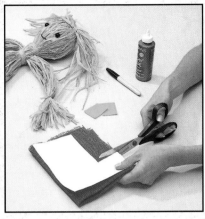

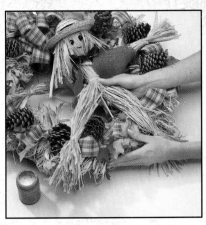

6. Hair: Tie a cluster of 10" strands of raffia together in center and pin to top of head. Glue black eyes to face by pushing glue coated shanks into foam. Draw crescent mouth with black permanent marker.

7. Jacket: Fold 15" length of orange burlap in half, then fold again in opposite direction. Following diagram, cut out jacket. Slit one fold for front opening. Hand sew side seams together (you may also staple seams); turn to right side. Cut out two gold felt patches. Glue patches to jacket with tacky glue. Make stitch marks with black permanent marker. Put jacket on scarecrow. Tie shoestring bow with ½ yard velvet ribbon and glue to neck.

8. Trim hat with green velvet ribbon and feather. Attach to head with several floral pins. Dip end of dowel stick into glue and push down into wreath to sit scarecrow in wreath.

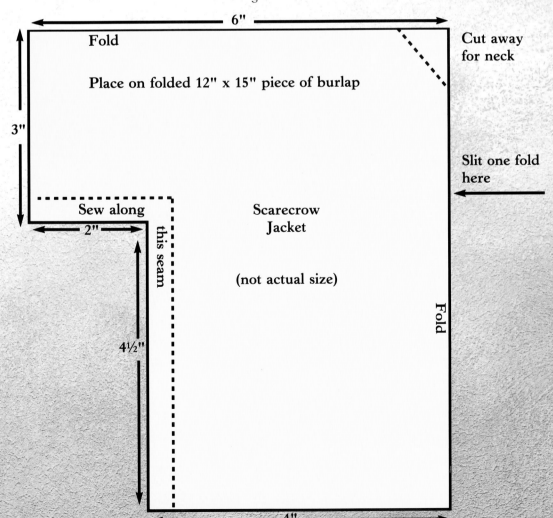

6"

Fold

Cut away for neck

Place on folded 12" x 15" piece of burlap

3"

Slit one fold here

Sew along

2"

this seam

Scarecrow Jacket

(not actual size)

Fold

4½"

4"

53

VICTORIAN WREATH

The glitz of the Victorian era is reflected in this lamé-wrapped wreath of evergreens, silk roses, and golden walnuts. You'll discover, as the Victorians did, that gold blends well with holiday decorating.

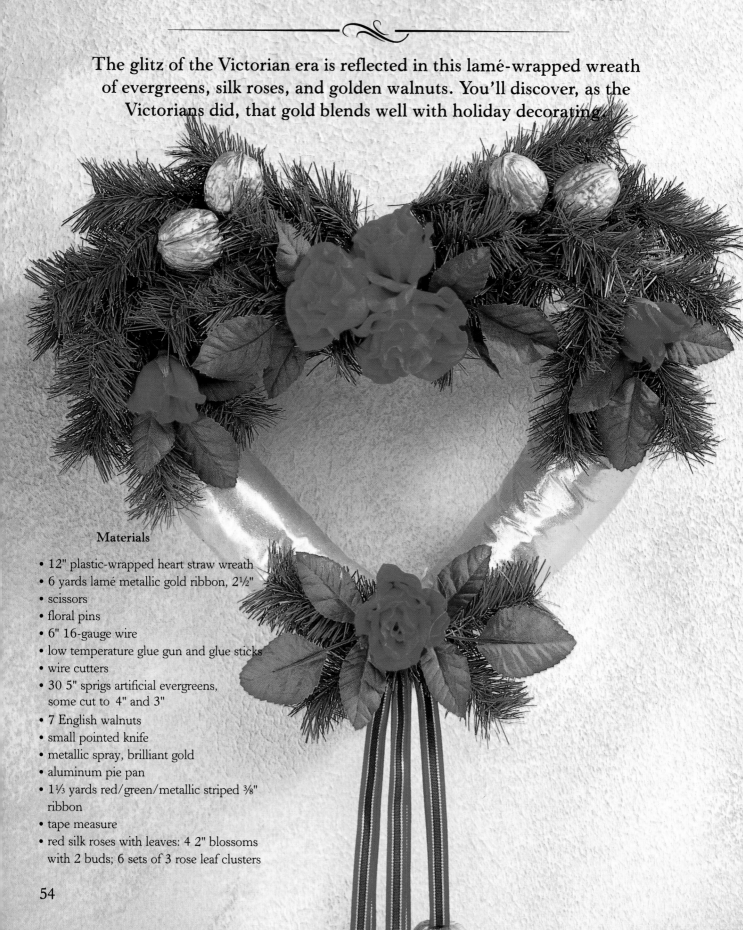

Materials

- 12" plastic-wrapped heart straw wreath
- 6 yards lamé metallic gold ribbon, 2½"
- scissors
- floral pins
- 6" 16-gauge wire
- low temperature glue gun and glue sticks
- wire cutters
- 30 5" sprigs artificial evergreens, some cut to 4" and 3"
- 7 English walnuts
- small pointed knife
- metallic spray, brilliant gold
- aluminum pie pan
- 1⅓ yards red/green/metallic striped ⅜" ribbon
- tape measure
- red silk roses with leaves: 4 2" blossoms with 2 buds; 6 sets of 3 rose leaf clusters

1. Spiral wrap the wreath with lamé ribbon, beginning and ending on the center top of the wreath on the front (covered later with greens). Secure both ends with floral pins. Make a wire loop hanger (see page 8) and glue to the upper back.

2. NOTE: The evergreen needles fall in one direction on each wire stem. Attach them to the wreath in the same direction. With floral pins, secure one end of 12 5" evergreen sprigs to the wreath on the left side beginning halfway up the wreath and ending at the center top. Position them in pairs in an inverted *V* pattern as you work up toward the center. Repeat on the opposite side. Adjust greens and trim the ends if too long.

3. Carefully pry open walnuts and remove nuts; glue the matching halves back together. In a well-ventilated area, spray them with fast-drying metallic gold paint. Place them in the aluminum pan and turn as needed to coat completely. From striped ribbon, cut three hangers: 14", 16", and 18". Glue the ends together and glue one walnut to the bottom of each looped ribbon. Glue the ends in a cluster and hang from the bottom point.

4. To conceal the ribbon ends of the hanging walnuts, glue two 4" evergreens (needles facing opposite directions) in a *V*. Glue two 3" sprigs beneath them in the same manner, but in an inverted *V* with all four stems converging at the point. Cut one 5" evergreen in half. Turn one piece around and glue them in an inverted *V* at the center top of the heart where the stems converge. Position them to be seen below the point.

5. Cut roses and leaves from stems. Glue three roses in a cluster in the center top and one at the bottom of the heart where greens converge. Glue one three-leaf cluster horizontally on each side of the upper roses and one on each side of the lower rose. Conceal the glued stems under the roses.

6. Glue a rosebud and one 3-leaf cluster on the left and right sides pointing down. Tuck the cut ends under the greens. Glue two walnuts among the greens on the upper left curve of the heart and two on the upper right curve. Conceal visible floral pins by gluing 1" sprigs of greens.

NATURAL ELEGANCE
CHRISTMAS WREATH

Pods, cones, preserved citrus slices, and pine create an elegant
decoration for the holiday season. A red velvet bow with cascading
gold jingle bells will surely add elegance to your Christmas decor.

1. Shape wreath by pulling out and fluffing branches. (You may choose to use a natural wreath, which will probably not need fluffing.)

2. Make garland of pods with wire stems, using paddle wire. Garland should be long enough to fit around wreath. Use lotus, okra, poppy pods, bell cups, and protea in garland.

3. Lay garland on top of wreath and twist pine fronds over garland to hold in place. (If using fresh wreath, wire garland into wreath.)

Materials

- 27" to 30" artificial Colorado spruce wreath
- stemmed pods: 7 medium lotus pods, 8 okra pods, 9 poppy pods, 5 bell cups, 4 protea
- 28-gauge paddle wire
- rosebloom protea
- 2 clusters agave
- 2 bunches preserved pepperberries
- 1 bunch yarrow, gold
- 7 persevered citrus slices
- preserved baby breath, natural
- hot glue gun and glue sticks or tacky glue
- 3 yards wired red velvet ribbon
- 28-gauge floral wire
- scissors
- ruler
- 1½ yards red velvet cording
- 4 1½" diameter gold jingle bells
- wire cutters

4. Glue in stems of rosebloom protea, agave, pepperberries, yarrow, citrus slices, and preserved baby breath.

5. Using wired ribbon, make a 6 loop bow (10" wide, with 12" streamers). Tie bells to ends of two 24" lengths of red velvet cording. Catch cording into bow wire at back of bow, staggering the lengths of cords. Wire bow to top of wreath. Trim wire. Drape streamers to sides of wreath and secure with glue.

MUSICAL HOLIDAY WREATH

Holiday music brings fond memories back to us all. This musical wreath is a reflection of that nostalgia, from the vibrant velvet ribbon inscribed with gold music to the matching gold instruments.

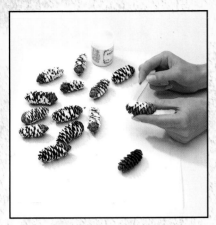

1. Insert a chenille stem through the wire frame on the back of the wreath. Twist the ends together making a hanger loop (see page 8). With a craft stick or butter knife, frost all sides of the cones with snow texturizing, starting at the base of the cone and working toward the tip. Set aside on wax paper to dry.

Materials

- 16" artificial evergreen wreath
- 12" green chenille stem
- craft stick or butter knife
- 12 2" spruce cones
- snow texturizing
- small piece wax paper
- 2 yards 8mm gold strung bead garland
- 3⅓ yards red velvet/gold wire-edge music score ribbon
- tape measure
- scissors
- glue gun and glue sticks
- 28-gauge floral wire
- 2 yards fine metallic gold cord (to hang ornaments)
- 12 3" assorted gold plastic instruments
- 39 wired double-ended red berries
- green floral tape
- 5" white feathered dove
- wire cutters
- 1 yard 32-gauge green cloth-covered wire

2. Entwine the gold bead garland among the branches, allowing it to fall gracefully. Final adjustments will be made later. For the banner, cut a 22" length of ribbon. Tuck it among the branches from between center left to top, just right of center. Glue ribbon to the branches, and ripple the wire edges slightly. Following the instructions on page 10, make a multiloop bow (8" wide, with 12" streamers). Crumple the wire edges of the ribbon slightly to create a rippled bow. Glue it to the bottom right of the wreath.

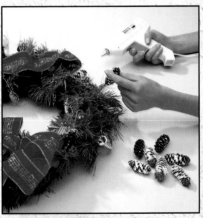

4. Cut the wires from the dove's feet and glue it above the banner at the top. Adjust the gold beads and secure them to the branches in about ten spots by twisting 2" lengths of green 32-gauge wire around them. When the cones have dried, glue them at random among the branches, tilting them at various angles.

3. Attach 6" lengths of metallic gold cord to the instruments as hangers. Position the instruments at random. Wrap each cord hanger around the bough twice, allowing each instrument to dangle. Adjust them for balance and variety. To make one berry cluster, bend three wired berries in half to make six berries per cluster. Stretch and wrap the floral tape around the wires. Make 12 more clusters. Glue their taped stems to the branches at random; conceal glue and tape under the branches.

PINE CONE WREATH

Enjoy the natural beauty of pine cones year after year with this lovely holiday wreath. Once you've mastered the technique, change the cone selection and pattern to create a unique gift.

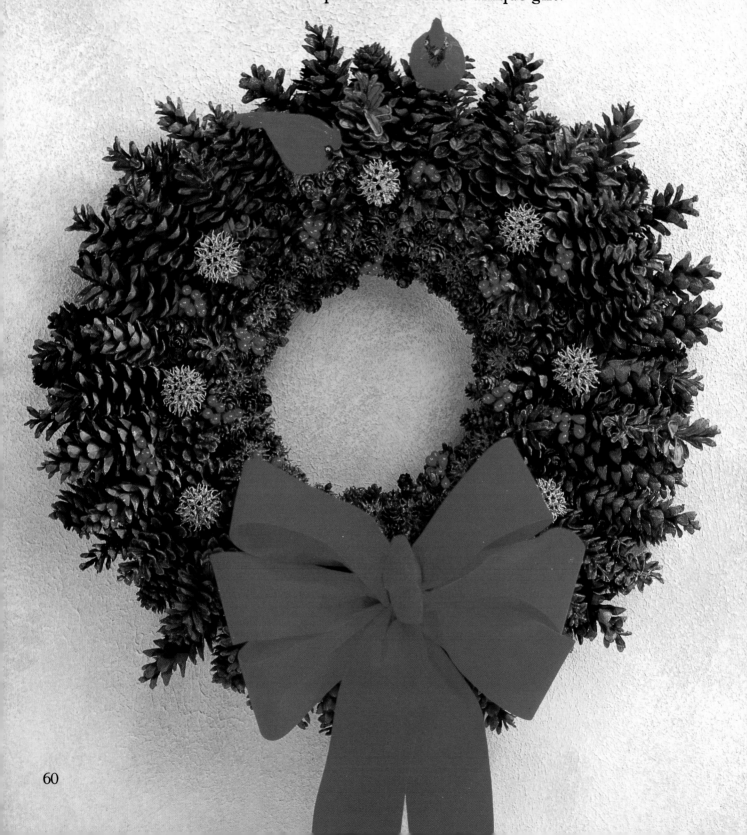

1. Soak the Norway spruce cones in water for two hours or until they close. Drain on newspapers. Curved side of the frame is the top, which is the front of the wreath. Wedge the stem end of the wet cones compactly between the two upper and two lower wires. Fill wreath with cones. Insert the chenille stem through the wires on the back and twist into a loop for a hanger. Hang to dry.

Materials

- Cones and pods: (approx.) 35 6" Norway spruce cones; 35 5" and 24 4" white pine cones; 65 sweet gum balls; 30 scotch (or banks) cones; 200 hemlock cones
- pail of water
- 14" wire box wreath frame
- 12" brown chenille stem
- gardening gloves
- wire cutters
- glue gun and glue sticks
- tape measure
- floral sprays: glossy wood tone and brilliant gold
- 2 4½" red feathered cardinals
- 3 yards red velvet craft ribbon, 2½"
- scissors
- 6" 32-gauge green cloth-covered wire
- 39 6mm wired, double-ended holly berries
- brown floral tape

2. The dry cones open again and create a tight base for the wreath. Wear gloves to protect your hands from sharp cones. Set aside seven large sweet gum balls for Step 5. With wire cutters, remove stems from the remaining sweet gum balls. Then glue two compact rows to the stem end of the spruce cones in the center of the wreath, concealing the wires. After gluing, hold each for a few seconds until it adheres. In a compact circle, glue the scotch cones close to the sweet gum balls. Glue half of the hemlock cones in the spaces between the sweet gum balls.

4. In a well-ventilated area, coat the wreath with glossy wood spray. Hold each of seven sweet gum balls by its stem and spray with brilliant gold. Cut off the stems and set aside. Glue the two cardinals to the top of the wreath facing each other. Make a multiloop bow (see page 10), which measures 10" wide with 3" loops on each side and with 12" and 14" streamers. Secure gathers with 32-gauge wire. Glue bow to the wreath at the center bottom.

3. Glue the stem end of the 5" white pine cones in a circle wedged between the scotch cones added in Step 2. Position them in the same direction as the bottom cone layer (like the spokes of a wheel). View the wreath from the side and note the space between the two layers of cones. Wedge in and glue the 4" white pine cones to fill spaces. Glue the remaining hemlock cones in the spaces around the scotch cones and around the stems of the white pine.

5. To make a berry cluster, bend three wired berries in half to make six berries per cluster. Stretch and wrap the floral tape around the wires. Make 12 more clusters. Glue the taped berries, with the stems tucked between the cones, at random. Glue the 7 gold sweet gum balls to the wreath spaced evenly.

WILLIAMSBURG-INSPIRED
CHRISTMAS SWAG

Create this vibrant Williamsburg-inspired holiday swag in two hours or less. In the true Williamsburg tradition, fresh greens, fruits, and berries are used. To have more than one season's enjoyment, use preserved greens like those pictured. Display your creation on a sheltered entryway and its beauty will be admired by all.

Materials

- 3" × 4" corrugated cardboard
- tape measure
- scissors
- awl
- 12" green chenille stem
- low temperature glue gun and glue sticks
- 3" × 4" block dry floral foam
- serrated knife
- small garden clippers

- 1-pound bunch preserved cedar
- 2 8-oz. bunches preserved boxwood
- 1-pound bunch preserved black spruce
- 3 2½" floral picks
- 6 long stemmed natural dried yarrow with 3" to 4" diameter blossoms

- 3 red delicious artificial apples
- 9 12" lengths 18- or 20-gauge wire
- 81 10mm wire-stemmed lacquered berries
- green floral tape
- wire cutters
- white pine cones: 7 6"; 1 4"

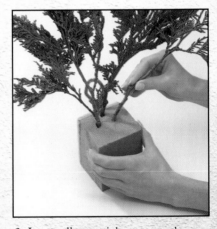

1. Cut a 3" × 4" piece of corrugated cardboard. With an awl, puncture two evenly spaced holes in the cardboard, 1" down and parallel to one narrow end. Make a hanger by bending a 12" chenille stem into a U. Three inches down from the U, twist the stem into a 3" loop. Push the wire ends through the holes in the cardboard, pulling the twisted portion of the hanger tightly against the cardboard, twist ends, and press flat against the cardboard. Glue the twisted wire down and reinforce the connection of the chenille stem and the cardboard around the holes with glue.

2. With cardboard as a guide and using a serrated knife, cut a foam block the size of the cardboard. Glue the cardboard to the foam block (with hanger on outside). For added reinforcement, place a beading of glue along the four edges where the foam and cardboard meet. Hold cardboard against the foam until glue cools.

3. Insert all materials at an angle as though to converge in the center of the foam block. With garden clippers, cut three long branches of cedar: one 19" and two 15" long. Trim bottom 3" of side branches. Insert the long branch in the center extreme back of the foam, extending 16" straight up from the top of the foam block. Place the other two branches angled in a V in front of the first branch with one closer to the front than the other.

4. In the same manner, insert cedar branches on the bottom of the swag, with the longest extending about 16" down from the bottom of the foam. Cover the remaining surface of the foam with 4" sprigs of boxwood on the front and sides with longer ones toward the back, while creating a horizontal width of about 16".

5. Within the outside dimensions of the materials already placed, fill in with long and short branches of black spruce. Insert long ones in a fan shape at the top and bottom between the cedar branches and shorter ones horizontally to extend the width to about 20".

6. Add two or three 12" branches of boxwood in front of the upper cedar branches and the same number below.

7. Holding apple firmly, carefully puncture it with an awl. Make a hole on the bottom of the apple large enough to insert the square end of a floral pick. Remove wire from the pick and glue into the hole; hold pick steady until glue cools. Insert apples clustered in center.

8. Insert six yarrow blossoms (three above apples, three below) into the foam at various levels. The longest ones can extend about 10" from the center of the apple cluster. To each of nine 12" lengths of 18- or 20-gauge wire, attach nine wired berries with floral tape. Place the wired berry stems in a cluster parallel to the floral wire, permitting the berries to extend 1½" above the wire. Tape the berry clusters to the wires. Insert the clusters at random among the greens, permitting a group of three clusters to cascade beneath the apples, and the remaining ones evenly distributed throughout the swag.

9. Glue seven 6" cones among the outside branches around the design. Tuck the glued stem ends between the branches, but make the cones visible from the front. Glue one 4" cone tucked among the branches above the apples. View the swag from all sides and fill in gaps with remaining greens. Use short branches of spruce and cedar in the front to add variety. When the swag is hung, the branches should be flush against the wall to conceal the foam holder.